LESSONS IN
HOPE

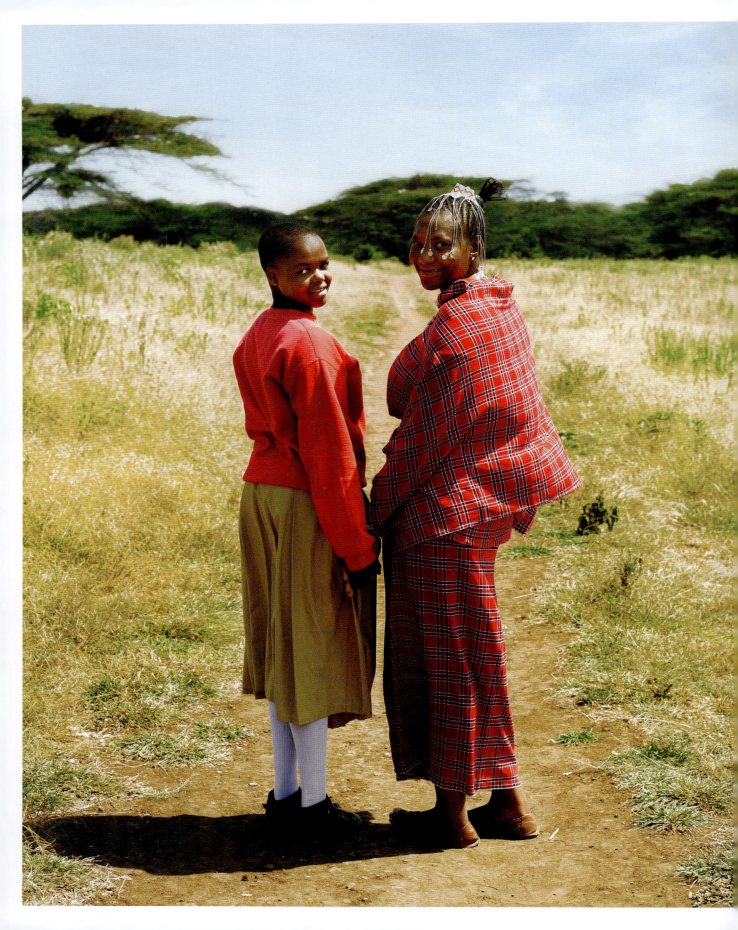

LESSONS IN HOPE

A New Era for Maasai Women in Tanzania

Juliet Cutler

with contributions by Esuvat Lucumay,
Lameck Tryphone Mutta, and Aron Williams

in partnership with Operation Bootstrap Africa

SHE WRITES PRESS

Copyright © 2025 Juliet Cutler

All rights reserved. No part of this publication may be reproduced, distributed, or transmitted in any form or by any means, including photocopying, recording, digital scanning, or other electronic or mechanical methods, without the prior written permission of the publisher, except in the case of brief quotations embodied in critical reviews and certain other noncommercial uses permitted by copyright law. For permission requests, please address She Writes Press.

Published in 2025 by
She Writes Press, an imprint of The Stable Book Group

32 Court Street, Suite 2109
Brooklyn, NY 11201
https://shewritespress.com
Library of Congress Control Number: 2025909842
Paperback ISBN: 978-1-64742-958-4
Hardcover ISBN: 979-8-89636-026-1
E-ISBN: 978-1-64742-959-1

Interior design by Tabitha Lahr
Front cover photo by Slade Kemmet
Back cover photos by Aron Williams (top left), Mountain Hearts Photography (top middle left), and Lameck Tryphone Mutta (all remaining)

Printed in the United States of America

No part of this publication may be used to train generative artificial intelligence (AI) models. The publisher and author reserve all rights related to the use of this content in machine learning.

Company and/or product names that are trade names, logos, trademarks, and/or registered trademarks of third parties are the property of their respective owners and are used in this book for purposes of identification and information only under the Fair Use Doctrine.

For the teachers and staff at the MaaSAE Girls
Lutheran Secondary School, who, past to present, have
carried the vision forward. And for the school's sponsors,
who have made education possible for so many.

OPERATION BOOTSTRAP AFRICA partners with Africans to strengthen their futures through education, healthcare, agriculture, and other long-term development projects. Founded in 1965, the organization invests in grassroots projects that empower local people to advance their own lives and communities, according to their own priorities, with a focus on Tanzania, Madagascar, and Kenya.

Since 1995, the MaaSAE Girls Lutheran Secondary School in Tanzania has been one of Operation Bootstrap Africa's flagship projects. Among the school's graduates are doctors, nurses, teachers, architects, social workers, entrepreneurs, and more. These young women are using their education to build a better Tanzania for future generations.

Operation Bootstrap Africa is a 501(c)(3) nonprofit organization in the United States and has earned top ratings on Charity Navigator for high impact projects, fiscal responsibility, transparency, and organizational leadership and culture.

Lessons in Hope was published in partnership with Operation Bootstrap Africa. All proceeds from the sale of this book will support the MaaSAE Girls Lutheran Secondary School.

If you are interested in learning more about how you can support education for Maasai girls, please visit www.bootstrapafrica.org.

Contents

About the Team ◈ X

Preface: **JULIET CUTLER** ◈ XII

Opening ◈ 1
 A School for Maasai Girls | 2
 Bega kwa Bega in Action | 14

Education ◈ 19
 Improving Schools, Advocating for Students: **JOSEPHINE SAMBEKE LAIZER** | 21
 More than an Education, Support After an Accident: **NESIKAR MEAGIE MOLLEL** | 24
 A Community Celebrates: **NEEMA MELAMI LAITAYOCK** | 31
 Once a Student, Now a Teacher: **SELINA LEYAN KIVUYO** | 38
 An Oasis in the Heart of Maasailand: **MARTHA MERESO SENGERUAN** | 42

Healthcare ◈ 59
 Caring for Children with Disabilities: **JACLYN SHAMBULO LEKULE** | 61
 Chasing a Childhood Dream: **MARIA NAMARAI LAIZER** | 67
 Becoming a Surgeon: **NANYOKYE NASIRA KIDOKO** | 72
 Opening a Private Practice in Maasailand: **MAGDALENA TOBIKO LAISER** | 78
 Pediatric Care for Maasai Children: **THERESIA MEPUKORI LAIZER** | 84

Nonprofits ◈ 91
 A Brighter World Led by Women: **AGNESS JOSEPH POROKWA** | 93
 Pioneering Solutions for Women and Girls: **SELINA NGURUMWA** | 100
 An Advocate for Her People: **JOYCE MICHAEL SYOKINO** | 106
 Protecting the Rights of Miners and Mining Communities: **ZAWADI JOSEPH** | 112
 Mentoring the Next Generation: **PAULINA MESARIEKI** | 119

Government ◆ 127

 Leading Change from Within: **UPENDO KATITO MALULU NDOROS** | 128

 Improving Public Health in Africa: **UPENDO BARNABA LETAWO** | 138

 A Real-life Superhero: **SANGAI MAMBAI LENGARUS** | 145

 Enhancing the Welfare of Women through Social Work: **UPENDO LEBENE LUKUMAY** | 150

Other Fields ◆ 157

 Architectural Design by and for Women: **NASHIVA ALBERT MEGIROO** | 159

 Building Agribusiness in Tanzania, Part One: **ELIZABETH LOIRUCK** | 164

 Building Agribusiness in Tanzania, Part Two: **FARAJA KIMETUU KURUBAI** | 172

 A Spiritual Counselor for Youth: **DORCAS WILLIAM PHILIPO** | 183

 An Entrepreneur in Action: **ENDESH LAZARO YAMAT** | 188

Closing ◆ 195

 Let's Hear It from the Board & Staff | 197

Afterword: **JASON BERGMANN**, Executive Director, Operation Bootstrap Africa | 214

Acknowledgments | 217

Swahili / Maa to English Glossary | 221

Maps | 224

Photo Credits | 228

About the Team

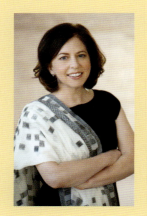

Juliet Cutler
AUTHOR

Juliet Cutler is a writer and exhibit designer for museums, parks, and cultural centers around the world. In 1999 and 2000, Juliet lived in Tanzania, where she taught English at the first secondary school for Maasai girls in East Africa. She recounts her experiences during those years in her award-winning first book, *Among the Maasai*. Twenty-five years later, she created this book to illustrate the positive impacts of education on Maasai women. Juliet holds a master of arts in English from Colorado State University and a bachelor of science in education from the University of North Dakota. She currently lives with her husband, Mark, near Atlanta. She regularly travels to Tanzania to support causes that uplift Maasai women and girls. All proceeds from the sales of her books support these causes.

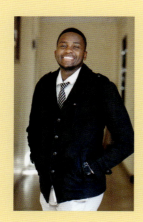

Lameck Tryphone Mutta
VIDEOGRAPHER & PHOTOGRAPHER

Lameck Tryphone Mutta works as a freelance photojournalist reporting for media outlets across Tanzania. He specializes in uncovering stories about the unequal treatment of people, particularly that of women and children. His reports have focused on societal problems such as discrimination against disabled children, the devastating effects of child labor, and the often unseen impacts of poverty on women. Through his work, Tryphone aims to promote awareness and to engender a spirit of action toward social justice. He holds a bachelor of arts in mass communication from St. Augustine University of Tanzania. He hails from Mwanza, though he frequently travels to Arusha, Dodoma, Dar es Salaam, and Zanzibar on assignment.

Esuvat Lucumay
INTERVIEW COORDINATOR & TRANSLATOR

Esuvat Lucumay serves as executive director for Eripoto for Girls and Women, a nonprofit organization committed to protecting and empowering Tanzanian women and girls who have faced gender-based violence. Eripoto achieves its mission by providing a safe house, counseling, scholarships, and support services. As a Maasai woman and survivor of childhood violence herself, Esuvat understands prevention is as important as shelter and support, which is why Eripoto also leads violence prevention and economic empowerment programs in communities and schools across northern Tanzania. Esuvat holds degrees in business administration and human resources management from the University of Arusha. She lives with her husband and two children in Arusha.

Aron Williams
VIDEOGRAPHER & PHOTOGRAPHER

Aron Williams is a videographer and photographer who works for a range of clients including Empowered Girls, a nonprofit organization that mentors and encourages young women to live into their full potential. Behind the camera, Aron captures stories of transformation, documenting the challenges and barriers young women face in Tanzania and bearing witness to the ways knowledge about personal and mental health, life skills, and women's rights changes lives. When he is not working, Aron enjoys exercising, reading, and spending time with his family in Arusha. He holds a bachelor's degree in education from Kampala International University in Uganda.

Preface

One of the amazing things about getting older is the change we get to witness over time. My memoir, *Among the Maasai*, which came out in 2019, told the story of my two years as a volunteer English teacher at the first secondary school for Maasai girls in East Africa. In that book, I gave voice to the profound effect working with young Maasai women had on my life. I looked back to the 1990s, when a group of Maasai elders began discussing how to help their people face escalating challenges in a rapidly changing world. These elders knew that in order for the Maasai people to endure in the twenty-first century, they would require different skills and ways of being. They believed that the Maasai needed more access to education, and that girls required a special school that would honor their cultural identity and maintain Maasai traditions. And so the MaaSAE Girls Lutheran Secondary School (MGLSS) was born in partnership with Operation Bootstrap Africa (OBA), a US-based nonprofit that would fund the school's construction and operation.

When I arrived in Tanzania in 1999, the school was still in its infancy, and in many ways so was I. I was in my mid-twenties—an idealistic young American who believed she could make a difference in the world. I had heard about the MGLSS from an OBA board member who'd told me about the challenges Maasai women faced in their quest to gain an education.

I soon learned that the Maasai are among the poorest people on the planet, and that women and girls often bear the brunt of this poverty. They rise early to milk cows and goats. They cook, clean, and care for children without access to running water or electricity. Many must walk miles just to get the minimum amount of water required to sustain their families. They live in austere, mud-walled homes in places where access to healthcare is limited and preventable diseases are prevalent. Too many Maasai girls still endure female genital mutilation (FGM) and forced child marriages as early as age ten or eleven, though both practices are illegal in Tanzania.

These challenges mean many Maasai girls are unable to attend school. Some are denied access because their families see more value in a dowry than in an education. Others can't afford even basic school supplies. For many, the workload at home means they don't have time to study. Yet if you ask most Maasai girls if they want an education, they will emphatically tell you that they do. They know it is a pathway out of poverty and into a life where they will have fewer challenges and more choices.

When I learned about these stark realities thirty years ago, I was inspired to action. The MGLSS had an opening for a volunteer English teacher, and as a recent university graduate with a bachelor's degree in English education, I fit the bill. However, I quickly realized I had as much to learn from my Maasai students as I had to teach

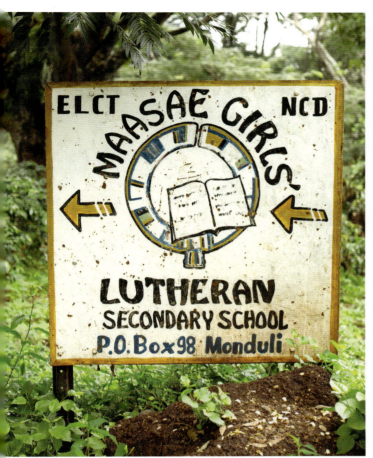
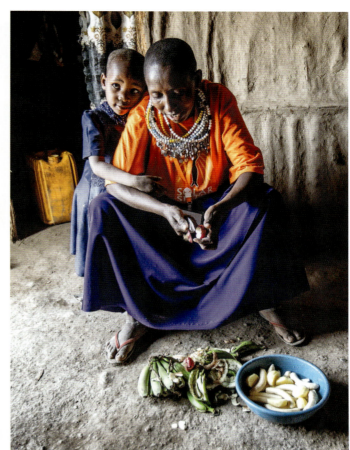
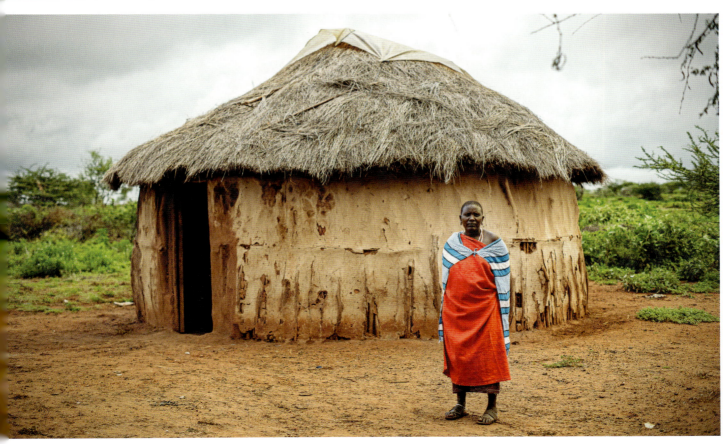

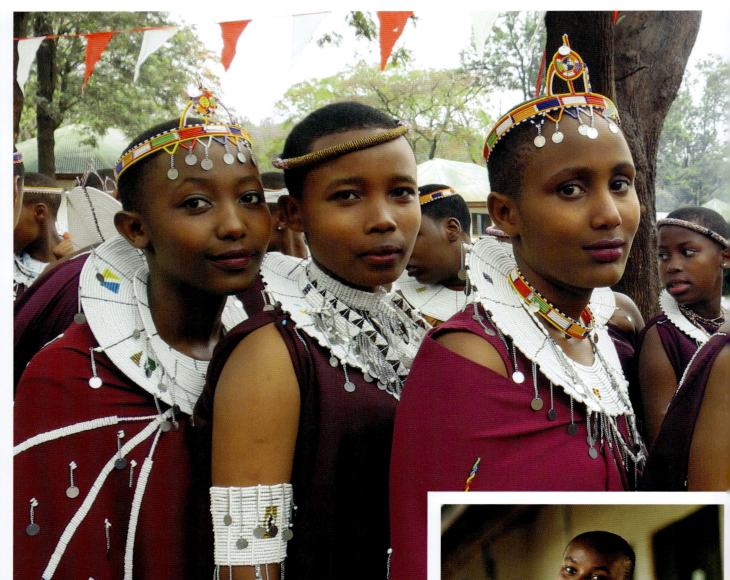

them. From them, I learned about determination, resiliency, community, and hope. They motivated me to lean into our differences even as we looked for common ground, and to work across cultural boundaries despite the inherent challenges of that work. Their generosity and courage touched my life, expanded my world, and changed my understanding of the plight of women around the world. I came to realize how privileged and rare my experience had been as a white girl growing up in America.

While I was teaching at the school, its first class graduated. As those young women decided their next steps after graduation, I saw glimmers of the ways the MGLSS would transform lives, creating ripples of positive change across families, communities, and even the nation of Tanzania. Today, nearly three decades later, this book, *Lessons in Hope*, brings those stories into focus.

The women featured in this book, graduates of the MGLSS, offer diverse perspectives on the challenges and choices they have faced and continue to face in their lives. They deeply value education, and many are working to ensure the next generation has even more access to education than they did. They recognize the need for cultural transformation when it comes to issues like FGM, child marriage, and women's rights, yet they remain committed to ensuring the Maasai people and their culture endure as a vibrant, powerful force in Tanzania. They are teachers and advocates, mothers and daughters, leaders and visionaries working to empower others and create positive change that will lead the Maasai into a new era of prosperity.

Addressing poverty and injustice is a complicated, difficult endeavor, and I've often considered westerners' role in doing that work in the Global South—how do those of us who care about people around the world engage in appropriate, meaningful action that is driven by local priorities? How can relatively small investments equip people who live in the Global South with the resources they need to advance positive changes within their own lives, cultures, and societies?

Over the years, I've come to see the many ways investing in girls' education centers these values, ultimately empowering women as changemakers within their communities. Abundant research in the field of international development defines the clear impacts of educating girls. They are more likely to lead healthy, happy lives; earn higher incomes; participate in the decisions that most affect them; and build better futures for themselves and their children. This book tells the story of how educating Maasai girls is achieving these outcomes, which in turn is bringing leadership and hope to Tanzania's Maasai community and beyond.

In the epilogue of *Among the Maasai*, I used the metaphor of moving mountains with a teaspoon to describe the task of shifting the conditions of poverty and injustice for Maasai girls. While far too many Maasai girls still have far too few opportunities, the inspiring stories in this book reveal a cadre of Maasai women working to improve life for their families and their communities. They are a generation of women leading their people into the future, and I have had the great privilege of witnessing and documenting their stories.

—JULIET CUTLER, September 2025

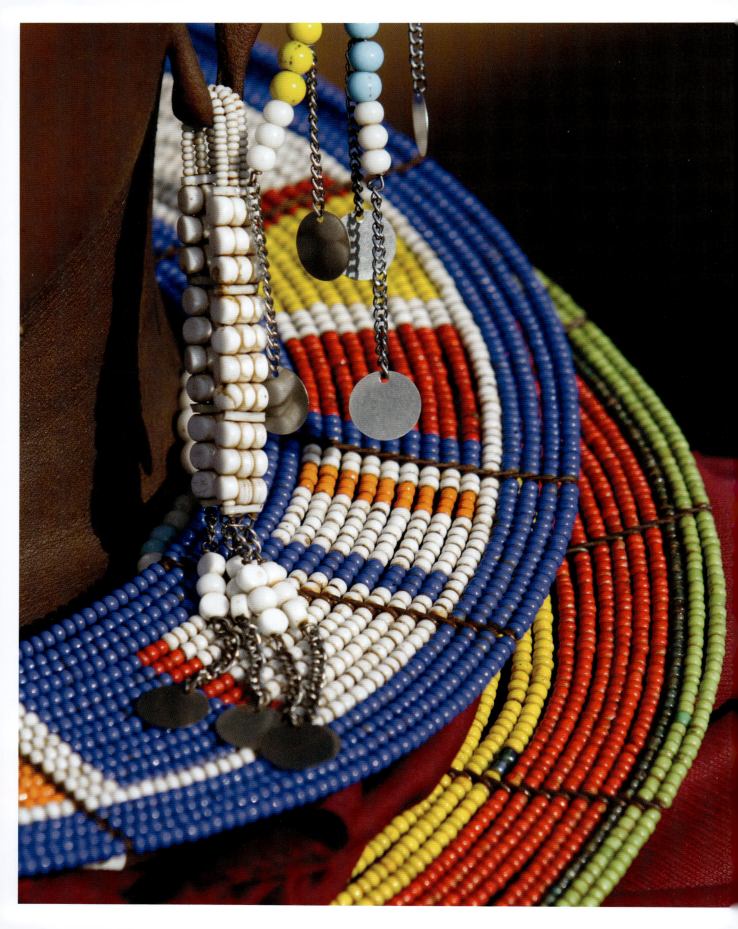

◆ OPENING ◆

A School for Maasai Girls

Silence Please! Brains at Work. A small, hand-lettered sign containing these words hangs outside the door to one of the classrooms on the campus of the MaaSAE Girls Lutheran Secondary School (MGLSS). Built thirty years ago in the heart of northern Tanzania's Maasailand, this secondary school serves girls with few other opportunities for education. Its students are predominantly Maasai, with the addition of a few girls from other disadvantaged cultural groups in the region, such as the Barabaig and Hadzabe.

The classroom's simple sign speaks to the seriousness with which these students take their studies. To gain a secondary school education as a Maasai girl remains rare, and these students don't plan to waste the opportunity. So, silence please, indeed. These girls are hard at work.

And yet not everything is quite so serious here. Despite the sign, light chatter and a few joyful giggles float out of this classroom's door as students gather inside to study after class.

Just down the hill from this classroom, two teams of girls play netball, a popular sport in Tanzania that is similar to basketball. A large group of students watches and cheers. Behind a nearby dormitory, several girls do their laundry while singing. They slosh their clothes in colorful buckets before wringing them dry and hanging them on clotheslines. The school's kitchen staff must also be hard at work, because the smell of cooked beans and ugali (a stiff porridge made of ground maize) wafts across the campus. This is a typical afternoon at the MGLSS. Classes are finished for the day, and the girls have free time to study, play, or do chores.

Walking around campus, observing students, and talking to staff, I reflect on how the same scenes have played out over the years. Thirty years ago, the MGLSS began with only forty-three students, one classroom, one dormitory, an outdoor kitchen, and big plans for growth. As that growth happened, young Maasai women came and went. They studied and played. They learned and grew. They laughed and cried. And they overcame many challenges with the unflappable resolve characteristic of so many Maasai people. In the travels I've made around Tanzania conducting interviews for this book, I've had the opportunity to talk to many graduates about their experiences at the MGLSS. Women from the school's first class have shared their memories of the school's

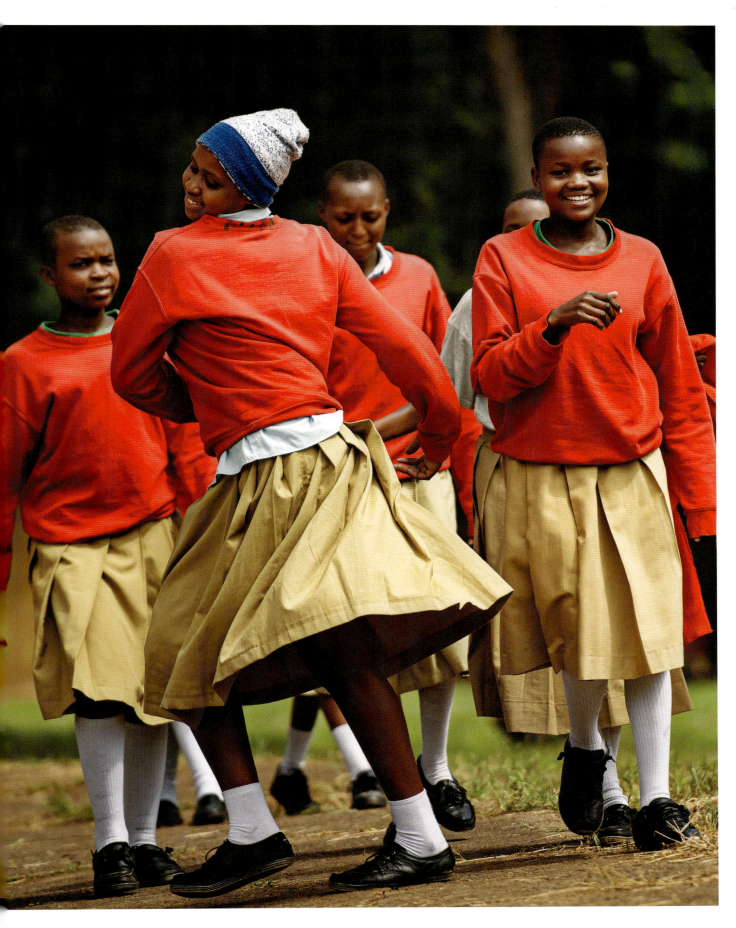

founding days, and more recent graduates have shared stories of the impact this school has had on their lives.

Recently, Upendo Katito Malulu Ndoros, a member of the school's first class, told me with fondness about her experiences at the MGLSS even before it officially opened. "We arrived the year before the school opened to take special classes and for tutoring," she shared. "Many of us came from places where the primary schools were poor and had few resources, so we were behind in our learning and not yet ready to start secondary school. While the campus was still under construction, we all lived in a dormitory at a nearby college. Every day, we would walk to the MGLSS campus and sit under trees watching the construction workers build our first classroom and dormitory. While we watched, we would sing and learn English and math. Some girls came and then left, deciding school wasn't for them. Others showed up and were already pregnant due to a forced marriage. They had to leave to give birth. By the time we officially started Form One [eighth grade] in 1996, we were forty-three girls."

> *"Every day, we would walk to the MGLSS campus and sit under trees watching the construction workers build our first classroom and dormitory. While we watched, we would sing and learn English and math."*
>
> **—UPENDO KATITO MALULU NDOROS**

Today, the school's campus has grown considerably, not only in its physical infrastructure but also in the number of students it serves, now numbering more than 350 and spanning six grade levels. The school's campus and its surrounding property encompass one hundred acres of upland, semi-forested land south of the Monduli Mountains, which rise sharply from the surrounding arid plains found in most of northern Tanzania. The school's property contains what remains of a colonial-era coffee plantation, as well as farm fields where staff and students grow food crops such as red beans and maize. Coffee trees (pictured at lower right) still surround the school's classrooms and dormitories, and each year the coffee is harvested to raise funds that support the school's operation.

The thriving town center of Monduli is located just west of the MGLSS and serves as a regional hub where many Maasai people gather at a weekly open-air market to barter livestock for food and other supplies. The town of Monduli is also the capital of the Monduli District and contains government offices, shops, restaurants, bars, churches, a bank, and a healthcare clinic. Several primary and secondary schools are also located in Monduli, as is the Monduli Teachers' College and the Monduli Community Development Training Institute. Just outside of town, the Tanzania Military Academy trains military officers from Tanzania and other East African countries. Thus, the MGLSS is not a remote outpost but rather part of a growing community that serves the Maasai as well as people from many other cultural groups—of which there are more than 120 in

SILENCE PLEASE! BRAIN AT WORK

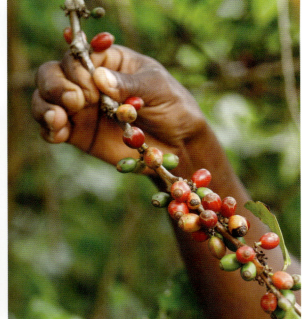

Tanzania. Though the Maasai dominate this region, Tanzania is a culturally diverse country.

About twenty acres of the school's property are fenced with an imposing, eight-foot-tall hedge. The hedge's dense growth and severe thorns serve to keep unwanted visitors, such as young Maasai morani (warriors) with an interest in meeting Maasai girls, off the school's campus. Today, that campus contains numerous buildings, including a dozen dormitories, nearly twenty classrooms, a library, a chapel, a kitchen, a dining hall, and an administrative building. All the school's buildings reflect a common architectural design: oblong, concrete-block construction with whitewashed walls and green metal roofs. Just outside the thorn fence, houses that match the school's architecture, as well as several that are fashioned like modern versions of round Maasai bomas (traditional round Maasai dwellings made of sticks, mud, grass, and cow dung and urine), provide housing to the school's staff and their families.

Unlike many schools in Tanzania, which grow in a hodgepodge fashion, buildings rising here and there as resources allow, the MGLSS was developed as part of a master plan that embedded Maasai culture into the school's construction. The school's buildings are arranged in a circular configuration (pictured at upper right), much like a typical Maasai engang' (a group of Maasai dwellings surrounded by a fence of thorn bushes). Dormitories and classrooms are layered on the periphery of the circle, forming an open central space where sports fields and the school's amphitheater-style chapel are located. Though the chapel has a roof, its tiered bench seating and partial exterior walls make it feel more open-air than it is. What makes the structure particularly unique, though, is its roof, which is designed like a Maasai elongo (shield)—an important symbol of Maasai power and protection. Though Maasai shields are less used today, they were an important tool for hunting in the past. Made of Cape buffalo skin attached to a wooden frame, they were decorated with culturally significant symmetrical shapes painted in red, white, and black, and so too is the chapel's roof (pictured at lower right).

Like most secondary schools in Tanzania, the MGLSS is a boarding school. In Tanzania's vast landscape, communities are spread out and secondary schools are few and far between, thus boarding schools are both a necessity and a remnant of British colonialism. Tanganyika gained independence from Britain and became Tanzania in 1961. Much of the country's education system, including the British penchant for boarding schools, remains inherited, albeit adapted to a Tanzanian context.

The Tanzanian education system consists of thirteen years of schooling that typically begin at age seven. Primary school starts with Standard One and goes through to Standard Seven. The language of instruction in public primary schools is Swahili, which is Tanzania's official language. However, some parents opt to send their children to private English-medium primary schools to give them an advantage when they start secondary school, where the language of instruction is English. Learning this

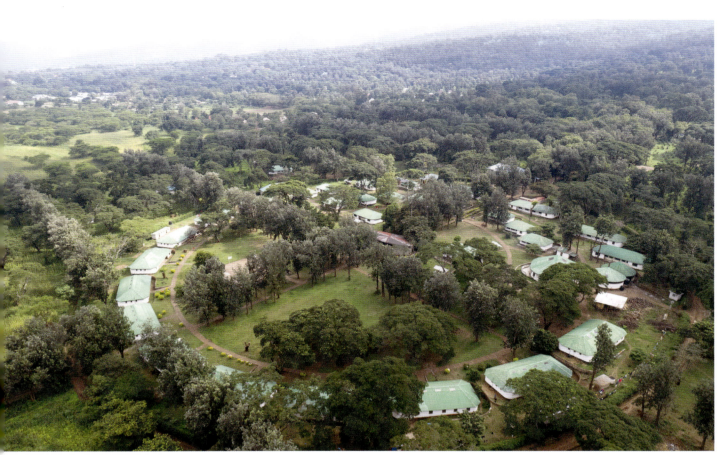
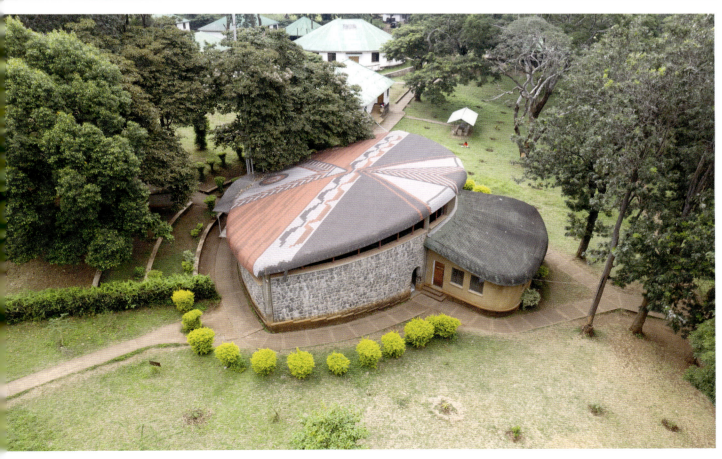

new language while simultaneously studying all other secondary school subjects in English proves a significant challenge to many students.

The Tanzanian government has created a robust system of free public primary schools due in large part to the country's first president, Julius Nyerere, who served in that role from 1964 to 1985. As a former teacher turned politician, Nyerere introduced a policy of "Education for Self-Reliance." Among other things, the policy ensured universal access to primary school education, and many primary schools were built during Nyerere's tenure. Most Tanzanians have access to a free public primary school within walking distance of their homes. Therefore, most primary schools are day schools rather than boarding schools.

While public primary schools are free, the cost of school supplies and school uniforms, which are universally required in Tanzania, means that even free public education is out of reach for some families. This is particularly true for Maasai families. Many Maasai people live in remote areas where children must walk long distances to get to the nearest primary school, often a rough-and-tumble outpost with few teachers, books, and other resources. Maasai families are also generally quite large. If a family can afford school supplies and a uniform for a single child, they will typically send their eldest son to school, leaving their girls out of education altogether.

Though this is slowly changing, some Maasai families still view investing in a daughter's education as a waste of resources, believing that any economic benefits associated with her education and future employment will go to her husband rather than to her family of birth, even though many educated Maasai women are now supporting their parents and siblings. Some Maasai men also measure a daughter's value by the dowry she can fetch, and education only delays or denies the exchange of a daughter for cattle, a highly valued commodity among the Maasai. Because a Maasai bride can earn ten or more cattle for

her father, early forced marriages cut education short for too many Maasai girls.

In an effort to educate all its citizens, the Tanzanian government has mandated that all children must attend primary school. Social workers and law enforcement officials work to encourage and at times enforce this mandate, yet they often do so without providing resources to support needy families. Thus, some Maasai children show up at school in worn-out, hand-me-down uniforms, without the supplies necessary to succeed, even as they face conditions at home that discourage their attendance and success. Those fortunate enough to complete primary school are generally fourteen years old when they enter secondary school, which is the age many Maasai girls are forced into marriage.

Secondary school is broken into two levels—Ordinary Level and Advanced Level, or O-Level and A-Level, respectively. O-Level goes four years, spanning Form One to Form Four. A-Level is two years, spanning Form Five and Form Six. At the completion of primary school, O-Level, and A-Level, students must pass national exams to continue to the next level. Understandably, these exams cause considerable anxiety for students who know their performance determines their future. While those who fail have options for vocational training, the exams often limit a student's education or change her career path irrevocably.

In the last decade, Tanzania has made strides in opening free public secondary schools. However, there are still too few spaces in these schools, and only the students with the best national exam scores are accepted. The only option for students who do not qualify for a free public secondary school is a private school, of which there are many in Tanzania. Private secondary schools have long filled the gaps in public secondary education in Tanzania and they come in every imaginable variety, though many are faith-based Muslim or Christian schools and the majority are boarding schools.

The MGLSS is one of several schools operated by the Evangelical Lutheran Church in Tanzania (ELCT). Though by American standards the fees to attend the MGLSS or any other private school in Tanzania are relatively low—less than $1,500 per year—this amount of money is an impossible barrier for many Maasai families to surmount. This means the girls who attend the MGLSS receive scholarships. Teachers from the MGLSS conduct interviews and testing at regional primary schools to identify and recruit the neediest girls who also demonstrate academic potential. OBA, the US-based nonprofit that has supported the MGLSS since its inception, raises funds for the school's scholarship program.

The collaboration between the MGLSS and OBA is best illustrated by a Tanzanian concept known as bega kwa bega, which translates literally as "shoulder to shoulder." This commonly used phrase conveys the idea of working together, supporting each other, and standing in solidarity. Though cross-cultural work is not always easy, Americans and Tanzanians have worked cooperatively to build and develop the MGLSS. Over the years,

Tanzanian and Maasai people have led the school and served as its principal staff members with volunteer and funding support from Americans and some Europeans.

The idea for the MGLSS first came from Maasai leaders who intimately understood the challenges the Maasai people were facing at the end of the twentieth century and, in many cases, continue to face today. Historically, the Maasai people have herded cattle and goats seasonally across the Great Rift Valley in southern Kenya and northern Tanzania. In recent years, however, they have increasingly been evicted from their traditional homelands in the name of conservation and private land ownership. With this land loss, many are no longer able to seasonally migrate to areas where they know their livestock can graze. Climate change is also affecting Tanzania's seasonal long and short rain patterns, resulting in severe drought that's often followed by flooding. Maasai survival is based on the health of their livestock, and these changes mean that survival is no longer assured for the Maasai. For these reasons, some Maasai people have been forced to stop migrating with their cattle and instead participate in a wage-earning economy. This has made education increasingly necessary for them.

In the 1980s, then Prime Minister Edward Moringe Sokoine, who grew up in Maasailand as a member of the Maasai tribe, began talking about building a special secondary school that would serve vulnerable Maasai girls. He knew firsthand the challenges the Maasai people faced and recognized that Maasai girls were particularly disadvantaged when it came to education. Unfortunately, Sokoine died in a tragic car accident in 1984 before he could see this vision come to fruition, but other Maasai leaders picked up the mantle.

In the mid-1980s, girls' education was becoming an increasingly popular area of focus in Africa as the United Nations, the World Bank, governments, and nongovernmental organizations (NGOs) began conducting research on gender inequality and developing strategies to address it. Several studies in Africa showed significant social, health, and economic benefits from investing in girls' education. Educated women married later and had fewer, healthier children. They knew more about nutrition and were less likely to suffer from preventable diseases. They were more likely to participate in wage-earning economies and earned higher incomes than their uneducated peers. They typically reinvested these earnings into their families. These studies showed strong links between investing in girls' education and improving the quality of life for families, communities, and countries. By the 1990s, supporting girls' education had become an important issue for Tanzania's political and religious leaders alike.

Several Maasai leaders carried forward Sokoine's vision for a secondary school that would serve Maasai girls, including Thomas Laiser, then bishop of the Arusha Diocese of the ELCT. Bishop Laiser held considerable sway in the region, as do most religious leaders in Tanzania. He approached David Simonson, an American pastor and missionary who by that time had spent thirty years in Maasailand

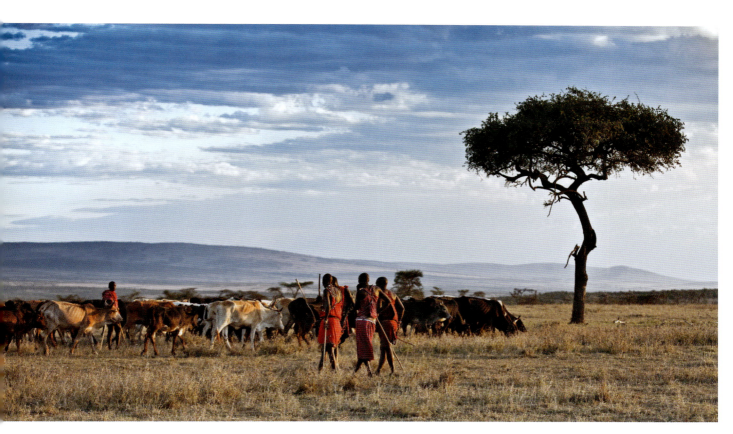
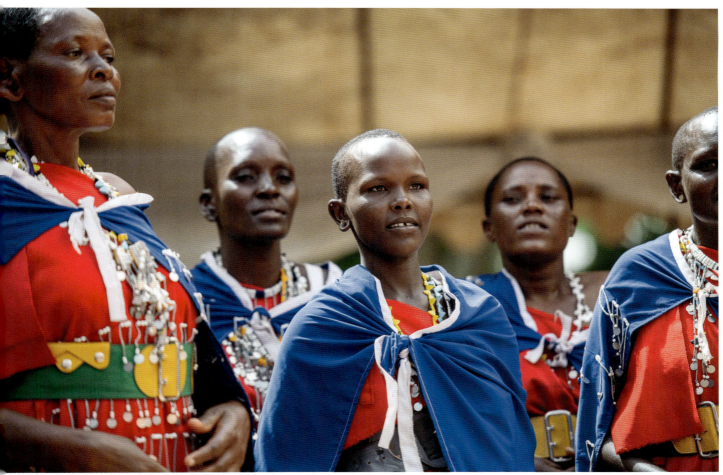

establishing schools, churches, and health clinics—efforts that had earned him respect from the Maasai people as a dedicated friend and partner—and asked him to support the school.

Together, the two men became an unstoppable force. Simonson raised funds for construction, supplies, and scholarships, and Bishop Laiser raised support within Maasailand among educators, pastors, regional politicians, and then-member of Parliament Edward Lowassa, a powerful Maasai politician who represented the Monduli District at that time. These men convinced reticent Maasai leaders and parents to educate girls, and so the MGLSS was born, not by Maasai women but by Maasai men who wanted more for their daughters and granddaughters.

However, many Maasai women wholeheartedly supported the effort having long wanted to attend school themselves and inherently understanding the ways education could improve their lives. One of the school's founding elders, Koko (grandmother) Ruth, served as an advocate for the school with Maasai leaders and parents alike. At a community meeting about the school's founding, she reportedly stooped to her knees and begged a group of male leaders to approve the school when it looked as if they might not. Once she succeeded in helping to establish the school, she took up residence there, interfacing with parents when they came to visit their daughters and providing a nurturing grandmotherly presence for students.

LESSONS IN HOPE

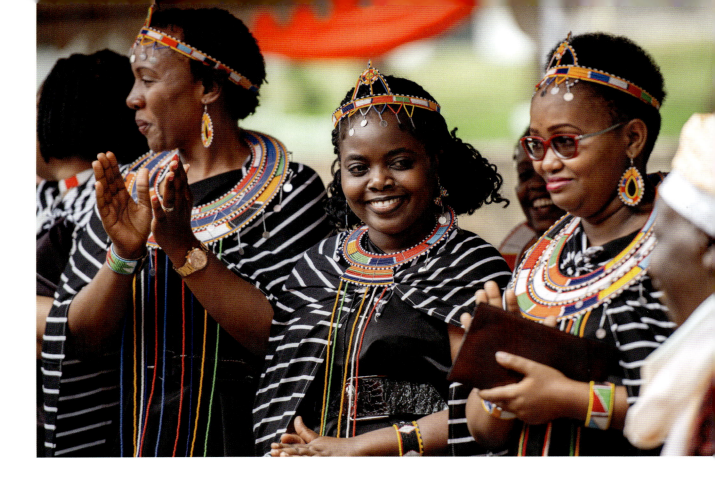

Since the school's inception, it has produced more than 1,100 educated Maasai women. More than 200 of its graduates hold university degrees. Approximately ninety of them work in healthcare. Several are doctors. More than 200 graduates work as administrators, teachers, or support staff in preschools, primary schools, secondary schools, and colleges and universities. Some graduates have founded nonprofit organizations, and still others are employed in that sector. Nearly a dozen graduates possess law degrees. A handful hold public offices, and at least two are planning to run for Parliament. Several have started their own businesses.

The Maasai women profiled in this book represent the many graduates of the MGLSS. Together, they stand as beacons of hope amid a culture and a people that still face enormous challenges. Their path has not been easy. Nevertheless, these women—an inspiring sisterhood of educated Maasai women standing bega kwa bega to support and uplift each other and those they love during a time of dynamic cultural change for the Maasai people—are up to the task.

Bega kwa Bega in Action

When Jason Bergmann, the current executive director of OBA, approached me in 2022 about traveling to Tanzania to interview graduates of the MGLSS, I felt honored by the request and enthusiastic about the project. Given my history as a volunteer teacher during the school's early years, I've long had an interest in the impacts of education on Maasai women and in hearing from graduates about their experiences. The project seemed like a natural extension of my first book, *Among the Maasai*, and I was eager to give the school's graduates a platform for sharing their stories with a broad audience both inside and outside of Tanzania.

During our initial conversations, Jason and I were unsure how the project might take shape, but we knew we needed to seek guidance from the MGLSS's staff and graduates and work closely with them and other Tanzanian colleagues to ensure its success. We wanted the production of this book to reflect a longstanding principle of our work in Tanzania—we wanted to work bega kwa bega across cultures in a collaborative, open way that encouraged input and generated excitement about telling these important stories—something that comes naturally to many Maasai, whose culture deeply values oral history and storytelling.

As we began sharing ideas with the MGLSS's staff and graduates, enthusiasm for the project became palpable. Many Maasai graduates wanted to tell their stories. With the help of a small advisory group of graduates, we generated a roster of interviewees that included women representing a range of ages, levels of education, professions, home villages, and perspectives.

From there, Esuvat Lucumay, who runs a safe house and empowerment program for Maasai girls in Arusha, volunteered to coordinate the interviews. Esuvat interfaced with interviewees to explain the project, answer questions, and address concerns. She identified local people to support the interview process during two different periods when I was in Tanzania in 2023 and again 2024, and she spent countless hours on the phone making sure everyone showed up when and where they were supposed to. As a Maasai woman, Esuvat also served as an invaluable cultural advisor to the project and to me personally. Though I conducted most of the interviews in English, Esuvat conducted interviews in Swahili or Maa, which is the language Maasai people speak among each

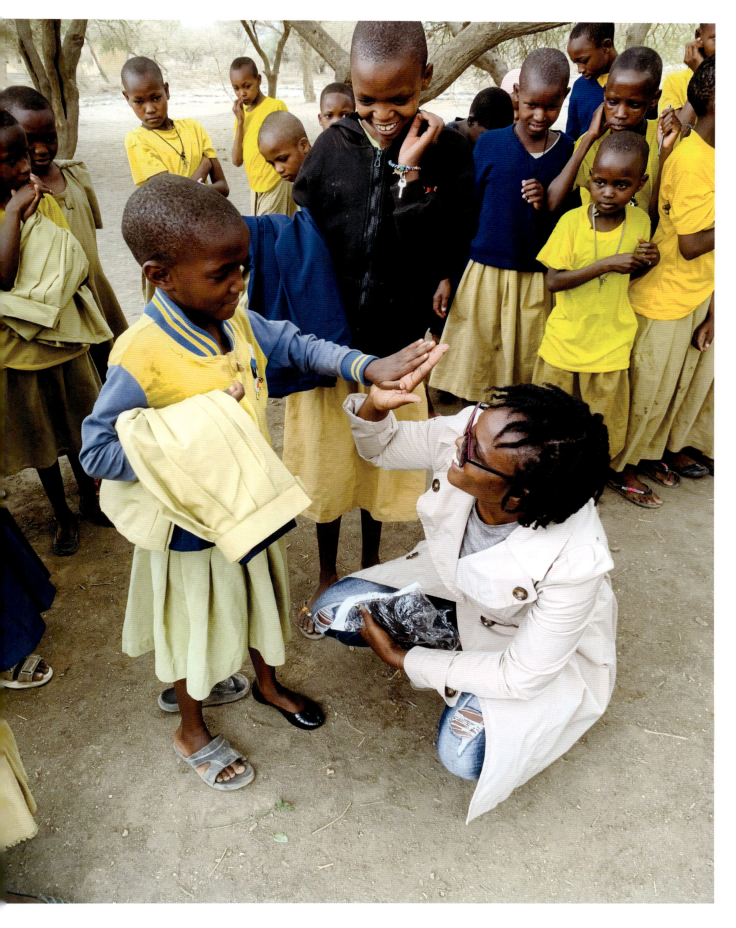

other, whenever necessary, and later translated that content into English for the book. Even more important, she reviewed many parts of the manuscript, providing corrections, advice, and encouragement along the way. In short, Esuvat made this book possible.

Beautiful portraits and photographs fill the pages of this book. These are largely the work of Lameck Tryphone Mutta and Aron Williams. These talented Tanzanian photographers traveled with Esuvat and me to photograph the graduates in this book and to record their interviews. These recordings were critical to my writing process, and the photographs bring the women and their stories to life in a way words alone cannot. Both Tryphone and Aron also served as advisors to the project and as translators for some of the video footage.

The profiles in these pages were written based on interviews with nearly fifty Tanzanians, including not just graduates of the school but also their family and community members and various staff and board members of the MGLSS. These interviews took place in June and July of 2023 and in May and June of 2024. For the first trip, my spouse, Mark Cutler, and Grace Gidion Mollel, a recent graduate of the MGLSS, joined the interview team, which included me, Esuvat, Aron, and Robert Dausen Swai, who handled transportation and logistics. For the second trip, Esuvat and I traveled with Tryphone, and Festo Mtui handled transportation and logistics.

During both trips, the interview teams traversed Maasailand to visit bomas, homes, schools, places of business, and hospitals. Time and again, we were warmly welcomed with singing and dancing, food and drink, handshakes and hugs. We found graduates eager to talk with us—excited to share their stories and to reminisce about their time at the MGLSS. While traveling between interviews on dusty, remote roads or stalled in Arusha's traffic, we as a team reflected on what we had heard, what we had learned, and what it all meant to us and to the women we had met. Along the way, we became confidants and friends.

As I wrote the profiles you'll find in these pages, I sought to capture each graduate's story in narrative form rather than simply present a series of questions and answers. Sometimes I adapted quotations to align them with conventions of standard English. I also expanded many profiles to provide necessary context to readers who might not be familiar with the social, political, and cultural context of the Maasai and of Tanzania, or to offer my own observations. Each of the women interviewed for this project also reviewed her profile after it was written and provided additional insights, clarifications, and corrections. This process often led to editing or to the addition of details and quotations that were not part of the original recorded interviews.

A range of people, including several graduates and staff members of the MGLSS, the staff at OBA, and members of the interview team, reviewed the final manuscript before publication. Though I worked with many Tanzanian and Maasai advisors and incorporated input from every woman I interviewed, ultimately I wrote this book,

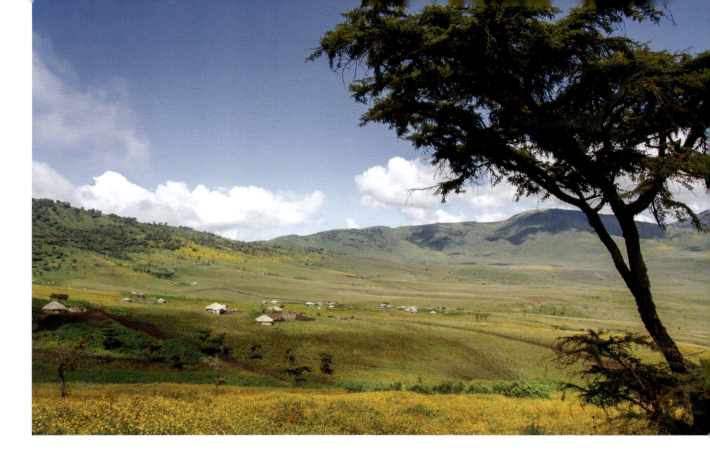

and as such I shaped the presentation of these interviews and the book's composition and content. As an American woman with many years of experience living and working among the Maasai, I did my best to capture these profiles with empathy, objectivity, attention to detail, and a commitment to due diligence. Nevertheless, my perspective as an unapologetic advocate for girls' education and a woman who remains deeply disturbed by practices such as FGM, child marriage, and other forms of violence and discrimination against women has inevitably colored my approach in these pages. Ultimately, however, I have endeavored to present these issues from the perspectives of the Maasai women featured in this book, and to present the Maasai people and their culture in the best possible light.

The women featured in this book participated in this project to promote awareness about the ongoing needs of Maasai girls and to raise support for the MGLSS. Thus, all proceeds from the sale of this book will support OBA's scholarship program for students at the MGLSS. Everyone who participated in this project knows the work is not yet done, and we sincerely hope you will consider standing bega kwa bega with us to ensure more Maasai girls will have an opportunity to attend school. Please visit OBA's website at www.bootstrapafrica.org to learn more about how you can help.

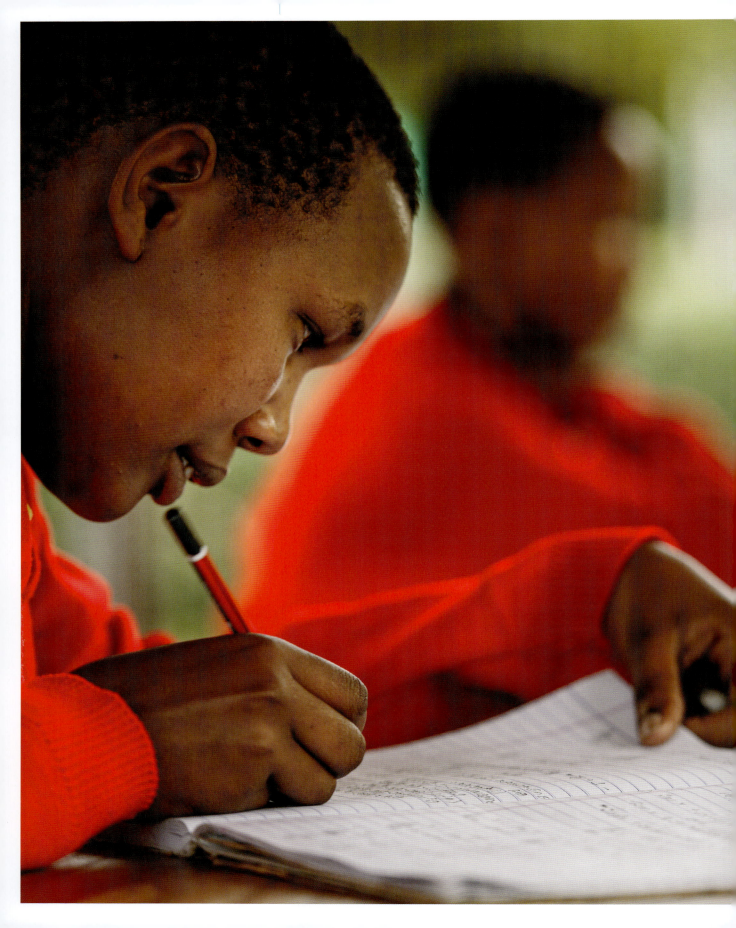

◊ EDUCATION ◊

JOSEPHINE SAMBEKE LAIZER, 2001 GRADUATE, O-LEVEL

Improving Schools, Advocating for Students

For our interview, Josephine Sambeke Laizer and I meet on the MGLSS's campus, a place familiar to both of us from our years as student and teacher, respectively. Though Josephine was never one of my students, the school's campus is small and our time there overlapped; we remember one another. She has arrived for what will be the first of many interviews for this book.

I've now been in Tanzania for less than twenty-four hours and am still suffering from the out-of-space-and-time feeling brought on by a long journey, jet lag, and a rapid shift from one culture to another. As an American who has spent a great deal of time in Tanzania, I feel confident that I can navigate these interviews, but I always experience some degree of uncertainty when I step outside my comfort zone. Though I've drafted questions, they are still untested. I'm hoping to uncover the heart of Josephine's and other graduates' stories, not just itemize the superficial details. Often what people say and what they mean are two different things, and I hope that I'm able to capture both in this context.

As we greet one another and make small talk before the interview, Josephine twists a kerchief in her hands. Like me, she seems nervous. I've brought Esuvat along as a translator because I recognize that asking Josephine and her fellow graduates to convey their stories in a non-native language could be a tall order—certainly something I would be incapable of doing. For Josephine and most of the women I will interview, English is a third language. Their first is Maa, and their second is Swahili. Josephine visibly relaxes when she realizes that she can offer her answers in whatever language she chooses.

We sit down on facing chairs set up in a quiet corner of campus under the shade of an umbrella tree. Before we officially begin, Josephine tells me with a crack in her voice, "I'm so grateful for my time at the MGLSS. Thank

EDUCATION 21

you for this opportunity to share my story. I want people to know the impact of education."

As the camera begins to roll, I ask her to tell me more.

"I visit different wards [a small town or a portion of a bigger town] to do my work as an education officer, and I see so many girls suffering," she says. "A few days ago, I saw a very young girl given away for early marriage because her mother had died, and the girl was given no other option. Today, there are still many girls who face challenges in the community. My education equipped me to overcome these challenges, but many girls aren't given the chance to go to school. Without education, they face difficult lives." Urgency enters her voice. "They cannot even meet their basic needs."

Before Josephine attended the MGLSS, she tells me, she too had few options. She grew up in a traditional Maasai boma in Longido, a remote village located northwest of Kilimanjaro, near the Tanzanian border with Kenya. When she recalls her early years and how she got to school, she reflects, "Before I went to school, my family considered education a waste of time. They did not support me. I only had the opportunity to go to school through village leaders who selected one pupil that year from my family to attend primary school."

Josephine shares that her father had three wives and eighteen children. Only six of his children attended primary school and only two of them, including Josephine, completed secondary school. At the time Josephine completed primary school, there were few options in Tanzania for free, public secondary education.

Through OBA's scholarship program, Josephine tells me, she was able to continue her education well beyond primary school. After she completed O-Level at the MGLSS in 2001, she continued her education at the Monduli Teachers' College and gained a certificate in primary education. She taught for several years before going on to complete a bachelor's degree in education at Mount Meru University in 2013, becoming the only member of her family to do so.

"How does your family feel about education now that you've completed a university degree?" I ask her.

"Now my family is proud of me," she says with a shy smile. "They see me as a role model. Also, the Maasai people are now seeing education as an important thing. Most of them are proud when they see us [graduates of the MGLSS]. We are opening doors to help them, and many of us are employed in different sectors in the community."

> *"Today, there are still many girls who face challenges in the community. My education equipped me to overcome these challenges, but many girls aren't given the chance to go to school. Without education, they face difficult lives."*
>
> —JOSEPHINE SAMBEKE LAIZER

Josephine currently works as a ward education officer, supervising and supporting teachers at two primary schools and one secondary school. She works not only with teachers but also with students, counseling them when they have problems.

"Tell me about the problems you encounter at the schools where you work," I encourage her.

"The biggest challenges that teachers in my ward face are lack of teaching materials and other resources, such as books," she says. "There are also few classrooms, meaning many students are in one room. That creates a challenge for teachers to teach the lessons to so many students." She shakes her head slightly. "In my job, it can be very difficult. I see many cases of children who are suffering. They have no opportunity to go to school. Their needs are not met. They are suffering very much."

I can tell from her downtrodden expression that she finds the circumstances she encounters through her work distressing, and I suspect it must feel overwhelming to be confronted with so many unmet needs, particularly those of children.

Josephine tells me that she encourages parents to send their children to school and works with teachers to find resources to support children who come from backgrounds like hers. She describes the importance of working in partnership as someone on the front lines of education—it takes local officials, community leaders, families, teachers, and supporters like OBA to get kids in school and keep them there. She emphasizes the need for ongoing support by saying, "Let us all continue to support the Maasai community. Without education, many will continue to suffer."

When the official interview ends and the recording stops, Josephine and I relax into a more informal conversation and the seriousness of our discussion lifts. We laugh after taking a few silly selfies. However, before she leaves, she takes my hands, looks me directly in the eyes, and says with great feeling, "For sure, if not for the MGLSS, it would have been impossible for me to get an education. God bless the people who are supporting this school. They are changing lives."

"The amazing thing about education is the ripple effect it has on communities," I tell her. "Your life was changed, and now you too are helping children in need through your work."

She smiles, nods, and pushes up her sleeves as if ready to get back to work—because she, too, is in the business of changing lives.

NESIKAR MEAGIE MOLLEL, 2004 GRADUATE, A-LEVEL

More than an Education, Support After an Accident

Dressed in traditional, red-checkered Maasai attire and adorned with a beaded necklace, Nesikar Meagie Mollel strikes me as a woman who is deeply connected to her culture. Though she is soft-spoken, Nesikar has come to our interview on the campus of the MGLSS with a story to tell. The directness in her eyes, the steadfastness of her posture, and the seriousness of her demeanor all communicate, even before she starts speaking, that what she has to say carries weight—that her story is difficult but nevertheless important to share.

As we sit under a shade tree together, Nesikar takes the lead by asking if she can tell me a story. When I nod in agreement, she begins.

"In 2006, I had an accident while I was completing my teaching practicum. I was walking across the road and a car hit me. My two legs were totally broken."

I suspect from her expression, and from my own experiences on Tanzania's roadways, that this accident could have killed her. Like many places in the world, Tanzania is a country where pedestrians and vehicles share the same roads, often in chaotic, overflowing disarray. Pedestrians walking alongside the roads compete with large buses, dala dala (minibuses), heavy trucks, safari vehicles, personal cars, bajaji (three-wheeled motor taxis), pikipiki (motorcycles), and even bicycles. Excessive speeds, few sidewalks, and the dog-eat-dog rules of the road here mean deadly accidents are frequent. I witnessed two during the years I lived in Tanzania.

As Nesikar continues her story, she closes her eyes, clearly overcome by the memory of her accident. I wait quietly for her to continue.

"I was very injured, but word of my accident came back to the MGLSS. Mama Jean [the chaplain at the MGLSS] really took on the role of my parent," Nesikar says.

Without anyone to advocate for her care or the resources to cover significant medical

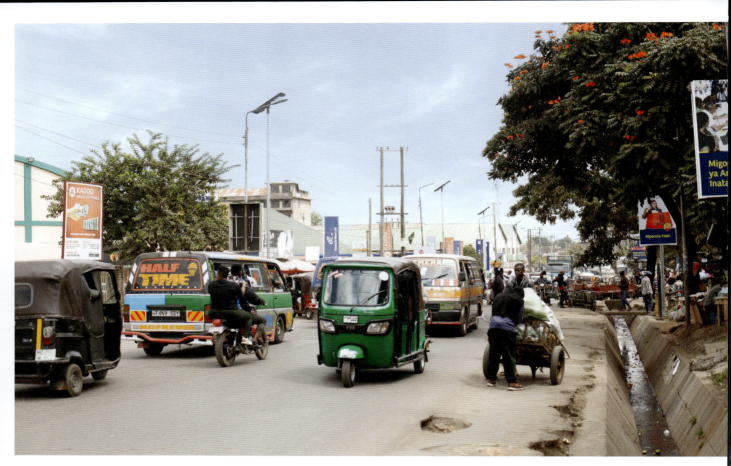
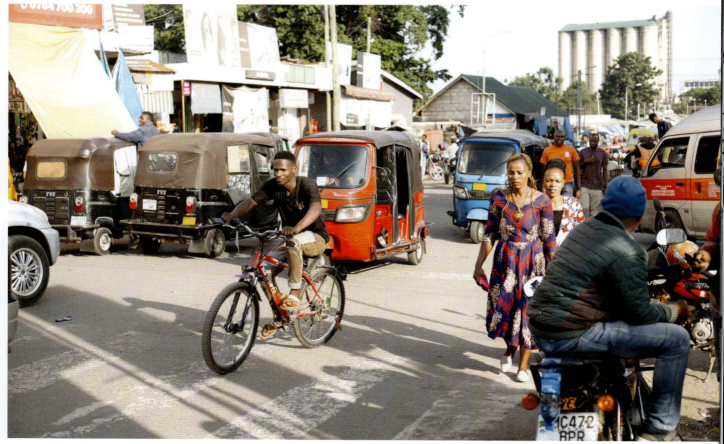

expenses, she goes on, her accident could have left her permanently crippled.

I know that navigating the world with a disability not only presents significant physical challenges in Tanzania but also means coping with a stigma that makes functioning in society difficult. Imagine living in a remote village where the terrain is rough and life requires hauling water, herding animals, and walking miles for basic necessities. The loss of her ability to walk could have relegated Nesikar to a sedentary life, reliant on relatives with few resources to care for her in every way. But this wasn't Nesikar's fate.

With the help of Jean Wahlstrom, an American woman and Lutheran missionary who spent more than a decade serving as chaplain at the MGLSS, Nesikar was transferred to a private hospital after her accident, where she immediately underwent surgery. She remained in the hospital for almost two months—evidence of the severity of her injuries.

"The timing of my accident was bad because I was about to finish my diploma in secondary education at Mbeya Teachers' College," she tells me. "I missed the final weeks of my student teaching, and I was afraid I would fail. But the school said I could still take my final exams. If I passed, I would get my degree. I was so determined that I insisted on returning to school. A car from the college came to pick me up at the hospital. I was still recovering and unable to walk, so I was admitted to the college's infirmary. They put a table beside my bed where I could sit and study. I had only two weeks before the exams, but thank God I passed."

In the months that followed, Nesikar's legs continued to heal, but one remained shorter than the other, which challenged her mobility and meant she was unable to begin teaching. Almost nine months after her accident, she underwent another surgery to further repair her legs, followed by nearly a year of rehabilitation. After this lengthy recovery period, Nesikar was finally able to walk without impediment. As she tells me this, she seems as amazed as I am that she survived the ordeal without permanent damage.

"Your recovery is a testament to your fortitude and resilience," I tell her with a smile.

"OBA really changed my life," she replies. "They gave me an education, but they also paid for my care during this time. If not for them, I would be like a koko now."

Nesikar, who is now in her late thirties, is far from being a koko today. She walks without even a limp, and she is an English teacher at Engutoto Secondary School in Monduli, where she has been working for over ten years. While teaching, she began a bachelor's degree at Tumaini University Makumira, which she completed in 2019.

Nesikar says she sees her role as a teacher as an opportunity to help her family and her community, and to influence the next generation of Maasai girls. After she shares this with me, I ask, "Can you tell me more about this?"

"Maasai women are not given the chance to express themselves," she explains. "Women want their children to go for further education, particularly secondary education. But if you find that the father is not ready to send his

> *"Educated women bring positive changes to their families. Like me and my classmates—we are the ones supporting our younger siblings to go to school. We are building modern houses for our families. We can do this because of our education."*
>
> —NESIKAR MEAGIE MOLLEL

children to school, the mother will not be free to take her children to school. I help parents see the positives of education—that taking children to school is very important, particularly for girls. Educated women bring positive changes to their families. Like me and my classmates—we are the ones supporting our younger siblings to go to school. We are building modern houses for our families. We can do this because of our education."

As a Maasai woman, Nesikar knows firsthand the challenges Maasai girls face. "I could have been married young, maybe a second or third wife, and living a very difficult life," she says. "I remember the matron at the MGLSS. She taught me to be confident and to trust myself. She would say, 'You have to be confident that you can do something, that you are capable. When a man approaches you, tell him in three languages, no, hapana . . . and, in the Maa language, mayieu.'"

Fortunately for Nesikar, this advice worked, because she escaped an arranged marriage at age fourteen and was later able to choose her own husband—a young Maasai man from her village whom she met after completing Form Six at the MGLSS. "Though we knew we wanted to get married, we agreed that I should complete my diploma first," she says with pride. "After my accident, he promised to wait for me to heal. After my recovery, we got married. I chose him, and he chose me." She tells me her husband is also a teacher, and they have four children.

"I want my children to get a good education so that they can achieve their dreams and goals. My second-born is a girl. She tells me she wants to study at the same school I did," Nesikar says with a smile.

She is hopeful for her daughter and for Maasai girls in general. "I think the situation for girls is changing," she shares. "More families understand the benefits of education. It isn't like it was when I started secondary school. Then, the situation for girls was worse than today. The Maasai are seeing the benefits through us, through the graduates of the MGLSS."

Nesikar is living, breathing, walking proof of this.

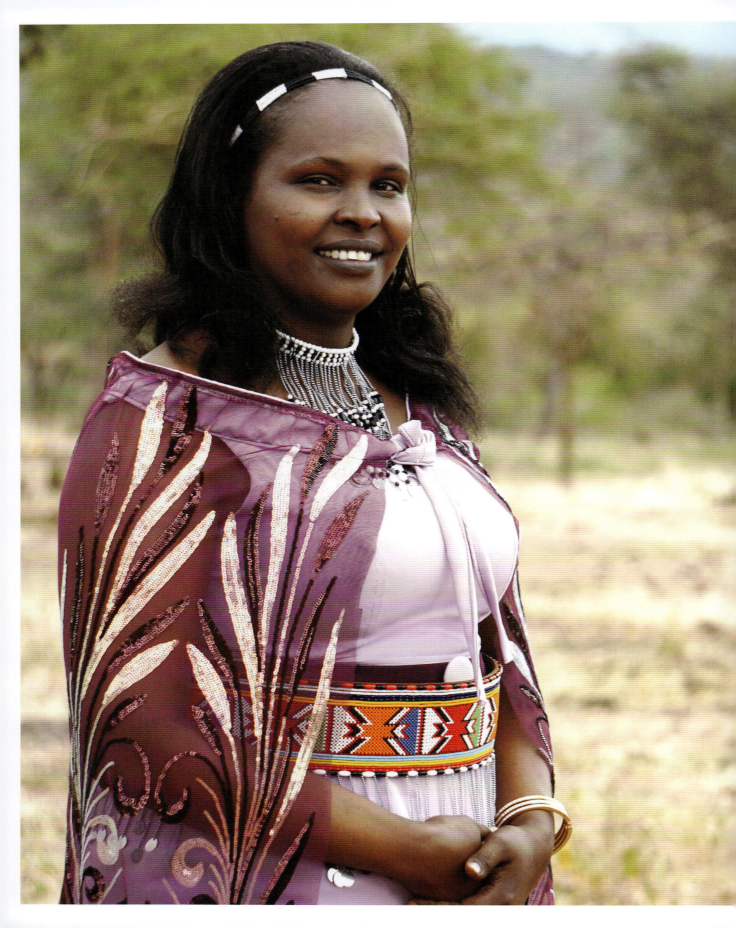

NEEMA MELAMI LAITAYOCK, 2004 GRADUATE, A-LEVEL

A Community Celebrates

The word for celebration in Swahili is sherehe, and though I don't know it yet, a sherehe is in the works. The interview team and I are on our way to meet Neema Melami Laitayock at her childhood home in Losimingori, which is located north of the highway that connects Arusha to Makuyuni in northern Tanzania.

Once our van leaves the well-paved roadway, it slows to a crawl by necessity, the rough terrain making anything more than a snail's pace out of the question. Our vehicle is almost immediately met by a small SUV, something I don't expect to see in this remote setting. Neema has sent her husband, a man who wears a ready smile and a well-tailored navy blue suit, as a chaperone to guide us to her home, knowing we would otherwise have difficulty finding it.

As we follow the SUV, a muted, barren landscape unfolds before us. Acacia trees, large volcanic rocks, traditional Maasai homes, and little else dot the countryside. Though a path has been painstakingly marked with small boulders—a measure I will later learn was undertaken in preparation for our arrival—the eroded, uneven landscape makes it clear most people come this way on foot rather than by car.

Today, the clouds hang low, casting the countryside in subdued grey, green, and earthen hues. After a couple of rough miles, we witness a well of vibrancy rising from the neutral landscape—our first clue about the impending sherehe. A gathering of nearly fifty Maasai people awaits us in front of a modern Tanzanian home.

The home itself is not layered in the neutral tones of a traditional Maasai boma; rather, the substantial concrete-block structure looks freshly painted in bright off-white with brilliant yellow and turquoise trim and a red metal roof. The people standing in front of it, meanwhile, are adorned in vivid blue, yellow,

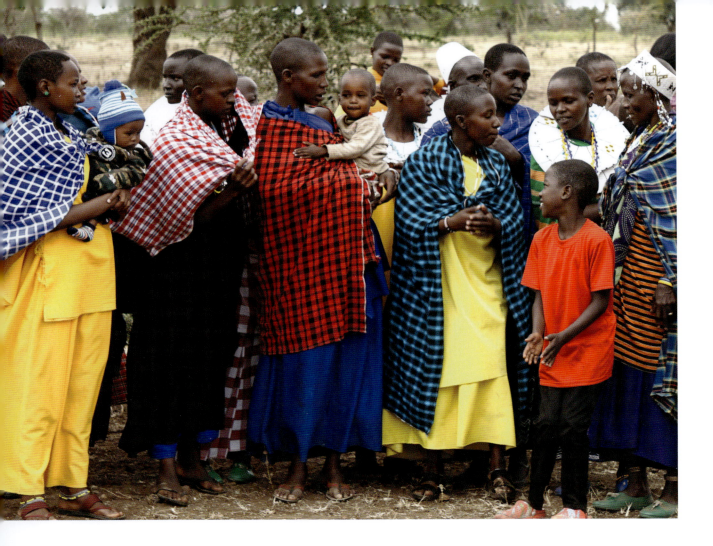

and red fabrics, and many of the women wear intricately beaded ilturesh (rigid, disk-shaped necklaces). The group is mostly made up of women, though a few men and boys are among them. Several babies ride on their mothers' hips, while the oldest people sit in chairs near the home's entrance, observing the goings-on. Half a dozen excited children race around the group's perimeter, jumping and gesturing in our direction as they run.

When our van pulls to a stop about one hundred yards from the group, they begin dancing and singing, all the while slowly advancing toward us. The interview team and I climb out of our vehicle and begin walking in their direction as they continue to bob and sway and lift their voices in a call-and-response arrangement. Many of the women make high-pitched trilling sounds—expressions of their joy and excitement at our arrival. Neema is leading the procession, with her mother on her left and her father on her right. They hold two handmade fabric banners with beadwork letters that say, "Welcome to Losimingori."

Though I have visited many Maasai homes, I am always amazed and overcome by the generosity and delight with which I am greeted—and today's reception is beyond

anything I have experienced before. Our group is received with hugs and handshakes, wrapped in the welcome banners and new mashuka (swathes of fabric worn by Maasai women and men in a toga or cape-like fashion), and escorted back to the house as the singing and dancing continues around us. I feel unworthy of this welcome, even though I understand I represent many educators, advocates, and sponsors who have made education possible for young Maasai women at the MGLSS. To say I am deeply honored by this show of kindness is an understatement. I am stunned and a little teary.

Once we reach the house we are welcomed inside, where chairs have been set up in the small living room. Neema's parents and two community elders take their seats on either side of our group while Neema and her husband—whose name, I learn, is Justine—remain standing to ensure everyone is comfortably settled. We are here to do an interview, but it is clear Neema has bigger plans for the day than a simple one-on-one conversation.

She wears a stunning purple dress and a flowing, sequined shawl around her shoulders. A belt beaded with a traditional Maasai pattern encircles her waist. She also wears a beaded necklace, bracelet, and headband. To me, she embodies a beautiful, modern Maasai woman who embraces her culture with a flair of style and independence all her own. Neema stands before this group without a shadow of self-consciousness, which is more than I can say for myself in today's setting.

Neema and Justine welcome everyone with short speeches about the reason for the sherehe.

Though I suspect the people gathered here already know this, Neema explains that our group has come to interview her about the impact education has had on her life. She tells everyone present that my husband and I were teachers at the MGLSS, and there is a small round of applause. When Justine speaks, he expresses his gratitude for Neema and the education she has received. "The people here today want to thank you for what you have done and what you are doing at the MGLSS," he says with a sincere smile as he references not just the people in the room but also the younger bunch just outside the opened door, jockeying to get a look inside.

Each person in the room introduces himself or herself before Neema ushers the interview team outside to several chairs that have been set up under an acacia tree. As we prepare to interview her, she tells us her mother and father and several village children also wish to participate in the interviews. This is unexpected, but I am delighted that I'll get the chance to hear from people who can provide more context for her story.

After Aron attaches a small microphone to Neema's dress and gives us the cue that the camera is rolling, I ask her to share the story of how she came to attend the MGLSS. She gazes into the distance as if she is looking into the past and begins to recount her childhood.

"Before I joined the school, I had a challenge because in our society many people don't know about education, so my parents and my relatives told me not to go to school," she recalls. "They wanted me to get married at a young age. My family had already taken cattle for a dowry, but

in 1997, the Honorable Edward Lowassa [the local representative to Parliament at that time] required all girls from Losimingori Primary School to go to the MGLSS for an entrance exam. Praise God, I was accepted with another girl from my village. My father still didn't want me to go, and there was no bus fare to travel to school at the appointed time, but my mother struggled to help me. Then I made up my mind to say no to early marriage while I was at school." She continues to look past me as she recounts all this. "I met Justine when I was in primary school. He is also from Losimingori, and we were neighbors. I would see him at church, and he sometimes came to visit my family. I never missed church when he was around. What a memory!"

She laughs and continues.

"There were no mobile phones in those years, but Justine never missed any event regarding me," she says, her shoulder-length hair blowing lightly in the breeze. "He attended all my graduations and he wrote to me. I loved to read his short letters. In 2005, he proposed, and I said yes. I didn't want to have a family until I finished university, so we waited to get married until 2009. Once I was engaged to be married, my father gave one of my younger sisters to the man who was supposed to be my husband so many years earlier."

Neema tells me that she completed Form Six at the MGLSS in 2004 and then joined the University of Dar es Salaam, where she completed a bachelor of arts in education, geography, and history in 2008. She has been teaching secondary school since that time. She and Justine have five children. Their eldest is already in secondary school, while their youngest is just a toddler and the only girl in the bunch.

"How do your parents feel about education now?" I ask.

"They think that education is very important. They see the things I have done as an educated woman. My classmate and I were the first ones to go to secondary school from our village. After getting a job, I have built them a house much different from the one I grew up in," she says, referencing the modern concrete-block house we just exited.

"I grew up in that boma over there." She points to a traditionally built mud-and-dung structure about two hundred yards behind her. The small, round hut has a roof made of dried grass and is surrounded by a ready-made fence of thorny tree branches. "Imagine a girl from this remote village going to school. The MGLSS changed my life, and my family's life too. That school is giving girls an opportunity to understand themselves, to gain confidence, and to have careers. The MGLSS is also preparing girls to serve the Maasai community. When you go to every village in Monduli, Longido, Simanjiro, Kiteto, and Ngorongoro, you will find the MGLSS graduates in all those districts. Every one in her own way shows the benefits of education."

I ask Neema to tell me how she is serving the Maasai community.

"Now I am a teacher," she says. "I am teaching others, but my husband and I are also helping

> *"Imagine a girl from this remote village going to school. The MGLSS changed my life, and my family's life too. That school is giving girls an opportunity to understand themselves, to gain confidence, and to have careers. The MGLSS is also preparing girls to serve the Maasai community."*
>
> **—NEEMA MELAMI LAITAYOCK**

less privileged students to go to school. Many women now want their children to go to school, but they have nothing. Getting school uniforms, exercise books, and other school supplies is a problem. We have organized as a family to help at least twenty children each year to go to school so they can start Form One. We are also supporting women with small loans that help them to start businesses so they can support their families." Her voice lifts with energy. "In 2020, I ran for public office to represent the Monduli District in Parliament. I was one of only two women who ran among twenty-two men. I did not win the election, but I tried. Why did I do that? Because I want to help my community." She lifts her chin and sets her jaw in a defiant way. "There are some problems that I can solve as a teacher and as a mere person, but as a member of Parliament, I could have more influence to solve bigger problems. I have that dream of being a member of Parliament."

Neema forges on with the intensity of a politician on the campaign trail.

"For example, we have a water problem in Losimingori. The water we use comes from a dam, and it is not reliable or clean. Water shortages create problems for girls, too. They must travel long distances to fetch water from the dam. They carry the water in buckets on their heads, and this difficult task means they don't have time to go to school. Some of them have been raped along the way, or kidnapped and married by force. We need help to get clean, piped water, which solves more than one problem."

Neema's eyes are fiery now, because this problem is personal to her. She knows these girls, and their safety is her concern.

"Even though I didn't win a seat in Parliament, afterwards I ran and was elected as a member of the District Central Committee. My agenda has been forming a special fund to support children who are struggling to join secondary school and creating awareness about the challenges my village faces, such as the water problem."

When we finish the interview, Neema hurries off to escort her parents (pictured on page 36) back to our seats under the acacia tree. Her mother wears pastel green-and-yellow-checked swaths of fabric with two beautifully beaded ilturesh around her neck, while Neema's father appears the quintessential Maasai man in his deep blue mashuka. As I watch them approach, I note that Neema looks like a younger version of her mother—their faces and eyes are a matched set. As Neema carefully guides her mother to a chair near me, I realize her mother is nearly

blind. Though I suspect Neema's parents are probably only in their early sixties, they appear elderly and a little fragile.

Before I can ask an interview question, Neema's father jumps in with his own comments while Neema serves as his translator. His tone is earnest and serious as he tells me, "In the past, I didn't know the importance of education, but after Neema went to school, I really supported it and wished others would go to school too. She has built a house for us, and she has taught us and other children in our community."

Her mother adds, "She got rid of the grass house, and she has been able to take me to the hospital. Before she went to school when I was sick, I couldn't even go to the hospital. I thank her very much, because other Maasai children are not able to take their parents to the hospital or build them a house."

Though I've often heard the stories of Maasai parents whose lives have been improved by their educated daughters, it's striking to hear Neema's parents talk about these improvements in concrete terms. Today they have better housing, access to healthcare, plentiful and nutritious food, and the ability to send more of their children and grandchildren to school. I realize that these are basic and essential things that I take for granted, but they are things that many Maasai people, who have neither education nor wage-earning employment, do not have access to.

As I finish talking with Neema's parents, half a dozen teenagers walk up to us. Neema tells me these are some of the students she and Justine have helped to attend school (pictured at right). All of them except for one are girls, and they all seem shy and uncertain of themselves. Neema beams with pride as she encourages them to speak up. She wants them to tell me where they go to school and what their dreams are for the future.

The single boy in the group wants to be a doctor. Three girls want to become teachers like Neema, and the other two say they'd like to be nurses. "My dream is to become a nurse because I really want medical services closer to my community," one of them tells me.

Once the interviews are finished, we return to the home Neema built for her parents. Though we arrived midmorning, it is now well past noon. Two women offer sodas in tall glass bottles to everyone. From a hallway off the living room, several other women arrive with large bowls of vegetables, rice pilaf, cooked chicken, and roasted goat. They place them on a long table that lines one side of the room and then invite our team to serve ourselves first. Everyone else follows in a buffet-style line.

Just as most of us are finishing our food, Justine brings in a large, roasted goat leg on a spit. Neema's parents and the other Maasai elders in the room are all smiles, clearly delighted by this treat. Justine explains that this is an important Maasai tradition reserved for special occasions as he carves it in front of us.

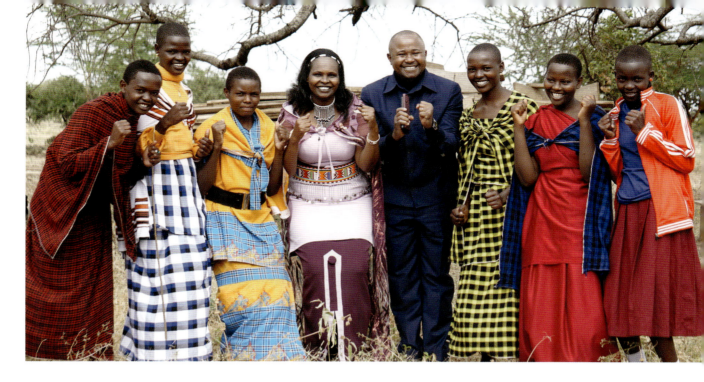

Everyone in the room eats shavings of meat off a communal plate.

When we are all stuffed full, we thank Neema and her family for their incredible hospitality and all they have shared with us. This day has been much more grandiose than we anticipated. I thought I would settle in for a quiet conversation with Neema at her childhood home; instead, she's thrown a community party to celebrate what education has done for her village. I know this day has been months in the planning, and I'm not sure how best to express my gratitude. Even creating the rock-lined path that guided us from the main road to her home must have taken hours of heavy labor, and I know all the special food must have been costly.

After Neema hugs me, I take her hands and squeeze them. My voice cracks as I tell her how special this day has been.

I can tell by the warm look on her face that this is exactly what she intended.

The same large group of people that welcomed our arrival this morning now escorts us back to our parked vehicle late in the afternoon. We once again share hugs and handshakes as we bid one another farewell. As our vehicle pulls away, I turn and look back at Neema, who is surrounded by her family and her community as they all wave goodbye to us. I can picture her more than twenty-five years ago in this same place, surrounded by many of these same people, growing up a Maasai girl on a path none of them could foresee. Like them, I'm so grateful for this sherehe—a celebration of the ways in which education has improved so many lives and for Neema's role in this transformation. Though she has already accomplished so much, I suspect her work is not yet done.

SELINA LEYAN KIVUYO, 2004 GRADUATE, A-LEVEL

Once a Student, Now a Teacher

The sun ebbs toward the horizon as our van stops adjacent to the central market in Mto wa Mbu, a bustling farming community of about 18,000 people located near Lake Manyara on the road to the Ngorongoro Crater in northern Tanzania. A sea of people clad in vibrant colors ebbs and flows over a large, well-worn, grassy pitch the size of an American football field. Sellers have laid out their wares—all manner of fruits, vegetables, groceries, housewares, shoes, and clothing—on tarps and mashuka cloths. Encircling the market are rough-and-ready buildings that house more permanent shops.

Though I'm accustomed to the hustle and bustle of market day, which typically happens once a week in most moderate-to-large Tanzanian towns, I still find this scene overwhelming—the cacophony of sounds, the piquant smells, the riot of color, and all the people. I'm content to remain inside the van, where I'm less conspicuous. In Mto wa Mbu, white tourists are common because the town is a stop on the safari circuit for visitors going to Lake Manyara, Ngorongoro Conservation Area, and the Serengeti. Even in a place where foreigners are common, however, I know from experience that my white skin will attract not only stares but also hawkers ready to sell me whatever they think I need.

Today at the Mto wa Mbu market, the interview team and I are waiting to meet Selina Leyan Kivuyo, who was first a student and then a teacher at the MGLSS. I spot her through the crowd, striding confidently toward our parked vehicle. We exchange brief greetings through an open window and then follow her into and through the throng.

Leading us on foot, Selina directs people to part so we can pass as we inch through the crowd behind her in the van. We are headed for an open-air restaurant at the back of the market.

A dala dala covered with beer advertisements is parked in front of the restaurant and is blasting Bongo Flava music from a rooftop speaker while a DJ shouts through a megaphone toward marketgoers who seem to be paying him little attention. I'm concerned about conducting

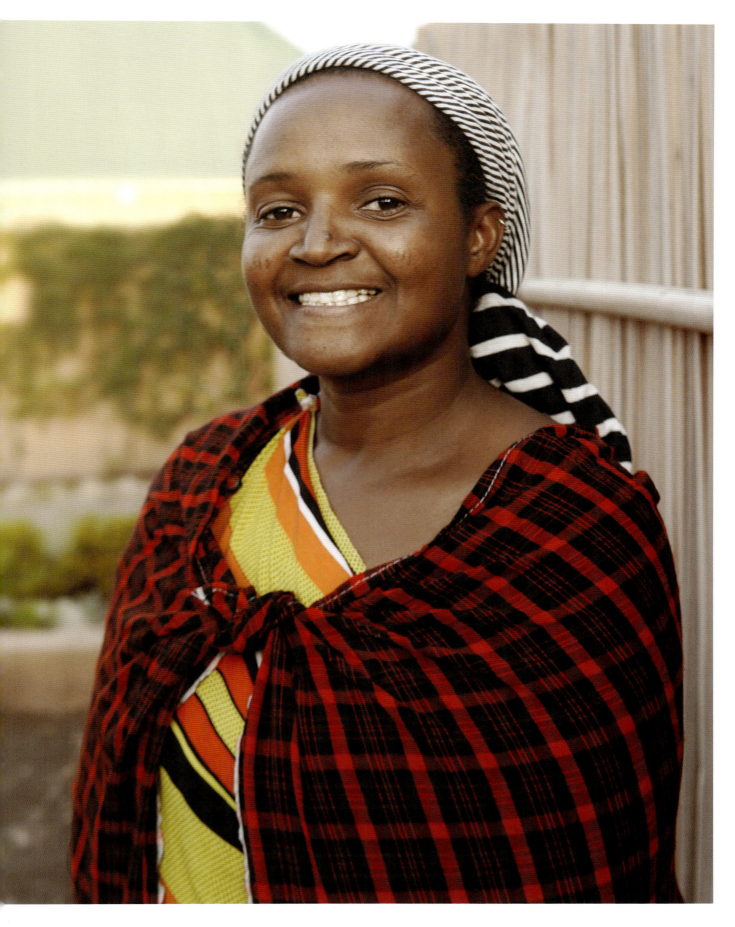

an interview over the ruckus, but after we all pile out of the van and find a shady seat under a thatched shelter, the marketing bus moves to another location farther away.

Selina tells us she has come to the market today to shop for new dresses for her three daughters, but she hasn't found anything she likes. "I will look on another day," she says, seemingly eager to get started with the formal part of the interview.

As the sun sets behind her, I ask Selina to tell me the story of how she came to attend the MGLSS.

"The Maasai keep their daughters at home to be married," she tells me. "My dad, as a normal Maasai parent, wanted me to get married so he could get the cows. My family didn't know anything about education. What they knew is a baby girl gets married. Before I went to school, life wasn't that easy as a girl in the village."

She goes on to tell me how a member of Parliament played a significant role in her life.

In 1997, then-member of Parliament Edward Lowassa, who would later become Prime Minister of Tanzania from 2005 to 2008, came to Selina's village—Losimingori, the remote town I just visited to interview Neema Melami Laitayock. Lowassa, a powerful Maasai politician, was instrumental in starting the MGLSS. He saw the challenges his people faced and, like many Tanzanian political leaders of the time, understood education as a path to self-reliance. He was motivated to recruit all children, but especially girls who had few opportunities, to attend school. In Losimingori and many other places in Maasailand, Lowassa advocated for education at community meetings, political rallies, and church gatherings, and soon students followed. Lowassa would work with village leaders to identify and recruit the most at-risk girls to attend the MGLSS. Once identified, girls would participate in intake interviews for the MGLSS, often with only the hesitant blessing of elders or parents and sometimes even in secret, with the help of a primary school teacher who saw potential.

"After Lowassa came to my village, I went to do the interview, and then, luckily, I was one of two girls from my village chosen to attend the MGLSS," Selina recalls with a smile.

She then explains that she attended the MGLSS starting in 1998 and graduated from A-Level in 2004. She went on to complete a bachelor's degree in education at the Catholic University of Eastern Africa in Nairobi in 2007.

"It seems your family didn't want you to go to school initially, so how do they feel about education now?" I ask.

"After I went to school, my family could see the difference between girls who went to school and those who did not get the chance," Selina says. "Now they are very happy, and they want all my younger sisters to go to school. I was able to bring solar power to my family's home. The whole village comes to charge their mobile phones at my home. My mother takes a small fee for this. She was able to buy a goat, which she named Nesola, which means 'solar charging.' And a few years later, she bought several more goats that provide food for the family. They have seen the benefits of letting girls go to school."

"This is great," I say with enthusiasm. "I can see how solar power would be beneficial in remote areas where many people live without access to electricity."

Selina tells me she was introduced to solar technology and taught about the ways it could be used in places like Losimingori while in school. When she started working, she used her wages to invest in solar equipment at her family's boma. It was Selina, with her entrepreneurial spirit, who also encouraged her mother to sell electricity to neighbors, allowing her to earn a small source of ongoing income for the family.

"I know you were a teacher at the MGLSS for several years," I say. "Can you tell me about your experiences as an educator?"

"After I completed my degree in Nairobi, I went back to the MGLSS as a teacher for six years," she says. "In 2013, I was offered a position as a headmistress at another secondary school in the Monduli District. I served there for a few years. Currently, I work as an English teacher in Makuyuni, not far from where I grew up. As a teacher and a Maasai woman, I understand the challenges many girls face. Sometimes girls are not aware of how to take care of themselves. They get pregnant before they are mature enough. Their families can't provide school supplies. In the school where I teach now, we have formed two clubs to talk to the girls about health issues. We invite experts to talk about different issues. On the supplies, some friends with big hearts donate, so girls can come to class with all the required supplies."

When Selina pauses, I prompt her to tell me about her family.

> *"Currently, I work as an English teacher in Makuyuni, not far from where I grew up. As a teacher and a Maasai woman, I understand the challenges many girls face."*
>
> —SELINA LEYAN KIVUYO

"I have three daughters," she says. "In my Maasai culture, I would say I am already rich, very rich, because they will get married and I will get cows . . . later on, of course. First, I will give them the education that the MGLSS gave me. I will not marry them off easily." She flashes a broad smile, and her tone indicates she is both joking and serious. I suspect she is navigating the careful balance between honoring her culture, knowing that girls are often most valued for their worth as brides, and acknowledging that there are parts of her culture she would like her daughters to escape. Selina knows what it means to gain an education instead of being forced into marriage too young.

"Without the MGLSS, the life I have today would not be possible; that school changed our [the MGLSS graduates'] lives, as well as my community's life," she points out. "I still have relationships with many of my former American and Tanzanian teachers, and even with my sponsor. I can't really put it into words, but I am who I am today because of them. I'm so grateful. I'm a teacher because I want to carry forward what they have given me."

And Selina is doing just that, bringing the light of education, and solar power, to her community.

EDUCATION 41

MARTHA MERESO SENGERUAN, 2004 GRADUATE, A-LEVEL

An Oasis in the Heart of Maasailand

As an oncoming vehicle approaches, sending a wave of dust rolling our way, our driver, Robert, grips the steering wheel a little tighter and calls out for us to close our windows.

This morning, Robert traded in the small, road-ready van we had been using for transportation for a more robust, high-clearance Land Cruiser with the power of four-wheel drive. Still, the dust is so deep on some parts of this road that the vehicle skids and fishtails as if in powdery snow. Though a passing car is rare on this isolated dirt road, it's common enough that we are blanketed with a coating of chalky brown dust even when we try to get the windows closed in time. After the dust settles from each passing car, however, we open the windows again, because this morning's temperature is approaching 70 degrees and the breeze feels good, even if dry and gritty.

The interview team and I are headed deep into Maasailand this morning to visit Engaruka English Medium Primary School, which was founded in 2018 by the MGLSS graduate Martha Mereso Sengeruan. Though we haven't met Martha yet, her reputation precedes her. She graduated from the MGLSS in 2004, and by all accounts she's been working tirelessly to improve the lives of Maasai people since that time, particularly in Engaruka—the remote village where she grew up.

As a university student, Martha volunteered at nonprofit organizations serving the Maasai people. After she got her degree, she went on to lead one of these organizations for several years. During her tenure, she learned about community development, but she clearly already had an aptitude and a heart for this work. In 2014, she decided to start her own nonprofit, the Engaruka Community Initiative Organization (ENCO), to serve the people in her village. While ENCO has many programs, its flagship project is the Engaruka English Medium Primary School, which we are visiting

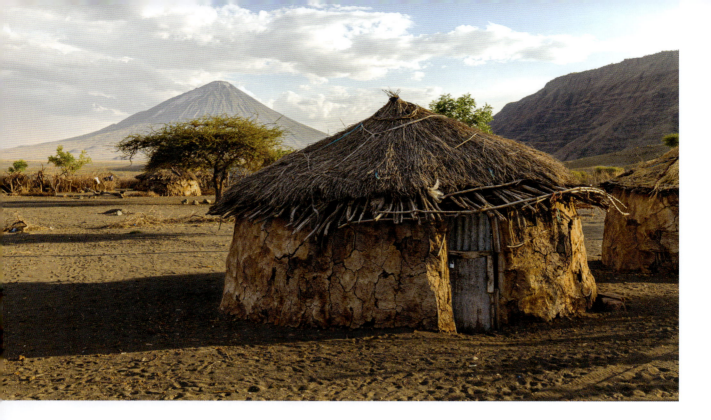

today. Already, the school ranks among the top primary schools in the region, which is remarkable given its recent launch, remote location, and impoverished population.

Regrettably, Martha won't be at the school today because she is nine months pregnant with her third child and plans to deliver her baby at a hospital in Arusha. Understandably, she decided not to risk riding on the isolated, rough roads to Engaruka at this point in her pregnancy. Instead, she has arranged for us to meet the school's principal, tour the campus, and connect with her later in Arusha.

Though I've never been to Engaruka, I know it sits east of the Ngorongoro Conservation Area in the Great Rift Valley—a 4,000-mile active continental rift that runs the length of East Africa. From where we're driving, I can see the forested rim of the Ngorongoro Crater rising dramatically from the valley floor.

Though the rim of the crater appears lush and green due to its high elevation, Engaruka sits deep in the Great Rift Valley, at sea level. From May to November, during the region's dry season, Engaruka receives less than five inches of rain, which explains the dusty conditions on this day in late June.

I am also aware that we are entering the epicenter of Maasai culture. Nearly everyone who lives in Engaruka is Maasai, and their ancestors have been living in harmony with nature for centuries in this region. This landscape holds profound significance for them. Just north of Engaruka, Ol Doinyo Lengai (pictured above), an active volcano, rises nearly 10,000 feet from the vast, low-lying, semi-arid scrublands that surround Engaruka. Ol Doinyo Lengai means "mountain of God" in the Maasai language, reflecting the sacred nature of this part of Tanzania to the Maasai people.

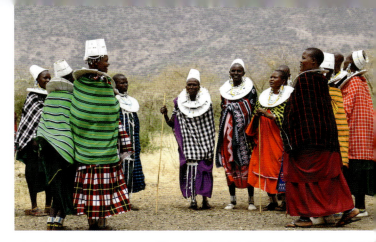

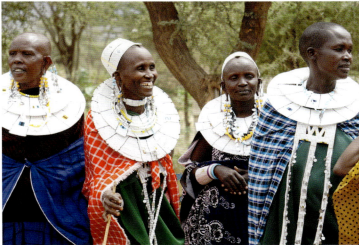

I expected to see more signs of life, but low-growing shrubs, stunted acacia trees, and little else line the road. We pass a few gatherings of buildings that I assume are village centers, but they seem vacant, and there aren't many bomas visible from the road. The only people we see during the bumpy, two-hour drive from the main road in Mto wa Mbu to Engaruka is a group of three children walking along the side of the road. They wave and yell greetings as we pass. They, too, appear muted in this dusty landscape.

I am, therefore, astounded when we finally arrive at our destination—a collection of large, modern brick buildings skirted by green agricultural fields and dotted with numerous leafy trees and plants. Clearly, this is an oasis in a harsh landscape.

As Robert parks the Land Cruiser near what appears to be a block of classrooms, a group of about twenty Maasai women, ranging in age from twenty to sixty, rises from beneath shade trees in the school's central plaza. Each of them wears at least two beaded ilturesh, as well as other long, loose-beaded necklaces, stacks of bracelets, and dangling earrings. Many have tall, white-beaded caps on their heads. A few carry slender walking sticks. All are dressed in traditional mashuka in bright reds, blues, greens, yellows, and purples. I know most Maasai women do not wear such elaborate beadwork for their daily comings and goings, so I imagine they've dressed up for our arrival.

The women form a circle and begin to sing and dance as we walk up to them. Their necklaces rock back and forth as their shoulders move up and down rhythmically. The hum of their voices is punctuated by high-pitched calls and responses. As the song picks up speed, two women enter the circle and begin jumping up and down to the music. With each jump, the two women move closer to each other while also jumping higher and higher in a contest to see who can jump the highest. They smile and laugh as the song ends, and then they begin animatedly chattering in Maa before turning to greet each of us with handshakes and slight bows.

As these greetings take place, an exceptionally tall man who looks to be in his early thirties and is dressed in sharp khaki slacks and a black shirt and jacket strides across

EDUCATION 45

campus toward us. He introduces himself as Moinga Mbukoti Mandalo, the principal of Engaruka English Medium Primary School. He explains that the women have come to welcome us to the school and that they are one of several savings and loan groups Martha has established in the community.

"The savings groups are self-managed groups of fifteen to twenty-five women who meet regularly to save their money in a shared lock box," Principal Mandalo tells us. "They make small loans to each other from these savings. This is just one of several community projects we run out of our school."

I thank the women for coming to greet us and for their beautiful song and dance. I talk about my experience teaching at the MGLSS during Martha's first years at the school and explain how eager I am to learn about her work in Engaruka. Principal Mandalo translates what I have said into Maa, further explaining who we are and why we are there, including that we will be interviewing Martha. The women smile and nod and further welcome us while Principal Mandalo translates. Many are not only part of the savings and loan program but also aunts, mothers, or grandmothers of students at the school. They want to impress upon us the importance of this place to them, but Principal Mandalo knows we have made a long journey and encourages them to let us go into his office first.

As we walk toward the principal's office, he points out the various buildings on campus. Behind us is a long, rectangular building with reflective windows and a covered portico that houses four individual classrooms. To our right, an auditorium-size building holds a modern kitchen and dining hall that doubles as a community gathering place. Adjacent to the dining hall, an asterisk-shaped girls' dormitory fans out with five wings off a central common area. In front of us, a smaller rectangular building contains offices, classrooms, and a makeshift boys' dormitory. Principal Mandalo explains that there are plans to construct a more permanent structure for the boys. The buildings are connected by a network of rock-lined paths that thread through flower beds and patches of lawn. Behind one of the buildings, a field of long parallel rows stands ready to be planted.

We are here during a school break so the campus is, unfortunately, largely vacant, but I can imagine its students. Small bodies dressed in neat school uniforms skipping across the central plaza. Sounds of laughter filtering out opened windows. Eager voices reciting lessons in classrooms. The clatter of plates and bowls in the dining hall. I suspect this school must feel like a sanctuary to its students, because it already feels like one to me.

Though his height makes him physically imposing, Principal Mandalo is gentle and soft-spoken. As he escorts us to his office, he tells us he grew up in Engaruka and that Martha and her husband played an important role in his life even before they established the Engaruka English Medium Primary School. Principal Mandalo is one of several students whom Martha and her husband sponsored through secondary school and university.

As if on cue, a well-built man with a salt-and-pepper beard and long, striking dreadlocks

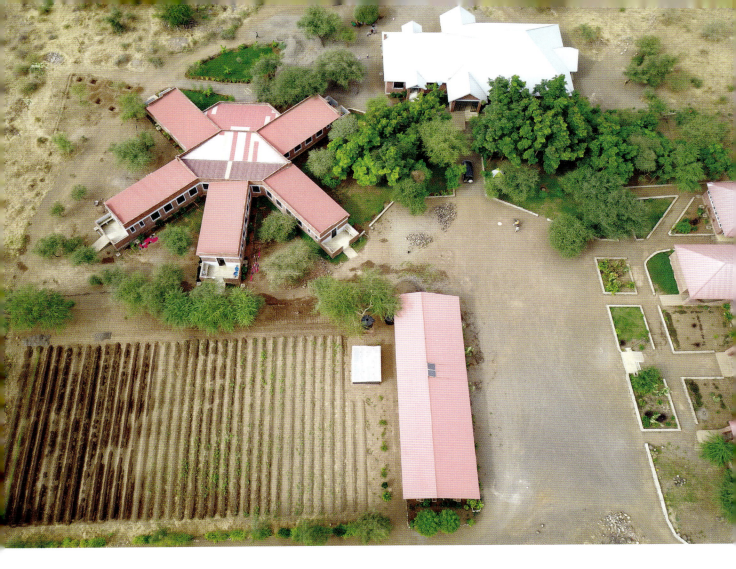

ambles into the room. Unlike most Maasai men, who dress in traditional mashuka, he wears shorts and a T-shirt with tall rubber boots and a striped rastacap. He smiles broadly as he introduces himself as Martha's husband, Abiya Matthew Olemisiko, or Abby for short. While Principal Mandalo's demeanor is thoughtful and earnest, Abby offers a playful, good-humored counterpoint. His eyes dance around the room as if he is looking for his next caper, and I imagine the school's children love his lighthearted presence. He tells us when he isn't helping at the school he operates the safari company he owns.

It strikes me that he's perfectly suited to this type of work—the kind of guy who makes friends fast. Today, he is busy on campus, and he sweeps out of the room as quickly as he swept in. I suspect he never sits still for long, and I soon learn why: Abby has been instrumental in the school's construction and in its agricultural programs.

After Abby departs, Principal Mandalo takes us on a tour of the school. He tells us that it began as a childcare center in 2018, serving forty-eight children. In 2020, Martha registered the center as a primary school, and by 2023, Engaruka English Medium Primary

School was serving more than 230 students with ten teachers and eleven staff members. Martha plans to expand the campus to serve secondary school students in the next few years. Eventually, the school will teach more than 600 students from nursery school through secondary school. Martha also has a vision for a vocational college here. Less than six years ago, none of this existed.

Principal Mandalo shares more information with us about the school and its importance to the region. "Before our school, Engaruka had only two primary schools and one secondary school serving a population of fifteen thousand people across a vast area," he explains. "More than half of those people were school-age kids. The demand for education was high, but there was not enough space to accommodate the kids. Our students come from Ngorongoro, Monduli, and Longido districts, but 95 percent are from Engaruka. We recruit students who live in poverty, don't have access to education, and often come from a single-parent home."

Astounded, I ask how they built such a beautiful campus so quickly. Principal Mandalo tells us that the school has many volunteers and supporters around the world, but that the physical structures came about brick by brick. "Way out here, we must make our own bricks. You can see the kiln near the entry to the school."

I also ask how the campus is so green when the surrounding area seems so dry. "We live in a semi-arid climate, but there is a permanent stream where we have our water line," he explains. "This allows us to operate the school, supply local women with water, and grow a lot of our own food. We grow vegetables, we have fruit trees, and we have a livestock project."

He leads us behind the dining hall, where we find a traditional boma with a small paddock for livestock. A calf bleats at us and a group of goats ambles about as Principal Mandalo tells us, "We want the kids to remember their roots, so we have this livestock project. Students milk the cows, sheep, and goats. They perform tasks as if they are at home. The boys are taught how to slaughter the animals, which provide food for our students. We are making sure they are doing their academics but that they are also maintaining a connection to their culture. When they go home, we don't want any complaints from their parents that they are missing this knowledge."

I ask Principal Mandalo to tell me more about how Maasai culture is embedded in the school's approach.

"Ninety percent of our students are from the Maasai community, and we know that some Maasai traditions are disappearing," he says. "At the school, we try to maintain Maasai culture because it is critical to our community.

> *"On special cultural days, we dress in traditional clothing and perform songs and dances. Elders tell stories and students perform dramas. We also play traditional games. This is one way we maintain Maasai culture."*
>
> —PRINCIPAL MANDALO

We have extracurricular activities that teach cultural skills. On special cultural days, we dress in traditional clothing and perform songs and dances. Elders tell stories and students perform dramas. We also play traditional games. This is one way we maintain Maasai culture."

When we have finished touring the campus, Principal Mandalo leaves us under a shade tree with Abby, who has made himself available to answer any questions we might have.

I'm curious about his relationship with Martha, so I ask how they met.

"We were both born in Engaruka, and we were neighbors," he says. "I have known Martha since childhood. We started dating when we were in secondary school. Her father was a Maasai leader in this area. He supported Martha's education and was very proud of her, but he wanted her to marry a man he chose. Martha chose me instead. Only her mother attended our wedding, even though Martha paid her father twenty-five bulls to try to reconcile with him. Unfortunately, that never happened before he died." Abby's light demeanor dampens a bit here, but he quickly moves on. "Despite these early challenges, we have a vision here. Our home has always been in Engaruka, even though we also have a house in Arusha. Martha's heart is here, giving back to this community, and I am behind her as a supporter."

Abby's voice takes on a sudden intensity as he says, "We both want to positively impact our society—a society that has been left behind. Maasailand is being taken by the Tanzanian government under the name of conservation, even though the Maasai people

have coexisted with wildlife here for centuries. There is not enough land now to graze our livestock, and our culture is fracturing. We can't survive with more people and livestock on less land. Many Maasai now see education as a tool. It is the best way to have our voices heard, and it's impossible to get a decent job without education. We built this school to provide access to education for kids without opportunities, just like the MGLSS did for Martha. The MGLSS provided Martha with the confidence to leverage resources to achieve all this." As Abby speaks, he makes a wide arc with his arms. I'm touched by how proud he is of his wife.

EDUCATION 49

After our conversation, Abby walks us to the dining hall for lunch. The seriousness with which he approached our earlier conversation quickly dissolves as he encourages our group to take more food, which is plentiful, delicious, and diverse. There are offerings of roasted meat, vegetables, pilaf, and even a pizza-like pie.

"Do you know what I tell the students here?" he asks with a mischievous smile. "They need to eat more, because nowadays we all need mobile phone cleaners." At that, he grabs his mobile phone and begins rubbing the screen over his slightly protruding belly. "You need to eat more to develop a bigger mobile phone cleaner."

Jovial and physically funny, Abby continues to make all of us laugh with his antics throughout the meal.

After lunch, we interview two girls, Ndanapi and Tomonik (pictured at right), who have stayed on campus during the school break because they face forced marriages at home even though they are only in the sixth grade. Though I know this is an English medium primary school, I am still astounded by their fluency. The young women easily articulate the challenges they face as Maasai girls—predominantly in overcoming the cultural stigma against girls' education—in English. Ndanapi tells me she wants to become a doctor, while Tomonik hopes to be a teacher.

Next on our tour, we meet with the group of women who originally greeted us when we drove up (pictured at right). They share more about their savings and loan program. Many have also participated in an adult literacy project at the school, and they now know how to read and write. These two programs have given the women the skills and ability to start small businesses. A few have retail shops, and many grow crops or raise livestock to sell. With the profits from these businesses, the women tell me, they can support their families, when before they could not.

It's already midafternoon, and we need to travel to Arusha to meet Martha. We bid everyone farewell and offer our thanks for the generous hospitality we have received. After we pull away from the school, the interview team remains quiet. It seems we are all reflecting on the magnitude of what we have just witnessed. Though I have visited many schools in Tanzania and elsewhere, the Engaruka English Medium Primary School is a rare place where local people and priorities are driving meaningful change that is profoundly improving the quality of life for an entire community while also preserving its cultural identity. I feel overwhelmed with emotion, because I know this is what the founders of the MGLSS had in mind when they started that school in 1995—that each graduate of the school would go out into the world as a changemaker ready to lead the Maasai people into the twenty-first century. Martha is an extraordinary example of this principle at work, and I can't wait to meet her.

The trip between Engaruka and Arusha takes about three hours—the first leg back over the dusty roads we traversed that morning. Though I'm exhausted and dirty when we arrive in Arusha, I'm aware I'm about to meet a remarkable woman, so I am nonetheless

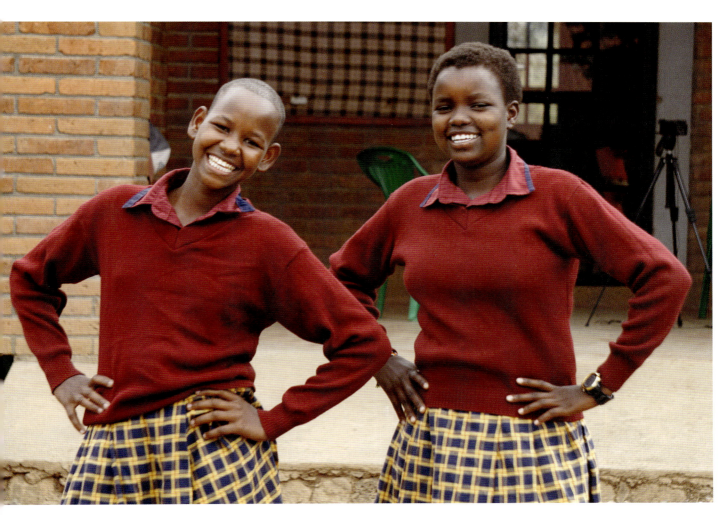
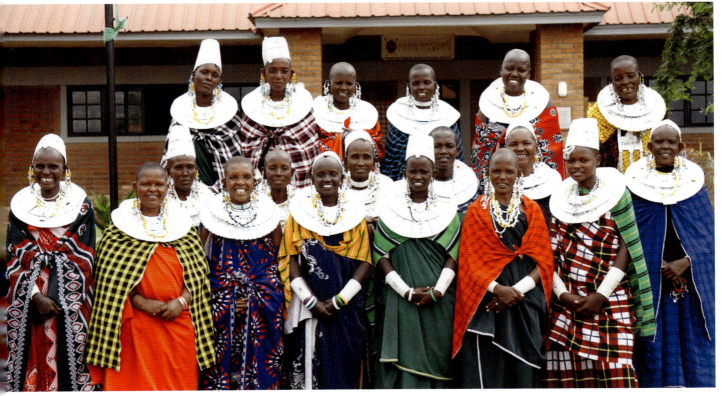

energized. In many ways, I feel like I already know Martha.

It's late in the day when we arrive at Martha's two-story home on the outskirts of Arusha. As we pile out of the vehicle and stretch our legs, she sweeps out her front door and toward us with a warm smile. She is wearing a flowing floral dress with a light sweater. Though nine months pregnant, she seems unburdened, even light on her feet. As Martha gregariously asks us about our day in Engaruka, she strikes me as the type of woman who always leads with warmth and generosity, and I immediately like her. It is clear there is a lot to admire about Martha.

After initial greetings, the interview team sets up two chairs and our recording equipment on the lawn just outside the front door. While that's happening, I tell Martha how impressed our whole team is with what she's doing in Engaruka. She smiles broadly and tells me how happy she is to be able to share her story with us.

"There is no way I can express in words what the MGLSS has done for many, many girls in the Maasai community," she gushes. "I never stop telling people I am the product of the MGLSS. That is why I am pushing to do something for my community . . . to pay back what the MGLSS invested in me. I never thought I could do something to touch people's lives, but the will is within me, so I can do it. This interview is my chance to tell the sponsors of the MGLSS about the impact that school is having on the Maasai community through all its graduates."

When we formally sit down to record, I start by asking Martha to tell me how her work in Engaruka began.

"After attending the MGLSS, I went to the Catholic University of Eastern Africa in Nairobi," she says. "During my university breaks, I volunteered at nonprofits that serve the Maasai community. After I completed my bachelor of social sciences, I got a job straight away with one of these organizations. I worked at Community Research and Development Services for one year. It was a good experience working in the gender department on women's rights and land rights. Then I joined the Maasai Women Development Organization (MWEDO) as a program officer for education. I worked with about two hundred and fifty girls who were in secondary schools all over Tanzania. I also had an adult literacy program for women. I did this for five years before I was promoted to supervise all MWEDO's programs for another three years. I grew so attached to the broader Maasai community, and I loved what these nonprofit organizations were doing, but I felt time passing."

Martha's expression grows somber as she considers her next words. "I appreciated what MWEDO was doing, but I felt my people in Engaruka were being forgotten, and I wanted to reach them. I needed to scale up activities there to reach more people." Her gaze grows distant, as if she is seeing the needs of those people. "I remember in 2016, after I had just resigned from MWEDO, some Americans went on safari to Lake Natron, just north of Engaruka. When they were there, they met a nine-year-old girl named Maria who told them she had dropped out of school because her father was ready to marry her off. When these

Americans returned home, they called and wrote many people in Tanzania to try to help Maria, but they couldn't locate her. I happened to receive one of their emails from a tour operator who is Abby's friend. When I heard the story, I said, 'In a week, I will get Maria.' I went to Lake Natron with my father-in-law, who is a trusted Maasai elder and who also has a Land Rover." At this, Martha winks and adds, "After today, you know we needed a Land Rover," before continuing.

"We visited the safari camp where the Americans had stayed," she says. "I had a photo of Maria from them, and I showed it to the people there. They took me to Maria's boma, where we met her parents and her uncle. My father-in-law and I were able to talk to Maria's family, explaining to them that we wanted to help Maria to continue her education. Maria's father was hesitant because he didn't know us well, but her uncle had been looking for education opportunities for children in the Lake Natron region, so he was very positive about this chance for Maria. With encouragement from her uncle, Maria's parents allowed her to come to Arusha with me. At first, she stayed in my home so I could teach her Swahili and some other things. Ultimately, Maria became like my own daughter, and today her parents are very positive about education. This experience inspired me. My dream became to have a school to accommodate more girls like Maria who could not go to school without support." Her head bobs with excitement. "The same people who met Maria on their safari came back to visit her and have supported her education. When I told them about my dream to start a school to help more girls like Maria, they said, 'We are retired, and we have time, so we are going to start a foundation to support this school.' That is the Maasai Education Foundation in the US. With the support of those friends and others, we started construction. Within two years, we opened the school in Engaruka. At first, it was a challenge to convince parents that their children should go to school, so in the first year, we went to the bomas to talk to the parents. By the second year, the applications were more than we could accommodate."

Since Martha's programs extend well beyond running the Engaruka English Medium Primary School, I ask her to tell me more about ENCO's work. She dives right in, her focus clear.

"ENCO has four programs: education, economic empowerment, community health, and environmental conservation. The school is one of our education projects. Most of our students are very vulnerable. We try to save them from early marriages and domestic violence. When a girl is nine or ten years old,

> *"At first, it was a challenge to convince parents that their children should go to school, so in the first year, we went to the bomas to talk to the parents. By the second year, the applications were more than we could accommodate."*
>
> —MARTHA MERESO SENGERUAN

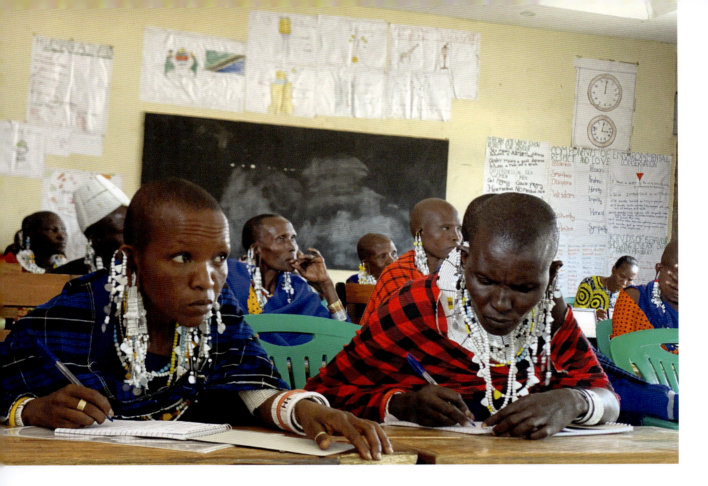

she is not ready to be a wife. She is married simply because her father needs cattle or shillings. She is too young to be pregnant and deliver in a safe way. Our school serves more girls than boys for this reason, but we don't want to forget the boys. As Maasai boys grow, they have responsibilities beyond their age. When it is dry, the boys herd livestock very far from their homes. Even three- to five-year-old boys are out unprotected from wildlife or strangers. They are not assured food. That's the education they get. Beyond this, most Maasai adults in Engaruka have not had access to education. People need to know how to read and write, so we offer adult literacy programs (pictured above) as part of our education program too."

Martha's focus remains laser sharp as she goes on, "You saw the women who are part of our economic empowerment program. We have about thirty-five savings and loan groups. We try to empower the women and youth economically by giving them the skills to use the resources available to them, like livestock, to maximize profits and help their families. We teach women how to participate in public meetings and how to join village leadership so their voices are heard. We also teach them about property rights, land ownership, and domestic violence so they understand their rights." She places her hands on her very round belly. "Maternal and reproductive health is also important to these women. Our community health programs depend on funding, which

we struggle to find, but we know that most Maasai women lack basic knowledge about reproductive health and don't know the importance of prenatal checkups."

This is the first time Martha has confirmed a suspicion of mine—that her dreams are sometimes bigger than her funding streams.

"There are a lot of diseases around and women need to know how to protect themselves, especially from HIV," she says. "This has been our focus with youth and women, but we also work with traditional birth attendants who need knowledge to do their work in a safe way."

At the next pause, I ask Martha to tell me about ENCO's fourth program area—environmental stewardship.

She points toward the sky, which is now growing dark, and says, "With climate change, the rain patterns are not regular anymore, and people are not prepared for drought. Through our environmental stewardship project, we are teaching people to plant drought-tolerant crops and to clean up the environment. We are distributing trees and other native plants to the community for planting (pictured on page 57). Within this strategy, there is an element of traditional knowledge, because these native trees give us medicine and food. We are encouraging elders with this traditional knowledge to share it with the youth, and we are documenting it so this wisdom is not lost."

By the time our interview is over the sun is well below the horizon, but Martha and I continue to sit on her front lawn, just outside the small circle of light cast by the lamp in her living room window. After visiting Engaruka and talking with Martha, I'm tired, and I feel she must be too. I want to ask her how she has the vision and energy for all of it. With so many needs, I imagine her work must be challenging and discouraging at times.

"Do you ever get overwhelmed?" I ask.

She pauses for a long moment while we sit together in the dark, looking up at the stars that now fill the sky above us. "You know, everything has a challenge. We needed to build this school. For several years, it was a struggle, but we feel like we are making progress. For me, all of this is not a coincidence. This is God's plan. I cannot explain it. I can only witness the miracle. If I had not gone to the MGLSS, I would be a local mama with eight children and no ability to impact the community, but that was not God's plan. Many people have come together to make all this possible, and that is a mystery. I know I can go through obstacles, and I will be okay."

As we say our goodbyes, I'm unsure how to express what I'm feeling. I want Martha to know how grateful I am for her work, but more than that I want her to know she has planted a seed of hope in me today, just like she is planting seeds of hope in so many. Tonight, the world feels a little less broken because I have witnessed the ways in which Martha is harnessing the power of her community to create a place where Maasai children, who are among the most vulnerable and poor on the planet, are thriving. And beyond that, she is bringing hope to the broader community through adult literacy, economic empowerment,

community health, cultural preservation, and environmental conservation. In short, I've encountered a mighty force today working through and in Martha. I too recognize the mystery and power of God's work.

Before I climb back into the vehicle, I give Martha a hug and tell her she is a great blessing. There are few times I've meant this so profoundly.

In a week's time, I will hear from Martha that she has given birth to a healthy baby boy, and I will think back on everything she shared with me. While I know Martha has escaped the hardships that many Maasai women endure, I also know her identity as a Maasai mama remains strong. Her baby boy will join her two other biological children, along with hundreds of other children like Maria—kids who were born into a life with few opportunities and for whom Martha is changing the equation. Just imagine how many more Marias will be transforming the world because Martha has given them a chance. Just imagine . . .

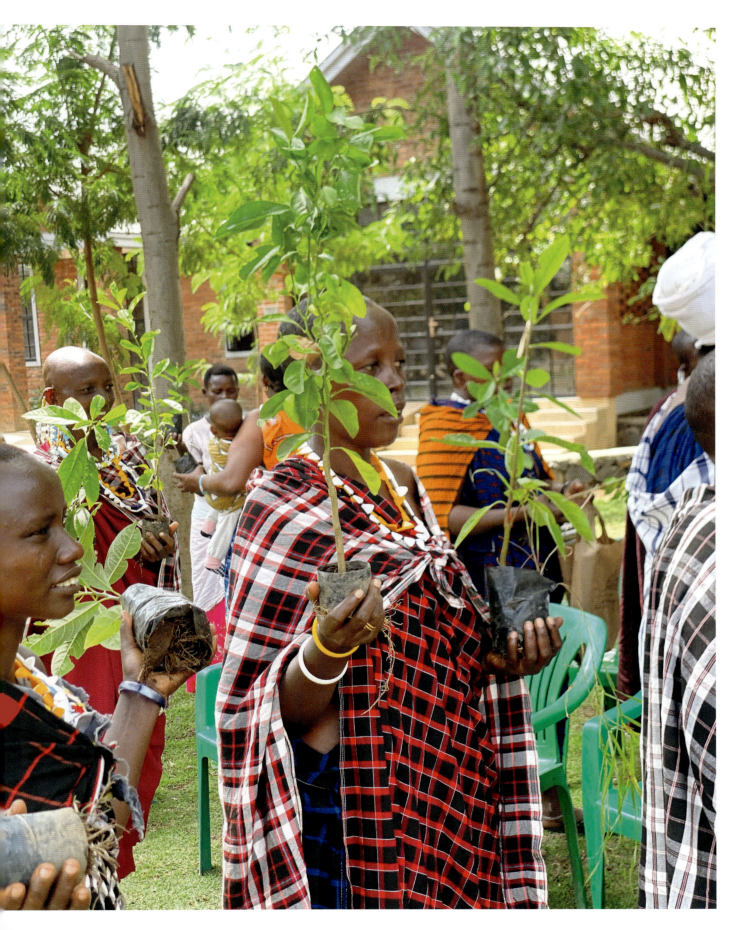

◊ HEALTHCARE ◊

JACLYN SHAMBULO LEKULE, 2004 GRADUATE, A-LEVEL

Caring for Children with Disabilities

The sound of a child's laughter fills the air as I sit down to talk with Jaclyn Shambulo Lekule. There is a playground just down the hill from the grassy area where we sit on the outskirts of Arusha. As Jaclyn and I begin talking, we are watching her daughter Timanoi run between the seesaw and the climb-and-slide fort.

Timanoi is delighted to have an adult playmate in my husband, Mark, who is following her back and forth across the playground. He is jokingly shooting me a look of fatigue, all the while encouraging Timanoi's exuberance by cheering her on as he operates one end of the seesaw with his arms and spotting her as she climbs up and slides down the fort-like structure.

An adorable streak of sound and energy, Timanoi is clearly an active, happy child. Jaclyn smiles as she tells me Timanoi is five years old and the youngest of her three children.

Jaclyn knows firsthand about the importance of play and movement to the healthy growth and development of children, not only because she is a mother but also because she works as an occupational therapist at Kafika House, a treatment facility for Tanzanian children receiving pre- and post-operative care and rehabilitation for surgically correctable disabilities such as a cleft lip or palate, clubfoot, osteomyelitis, hydrocephalus, or spina bifida.

While Mark continues to entertain Timanoi, Jaclyn and I begin our interview. I ask her to tell me about her work at Kafika House.

"We treat children with any disability that requires corrective surgery," she explains. "The work at Kafika House is very important because many of the children come from villages where they don't have access to treatment. Furthermore, their families can't afford treatment. When children come to Kafika House, they get treatment that changes their lives. They can go back to school. They can play with others. They can attend to their daily activities independently without their parents' help."

HEALTHCARE 61

As Jaclyn explains her work, I think about the stigmas people with disabilities face in nearly every culture around the world—the stares, the whispers, the exclusion, the unkindness. From my years of living in Tanzania, I recall seeing disabled children and adults on Arusha's streets begging for food and money. Here in Tanzania, people with disabilities are not only often ostracized from their communities but also forced to navigate the world without accessible design features and equipment that could make everyday life easier. The unjust reality that many of the world's disabled children have treatable conditions and yet must live without access to that treatment because of poverty is particularly difficult to accept.

However, as Jaclyn describes her work at Kafika House, I image a different world—one where disabled Tanzanian children are surrounded by others like them, and where they are given life-changing care by adults, like Jaclyn, who show acceptance and support. The word kafika means "arrived" in Swahili, and I like the image of Kafika House offering a sense of arrival to disabled children and their parents, providing a soft landing where burdens are removed and hope is restored.

"We educate communities across Tanzania about disabilities and the treatments available, transforming stigma into understanding and reaching children who can benefit from our program," Jaclyn tells me. "After surgery,

62 LESSONS IN HOPE

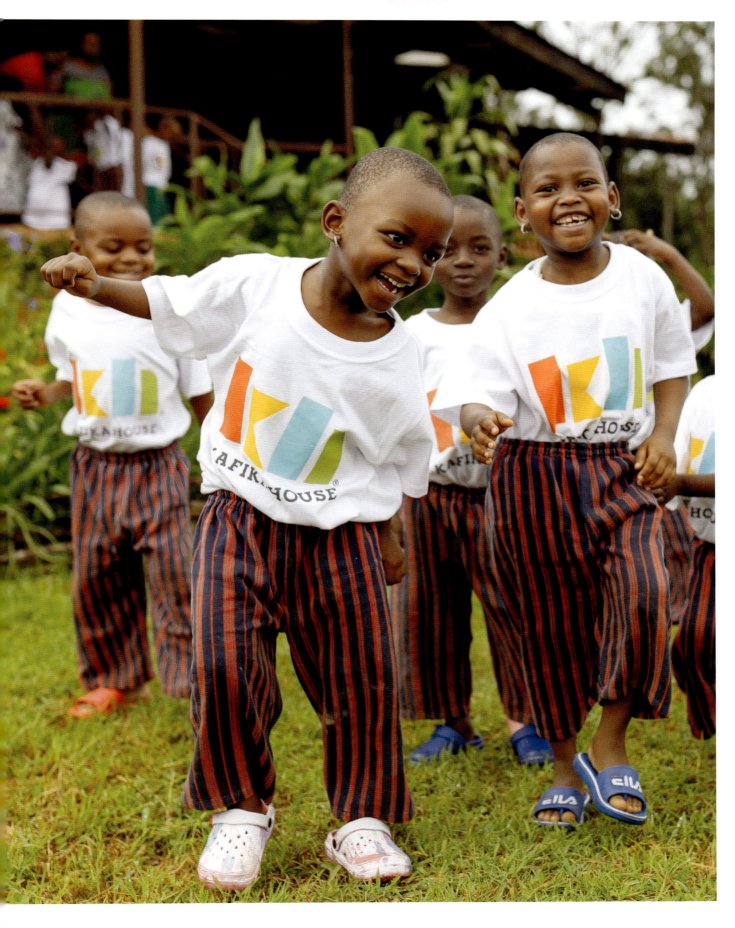

children begin an intensive rehabilitation program to start adjusting to their new lives. This is a big part of my job as an occupational therapist. Most children stay at Kafika House for about three months, so in a short period of time their lives are transformed."

Jaclyn seems to be a natural caretaker; her soft-spoken presence and gentle demeanor come through clearly as she describes her job. I ask her to tell me about her path to this work.

"I come from a very traditional Maasai family," she says. "I grew up in Kitumbeine in the Longido District. My only option for primary school was a boarding school, because my parents moved to different areas to find green pastures for the cattle. Sometimes, when I had a school holiday, I couldn't find them because they had moved to another area. I only went to primary school because village elders made it possible. I often didn't have simple things like notebooks, pens, or clothing, but some of my teachers and classmates helped with these things. I was at the MGLSS for six years, and I couldn't go home even a single day because I would not have been allowed to complete my dream of finishing school. My parents would have found a husband for me."

I realize this is a common story for too many Maasai girls, but I'm nevertheless given pause as I think about Jaclyn's plight—first a child fending for herself, unable to find her parents during school breaks, and later a teenager facing a forced marriage.

"Of course, as a child I knew nothing about a profession like occupational therapy," she says. "When I was at the MGLSS, I became interested in working with children in healthcare. Five of us went on a school visit to the Monduli Rehabilitation Centre, where I met an occupational therapist who was volunteering there. She changed the course of my life, because she is also the woman who founded Kafika House a few years later." Jaclyn smiles slightly. "After I graduated from the MGLSS, I went to Kilimanjaro Christian Medical University College, where I studied occupational therapy. Then I went to work at Kafika House." At this, her face breaks wide open into a warm expression that tells me how much she loves her work.

"Before I went to school," she continues, "my family did not know the importance of education for girls. The only thing they knew is that girls get married. That's it. When I completed school, I got a job, and with my salary I now help my family in many ways. Now they see education is very important, and they wish more girls could go to school. The MGLSS has educated so many women. These graduates and their families know the importance of education. I went to school and

> *"Our children go to school, and I send my sister's children to school. I convince my neighbors to take their children to school. My grandchildren will go to school. It's an expanding circle. The chains of poverty are being broken."*
>
> —JACLYN SHAMBULO LEKULE

my husband went to school. Our children go to school, and I send my sister's children to school. I convince my neighbors to take their children to school. My grandchildren will go to school. It's an expanding circle. The chains of poverty are being broken. So, you can see how the Maasai culture is changing. Many Maasai people now believe girls can do anything."

Hope wells up in me as Jaclyn describes how intergenerational change is improving life for the Maasai. As if to underline Jaclyn's point, Timanoi runs full speed from the playground to where we are sitting and begins to pepper us with questions about what we are doing and why. She is clearly part of this expanding circle of hope, as are the children Jaclyn treats at Kafika House. I know Jaclyn has traversed a challenging path to get where she is, but she persevered and now she too has "arrived," changing the world one child at a time.

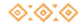

MARIA NAMARAI LAIZER, 2012 GRADUATE, O-LEVEL

Chasing a Childhood Dream

In the middle of Arusha, one of northern Tanzania's largest cities, Maria Namarai Laizer and I find a place to sit in a garden outside Arusha Lutheran Medical Centre (ALMC). Though Maria is not on call today, she spends many days at the hospital, working as a nurse in its neonatal unit. Around the hospital, the city is abuzz with the sounds of life on the move. Traffic oscillates on nearby roads, people shout greetings to one another, and Tanzania's distinctive Taarab music floats in the air.

We are in downtown Arusha, only a few blocks from the chaotic and bustling central market, a place where you can find fruits and vegetables side by side with electronics, clothing, shoes, pots and pans, and a diverse array of other items. From our shaded location amid palm fronds and tropical plants, we are removed enough from the tumult of downtown and the hospital's comings and goings to talk, yet close enough to see and hear what is going on.

Sheltered by a broad portico, the hospital's main entrance is part of a two-story building that fronts a three-story quadrangle (pictured on page 68). The complex covers nearly a city block. On the west side of the building, an ambulance is parked under a broad sign announcing, "EMERGENCY." Opened in 2008, ALMC provides a comprehensive array of medical services in a thriving urban center.

Slight of build and quiet in demeanor, Maria seems shy and timid at first, but as we begin to talk about her life and work it becomes clear that her circumspect disposition is just the surface layer of a very determined young woman. Though she wears a modern, light pink jacket, underneath she is dressed as a traditional Maasai woman in green-striped and blue-checkered mashuka. She tells me she is more comfortable speaking in Swahili. Her English is certainly better than my Swahili, but neither of us feels adept enough in a foreign language to

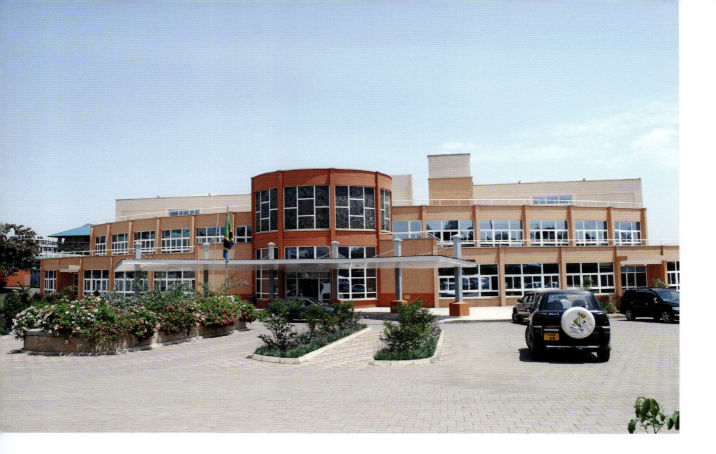

easily communicate, so we use Esuvat as our translator.

Maria begins by telling me about a dream she had when she was a child.

"I was very sick, and my mother brought me to the hospital. I had to stay overnight, and while I was sleeping, I dreamt that I would become a nurse. In the morning, I told my mother about the dream. She asked me if I was frightened by the possibility of becoming a nurse. I told her I wasn't, and she said she would pray that I would become a nurse one day. Since then, I've pursued this dream."

Though Maria had this dream from an early age, she grew up in Ndedo, an isolated Maasai village separated from Arusha by about 165 miles of rough terrain. With many responsibilities at home, girls in Maria's village irregularly attended primary school. Most were married by the age of fourteen and having children soon after that, but Maria's dream motivated her.

"My father didn't want me to go to school," she tells me. "At the end of primary school, he told me to fail my exams on purpose so that I would not be able to continue to secondary school. However, my mother encouraged me. She wanted me to continue to study. Fortunately, a politician's wife from my region supervised the exams, and she encouraged me to go through the selection process at the MGLSS, where I was accepted."

When Maria completed O-Level at the MGLSS in 2012, she took a three-month computer course before starting a pre-nursing course in Monduli, where the MGLSS is

located. These courses gave Maria the skills necessary to gain acceptance into ALMC's School of Nursing. First, she completed a two-year certificate in nursing and midwifery, which gave her basic nursing skills. After completing that foundational study, she began working in the neonatal unit in a role similar to a nurse's aide in the United States. She did this for seven years before completing an additional diploma in 2023, which gave her the ability to take on increased nursing responsibilities at the hospital.

Though her voice is quiet as she relays these details, she is clearly confident and proud of her achievements. "My dream is not finished yet," she says. "I want to gain a university degree in nursing, which would advance my career further."

When I ask her to tell me about her work at the medical center, she becomes more animated. "Maasai people come to be treated at the hospital, but they don't know the Swahili language. They can't express themselves and most doctors don't know the Maasai language, so it can be difficult to serve them. But when patients find me there, an educated Maasai woman, they are happy. I can interpret for them, and they often say with pride, 'The Maasai are everywhere now.'"

While Maria cares for new babies, she also works with expectant mothers. Unfortunately, she often sees what can go wrong when mothers don't get prenatal care, or when they try to deliver at home and something goes wrong. "At-home births are risky for mothers and babies," she explains. "Equipment is not sanitary, and the women who help with at-home births sometimes do not have training to handle complications. Too many mothers die on the way to the hospital because they wait too long when problems arise. As a nurse, I see many preventable deaths, so I educate women that they should go to a clinic or hospital to give birth."

In recent years, infant and maternal mortality rates have decreased in Tanzania due in large part to educational messages like those Maria is sharing with expectant moms. Encouraging mothers to seek medical care before, during, and after giving birth has led to an increase in the number of births that take place in healthcare facilities like ALMC, which has in turn saved the lives of countless women and babies.

However, many Maasai women still give birth without ever seeing a healthcare professional. They rely on traditional midwives and family members to help with home deliveries. For those that live in far-flung locations where they have little access to clinics, doctors, or nurses like Maria, training programs for traditional midwives are making home deliveries safer. Still, Maria's ability to speak to Maasai women in their language and from their cultural perspective is often enough to convince them that a hospital or clinic is a safe, welcoming space for them—a place that is beneficial and necessary to their health and that of their children.

"As a nurse, I have the power to erase the chains of poverty by educating Maasai women about the importance of healthcare and by

> "As a nurse, I have the power to erase the chains of poverty by educating Maasai women about the importance of healthcare and by providing access to healthcare in their language."
>
> —MARIA NAMARAI LAIZER

providing access to healthcare in their language," she tells me. "Even more, I'm erasing poverty in my own family. My job allows me to help my younger siblings and my parents because I have an income now. When I give my father a small amount of money, even 10,000 shillings [about $4], he is happy and likes to tell people that his daughter who is a nurse has sent him money. He sees the fruits of my education now."

This is not unusual for Maasai fathers with educated daughters. Once they begin to see the tangible benefits—the ways even a small income can change the conditions of poverty—most are eager to send all their children to school.

Before we end our conversation, I ask Maria about her mother, who so many years ago encouraged a little girl to dream big. She smiles and says with warmth, "My mother is very proud. She prayed that I would achieve my dreams, and now I have done it. I am a nurse."

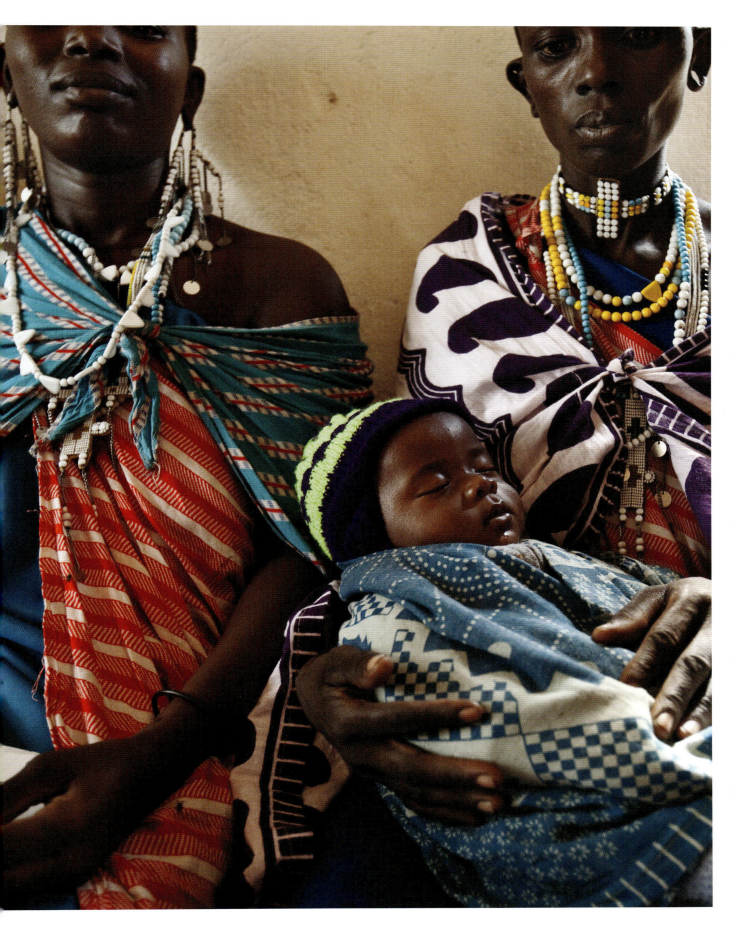

NANYOKYE NASIRA KIDOKO, 2007 GRADUATE, A-LEVEL

Becoming a Surgeon

The interview team and I have just checked in at the reception desk inside ALMC's main entrance when Nanyokye Nasira Kidoko appears. I had expected to be the one waiting to see Dr. Kidoko at the appointed interview time rather than the other way around, given the hospital setting, but here she is, clearly more than ready to begin.

On a late afternoon midweek, the hospital's lobby has all the hallmarks of a large medical center—bored-looking people waiting around, uneasy-looking patients slumped in chairs, and official-looking staff coming and going.

"Most people call me Dr. Kidoko," she says as she shakes my hand in a friendly but reserved way. While she is dressed professionally, Dr. Kidoko bears no visible signs that she is a doctor—no stethoscope around her neck, no white coat over her tidy shirt and slacks. Instead, encircling her neck is a scarf with vibrant green, yellow, black, and blue stripes—the colors of the Tanzanian flag. I suspect this accessory keeps her warm during a cool time of year and also makes her more approachable to her patients.

Though petite, Dr. Kidoko walks with ample authority as we breeze past the reception desk, down a series of sterile hallways, and past the restricted entrance to the surgical department. Small windows in the department's closed doors reveal people in scrubs and surgical caps consulting one another in a hallway laden with blood-pressure cuffs, heart-rate monitors, and other equipment.

Just off this restricted area we enter Dr. Kidoko's office, a modest space with three desks. As she takes a seat behind one of them, she tells us she shares the office with other doctors but doesn't spend much time there because she sees patients in other parts of the hospital.

As the videographer sets up his equipment, I ask Dr. Kidoko if she will put on one of the white coats hanging on a coat rack in the

corner, joking that this will give her an official air in the video recording. She laughs as she puts one on.

Before we begin the interview, Dr. Kidoko leans over the desk she is sitting behind and gives me a serious look. "I'm nervous about this interview," she tells me. "My story and my picture have been used in the past without my permission, and I'm honestly not sure how much I'm willing to share."

"I appreciate your honesty," I say as I consider how best to respond to her concern. I suspect that Dr. Kidoko has worked extremely hard to get where she is in a field that remains thin on women, particularly in Tanzania. Revealing personal details in a competitive, male-dominated setting probably comes with some risks. And not everyone wants the details of their life shared broadly. Given my work, I am keenly aware that Maasai culture and stories can be appropriated for purposes that do not always benefit Maasai people or their communities.

"I'm nervous too," I admit. I'm trying to alleviate her apprehension, but it's also the truth. "In conducting interviews with successful Maasai women like you, I'm often unsure if my questions are the right ones. I don't want to overstep or offend, but I also don't want to miss important aspects of each story. I'm convinced you and your fellow graduates have valuable wisdom to share about the transformative power of education on your lives and those of your families and communities. I believe these stories will inspire anyone who cares about poverty alleviation—so it is important to me that I get these stories right, and I hope you'll help me do that with yours."

She seems to relax a little as I assure her that I have insisted on written consent and editorial review by each participant in this project. When I ask if she is willing to continue, she simply nods, and I start with what I hope will be an easy question: "Could you tell me about your childhood?"

She sighs softly, a thoughtful look on her face, and acknowledges with a smile that this is already a personal question—but she dives in anyway.

"I come from a small village in the Monduli District called Lepurko," she begins. "I grew up in a very poor family. When I was young, my parents had a lot of cattle, sheep, and goats. The land was good, so we farmed maize and beans, and we did not lack as much in those years. But before I began secondary school, there were some very dry years, and we would go days unsure about what we would eat. There was a lot of hunger." Her voice gets quieter and more somber as she remembers this difficult past. "My mother worked so hard," she emphasizes. "She gave birth to eight children."

She pauses there, and I take the moment as I believe it's intended, letting that information sink in. I can't imagine raising eight children, especially in the conditions she just described, though I know this is the plight of many Maasai women.

"Most students at the MGLSS have a similar story to mine," Dr. Kidoko goes on. "They were recruited from very poor communities where food and water are in short

supply. In the arid, semi-desert region where the Maasai live, rainfall is never enough. Crops often fail, and livestock suffer. I remember in my village we would go with donkeys to fetch water from a dam about ten kilometers away. It was not even clean water. Imagine walking that far to get water every few days. This is the life of most Maasai women and girls."

Dr. Kidoko's serious, reflective expression exposes the depth of her understanding. I imagine this helps her to be a compassionate and empathetic doctor. She is a Maasai woman who escaped these conditions of chronic poverty, but she knows many women who haven't.

"I'm so impressed by your success," I tell her considering her upbringing. "After all, you are a Maasai woman working as a surgeon at Arusha's largest medical center."

She smiles shyly.

"Tell me about your education and your path to becoming a surgeon," I prompt her.

"When I was selected from my primary school to go to the MGLSS, my father was not at home, but my mother was supportive. She said, 'Let her go.' It was my primary school teacher who brought me to the MGLSS. That school took me from zero to one hundred. Up, up, up . . . the MGLSS transformed me completely," she says, pointing from the floor to the ceiling. "It opened my eyes and my heart to see that I had more opportunities than I could imagine. It was a safe home for me. You know, many Maasai girls are forced into FGM and early marriages. The MGLSS helps girls escape this. It helped me. I stayed at the school during the holidays when I knew I might face FGM at home."

I ask how her parents felt about her education and she tells me with a smile, "Well, my schooling and career path were a bit too long for my parents, but they are so proud of me now. They see education as the best thing that can happen to a family. My father tells his friends, 'Education has made me a person,' and he is right. The MGLSS changed my life and theirs, too. I have a reputation in my village as being the most educated person. Although I have supported my siblings' schooling, I have not been able to skyrocket my family's finances like some other youngsters in my village who went into Tanzanite gemstone dealings. My father once told me that money that comes slowly is the right kind of money. I'm helping them as I can. My parents are still alive, thank God."

As Dr. Kidoko has pointed out, most graduates of the MGLSS come from remote places where chronic poverty and lack of healthcare take their tolls, leaving many young women without parents at an early age.

"My parents have kept me going during difficult times," she adds.

I suspect that getting through medical school might have been one of those times, so I ask her about this. She meets my question with a clear-eyed gaze.

"After attending the MGLSS, I went to Hubert Kairuki Memorial University in Dar es Salaam," she explains. "After five years of study, I was awarded a doctor of medicine in 2012. I then did one year of internship in

general medicine at Kilimanjaro Christian Medical Centre in Moshi. After that, I came to ALMC and worked some years as a general practitioner, treating everything from flu to hypertension. Eventually, I joined the surgical department where a pediatric surgeon was leading the team. I started treating pediatric cases. At that time, we were treating a lot of neurological cases, such as spina bifida and hydrocephalus. I went to Uganda for further education as a general surgeon before coming back to Arusha to continue my work as a surgeon here."

As if peering into a past full of different choices, Dr. Kidoko gets a far-off look on her face. "Sometimes I feel out of place. My dream job would have been serving Maasai people in the villages. When I went to medical school, I thought I might specialize in obstetrics and gynecology to help Maasai women who are still giving birth in unsafe environments at home, but by the time I finished, I was more interested in surgery. Obstetrics is always happening in a rush. In surgery, I have time to prepare before taking a patient to the operating room. Through my internship, I came to realize that my mind works better when I am calm, so surgery is a better fit for me."

A light laugh escapes her; I imagine it's the levity that comes from meeting a moment of self-awareness.

"I could still go deep in the villages and provide medical services that are lacking there," she says. "Sometimes I think I am not doing

enough in town—but I don't think I am ready to go yet."

Between the lines, I read the push and pull of conflicting priorities and responsibilities. "Do you have a family of your own?" I ask, imagining this would influence these decisions.

"My husband is also Maasai," she says, nodding. "We have two children. The eldest is a girl and the youngest a boy. They are doing very well. They have a better environment than I did as a child, and more opportunities. They can choose to do anything." Her eyes shine as she says this; she is clearly proud of what she and her husband are able to provide for their children.

When she pauses, I reflect on her straightforward, honest assessment of her upbringing, her life, and her choice to become a surgeon. I admire her transparency, especially considering her nervousness about sharing her story. Dr. Kidoko has given me a gift in sharing her truth in a way that acknowledges the dissonance in life—that we don't control where and how we were raised and that things don't always work out the way we expected. I suspect this quality makes her a great doctor. She sees things as they are, not as people wish them to be, and is able to speak from that certainty with compassion.

Dr. Kidoko also recognizes that she is among the lucky ones.

> *"I received a rare opportunity to have a career where I can serve people. The MGLSS has supported a lot of Maasai girls like me. You go anywhere in Tanzania, and you see these women. . . . I'm a doctor. How many times have I saved someone from dying? That school has transformed lives upon lives."*
>
> —**NANYOKYE NASIRA KIDOKO**

"I received a rare opportunity to have a career where I can serve people," she says with feeling. "The MGLSS has supported a lot of Maasai girls like me. You go anywhere in Tanzania, and you see these women. Some are managers in companies. Some are teachers or nurses. I'm a doctor. How many times have I saved someone from dying? That school has transformed lives upon lives. It continues to serve girls who are lost somewhere in the wilderness, giving them opportunities like the one I had."

Though Dr. Kidoko's path has clearly led her through some wilderness times, today she stands as evidence that anything is possible when the windows of opportunity are thrown open, especially for a Maasai girl whose determination was forged in the fire of life before education.

HEALTHCARE 77

MAGDALENA TOBIKO LAISER, 2004 GRADUATE, A-LEVEL

Opening a Private Practice in Maasailand

Magdalena Tobiko Laiser meets me and the interview team at a quiet outdoor space on the grounds of Selian Hospital, a modest campus filled with green spaces amidst sprawling, low-slung buildings. Magdalena works here as an occupational therapist, and she suggested we meet at this location. On this sunny, Saturday morning, her suggestion is a good one. The hospital feels quieter than it might on a weekday, but from our outdoor location, we can see a few people coming and going from the hospital's main building.

Since it's a Saturday, Magdalena isn't wearing her white clinician's coat but rather a dressy grey jacket over a peacock-blue dress. Even though a friendly smile lights up her face when we first meet, she assumes a serious look while we set up for the interview. I suspect her demeanor reflects some nervousness, so I tell her that her answers don't have to be perfect the first time. We can always do a second take. At this, she relaxes some.

Though Selian Hospital (pictured on page 81) began nearly seventy-five years ago as a small community clinic and training site for rural healthcare workers in Maasailand, today its campus spans nearly a dozen buildings. Some buildings look more modern than others—the campus was clearly developed in stages over many years—but their congruous architecture, earthen tones, and similarly sloped metal roofs give our surroundings a cohesive feel.

Just beyond the tall fence that surrounds the campus, I can hear the mechanized clatter of vehicles driving the rough roads that surround the hospital. When it opened in the 1950s, the small clinic, now hospital, was located well outside of Arusha in an area northwest of the city dominated by the Maasai. Then, I might have heard cattle lowing instead of today's suburban traffic. While many Maasai people still live in this area, Selian Hospital is now surrounded by residential Arusha rather

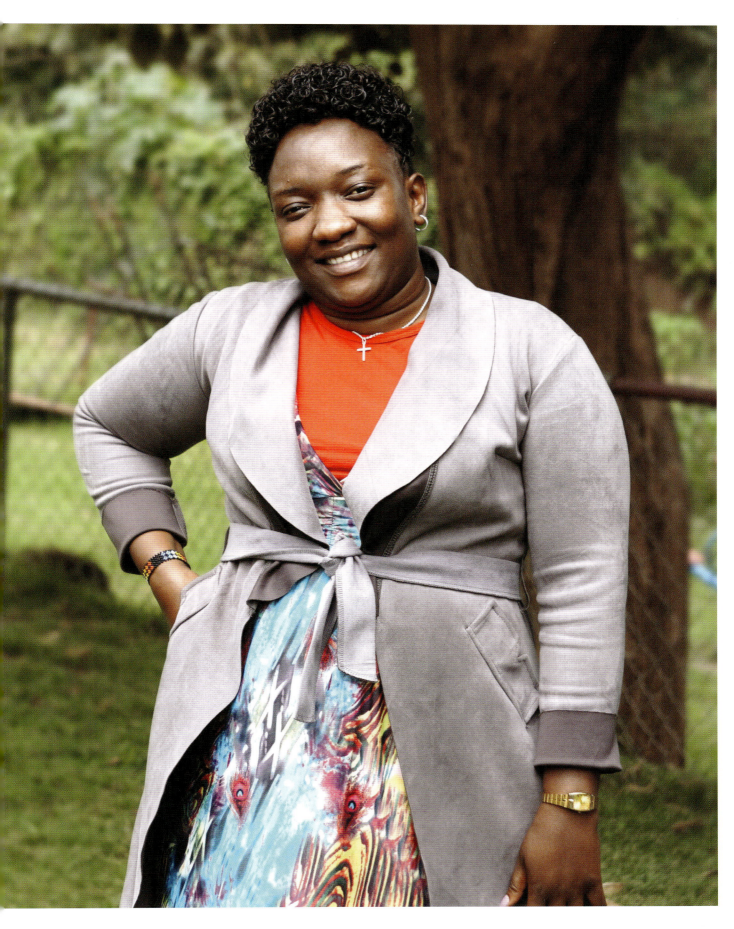

than by rural bushlands. The hospital is no longer a small, pastoral outpost but rather a regional medical center. Selian Hospital still predominantly serves Maasai people, and it now also has internal medicine and surgical departments, a full-service laboratory, hospice and palliative care, and several outreach programs focused on maternal and reproductive health.

As we sit in the sunshine watching people float in and out of the hospital, I ask Magdalena to tell me about her work here.

"I'm so happy to work at Selian Hospital because it serves the Maasai community." Her expression remains serious and steady, but she speaks her words with warmth. "I'm the only occupational therapist here, and I work with children and adults. I see children with congenital disabilities, such as bone deformities, and acquired disabilities from burns and other accidents. The adults I work with often have neurological diseases, or they've had strokes. Some patients have been involved in traffic accidents. I can see up to forty children and sixty adults each month. I am here five days a week, eight hours a day. I have many patients every day. My work keeps me very busy."

> "I'm so happy to work at Selian Hospital because it serves the Maasai community. I'm the only occupational therapist here, and I work with children and adults."
>
> —MAGDALENA TOBIKO LAISER

Her eyes sparkle as she talks, and she nods as if encouraging herself. Her expression tells me this heavy workload isn't a reason for complaint but rather a point of pride.

"I love working with children the most," she continues, smiling. "This is my favorite part of my job." Her expression tightens slightly. "Unfortunately, I see a lot of children with severe burns. For example, I recently worked with a young girl named Careen, who was in the hospital for more than four months. Like in many Maasai homes, her family uses an open fire to cook. Careen's clothing caught fire, and it spread quickly. Over half her body was burned. She needed several surgeries. As her scars thickened and tightened, I worked with Careen on the affected joints to keep her mobile and prevent permanent disability. This is what occupational therapists do." Magdalena's solemn expression shifts as she speaks about the outcome of her work. "When I can positively impact a child's life, and even her parents' lives, it makes me happy."

I ask her to tell me how she decided to become an occupational therapist.

"After I completed A-Level at the MGLSS in 2004," she says, "I joined Tumaini University at Kilimanjaro Christian Medical Centre in Moshi. I finished my occupational therapy diploma in 2007 and started working at Selian Hospital in 2008."

Like fellow graduate Jaclyn Shambulo Lekule, another occupational therapist featured in this book, Magdalena tells me she was introduced to the profession by a teacher at the MGLSS who took her and several other

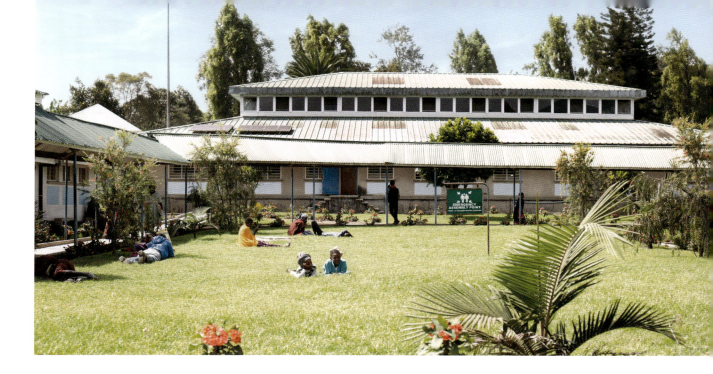

students to visit a rehabilitation center to observe the work done there.

"That's where my vision to help children began," she says.

At this, I prompt her to tell me about her own childhood.

Her face takes on a thoughtful expression as she considers her response. "I experienced many challenges as a child. My parents didn't know anything about education, and they were not able to pay school fees, so it was difficult for me to go to school. I made it to the MGLSS, though, and I benefited a lot. We were taught more than just academics there. We learned how to love each other like sisters. We learned about life. I was really blessed to be there."

Her answer makes me pause for a moment to reflect on the lifelong friendships I've witnessed among the MGLSS graduates. Whenever I'm in Tanzania and visit one of them, others show up too, and they all give me news of their classmates who aren't there. Magdalena is right. They are sisters.

"Though the MGLSS helped me individually, it is really like my whole family went to school too," she continues, her tone soft but full of conviction. "I'm passing my education on by giving other children in my family and my community the chance to go to school. I have three children myself, and I'm supporting them to go to school. But I am also teaching them Maasai ways so that they are part of the community and they understand its importance. When you take a girl to school, it's as if you have taken the whole community to school. I'm

> *"We were taught more than just academics there. We learned how to love each other like sisters. We learned about life. I was really blessed to be there."*
>
> —MAGDALENA TOBIKO LAISER

HEALTHCARE 81

an example of this. I live differently than I did when I was a child, but I love my family and my community. I am still there supporting them."

As the interview comes to a close, Magdalena invites me to walk with her into the main hospital building, where she shows me around. Staff in white coats consult with one another at a nurses' station. They greet her warmly as we walk by. Magdalena points out the lab equipment in another area before leading me back to the exit. She is clearly proud of the facility.

Before I go, she has something she wants to confide in me.

"I have a big dream," she shares shyly. "There are so many children in my community with disabilities, and I have a vision to help them. I'm building a rehabilitation center in the village where I grew up. This is my dream for underserved children with disabilities . . . to help them lead functional and productive lives."

She pulls out her phone and brings up a video to show me. Two construction workers stand on ladders. They are stacking a layer of concrete blocks on the exterior wall of an L-shaped building. In the video, five rooms are already defined, with openings for doors. Though the building does not yet have a roof, it is well underway.

"I have purchased a piece of land in Ngereyani where I grew up," she explains. "As you can see, the first building is under construction. I am doing this slowly, as I have the funds to continue."

I'm moved to see this, and so glad she has decided to share this important part of her story with me. While Magdalena is already helping many children and adults at Selian Hospital, her entrepreneurial spirit is leading her back to the community where she grew up: Ngereyani, a remote Maasai village west of Mount Kilimanjaro in the Longido District near Tanzania's border with Kenya.

Magdalena tells me she plans to pair her rehabilitation services with those offered at a medical clinic in the community, which is also home to a primary school, several small shops, and a church, all surrounded by open grasslands that still support herds of Maasai cattle.

"I hope it's a good beginning," she says.

"It certainly is," I assure her. Her efforts and tenacity bring a smile to my face. It's women like Magdalena who are improving the future for the Maasai. Though public hospitals and clinics are common in Tanzania, private practices are growing. In fact, Selian Hospital's beginnings were much like those of Magdalena's clinic—an austere outpost in Maasailand with a big mission to improve the community's access to healthcare. Magdalena, like so many of the MGLSS graduates, is blazing that path now too, choosing to see the possible rather than the impossible. I imagine her profession has trained her for this—to see abilities rather than disabilities. Soon she will be doing just that right where she grew up, in the heart of Maasailand.

THERESIA MEPUKORI LAIZER, 2003 GRADUATE, A-LEVEL

Pediatric Care for Maasai Children

When the interview team arrives at Selian Hospital, the place is hopping. It's a weekday, and people are coming and going across the hospital's lush, green campus. Well-manicured, parklike spaces separate numerous hospital buildings that house different wards and specialties, including pediatrics, obstetrics and gynecology, surgery, physical therapy, internal medicine, and dentistry. During the week, patients are here for appointments and checkups, and the interview team watches as medical staff and patients move with purpose across the hospital's grounds. We are waiting at the main entrance for Theresia Mepukori Laizer, one of the doctors here, to meet us.

Soon, Dr. Laizer approaches us wearing a brilliant white coat with a stethoscope around her neck. Under her coat, she's dressed in a floral shirt, dark slacks, and black flats. A tidy fabric headband holds her long hair away from her cheerful face. She is accompanied by a tall, slim man who has an official air about him even though he is not wearing a doctor's coat. Dr. Laizer politely greets us before introducing the man as Dr. Elibariki Marco Lucumay, the hospital's director of clinical services and her boss. Dr. Lucumay shakes our hands as he welcomes us to Selian Hospital. We explain the purpose of our visit, and he tells us how grateful he is we've included Dr. Laizer in the project before taking his leave. No doubt he is a busy man with many responsibilities, and we're honored that he has taken the time to meet us.

Once Dr. Lucumay departs, Dr. Laizer visibly relaxes. She makes small talk with the interview team, and I note right away that she has a knack for making everyone feel seen.

"How have you been after so many years?" she asks me.

Though Dr. Laizer was never in one of my English classes at the MGLSS, we were on campus at the same time in the late 1990s, and we remember each other. She tells me she also

remembers my husband, Mark, who taught her mathematics. She asks after his health—a common question and way of greeting each other in Tanzania even if you aren't a doctor.

After some discussion about the best location for the interview, Dr. Laizer guides us past the hospital's main in-patient ward, where family members and visitors meander on the sidewalks and sprawl on the lawn outside the front door. Several people stop her as she walks by to say hello. She has an easy, ready smile. It's clear that she's well known and liked here.

Beyond the ward, we find a shady spot under a tree where it is quiet and there are few people. We gather chairs from a nearby meeting room and set up our camera equipment. I'm aware that this is a workday for Dr. Laizer, and I don't want to take up too much of her time, though she gives no indication that she is in a hurry. Once we are ready, I ask her to tell me what she's been up to since the last time I saw her some twenty-five years ago.

"I graduated from Form Four in 2000," she starts. "When I passed my national exams, I continued through Form Six at the MGLSS and graduated from A-Level in 2003. Then I went to the Machame Clinical Officers Training College in Moshi. I studied there for three years and graduated as a clinical officer, which is like a physician's assistant. After that, I came here to Selian Hospital where I worked for two years. During this time, I got married to Goodluck Marandu, who is also in the medical field working as a lab biotechnologist at ALMC. I then attended medical school at Kilimanjaro Christian Medical Center in Moshi for five years before completing a one-year internship at Mount Meru Hospital in Arusha. My husband and I had two children during this time, too. Then I came back to Selian Hospital in 2014 and worked as a general practitioner for two years before I went for my master's residency in pediatrics at Makerere University in Uganda. I completed that in 2022, so this is just my second year working as a pediatrician at this hospital."

I'm reminded of the lengthy educational journey required of physicians no matter where they practice medicine. Though she is roughly forty years old, Dr. Laizer's pediatric practice is relatively new because she has spent the last twenty-five years, on and off, in school and training programs.

"Can you tell me about your practice here at Selian?" I ask. "Who does this hospital serve?"

She looks back toward the main in-patient ward we walked by earlier, seemingly to acknowledge it, before she speaks. "Selian Hospital mostly serves marginalized people. Many are from the Maasai community. The families that come to this hospital are very poor. They come here because our prices are low compared to other hospitals, and we have funding to support people who cannot afford medical services. Working at this hospital as a Maasai woman is very important to me and to my community. When I speak to patients in our Maasai language, it's easy for them to understand and to take my advice, but if nobody here was able to speak Maa it would be difficult for patients, because most of them don't speak Swahili." She glances over at the in-patient ward

> "Working at this hospital as a Maasai woman is very important to me and to my community. When I speak to patients in our Maasai language, it's easy for them to understand and to take my advice, but if nobody here was able to speak Maa it would be difficult for patients."
>
> —THERESIA MEPUKORI LAIZER

again. "Selian Hospital treats about one hundred people on an outpatient basis every weekday. Currently, we have a total of ninety patients admitted, including children and adults. Most of them are Maasai people who live around here, but we also have people from other regions. Some are even coming from Namanga, which is very far away. We also have some referrals from Moshi. When people hear about the services we provide here, they come. We treat patients who are struggling to afford medical care, and we have a big impact doing this work." Once she finishes, she gives me an affirming nod.

"It's a triumph that you are here as a pediatrician and a Maasai woman," I tell her. I swallow hard and blink back tears as I think about the difference she is making for Maasai kids who otherwise would not have access to healthcare. "I bet families are so happy when their kids are in your care," I say before moving along with, "Could you tell me about your typical workday?"

"My workday is usually very busy," she says. "I see patients in the wards who have been admitted. We have some who are admitted in the intensive care unit (ICU), some in the general pediatrics wards, and some in the neonatal ICU. So, for example, we might see twenty patients in the general pediatrics ward, maybe two or three in the ICU, and another nine or ten in the neonatal ICU. We have only two pediatricians in the hospital, and we have one general practitioner who works in pediatrics. Two days per week, usually Tuesdays and Wednesdays, we have the outpatient clinic. When one of us is running the clinic, the other one is doing the ward rounds and teaching the intern doctors. If we have visiting doctors, we also make rounds with them, so it can be very, very busy."

As she explains her full schedule, Dr. Laizer seems calm, as if she takes her days in stride. I think this must be a common characteristic of doctors—the ability to remain unruffled in the face of busy and often unpredictable and serious circumstances.

"Can you tell me what types of cases you're treating?" I ask.

"We see a wide range of conditions in the pediatric population at this hospital, but the major ones are respiratory conditions, like pneumonia, and acute malnutrition," she explains. "Children are malnourished because they aren't getting enough to eat or because they don't have a balanced diet."

I'm reminded of how many children in Tanzania don't have access to fresh fruits and vegetables, or to meat. Instead, families rely on foods like uji (a thin porridge made of ground maize), which they can grow or buy at low cost.

HEALTHCARE 87

"I know you work with children all day, but I'd love to hear about *your* kids," I say with a smile.

"Yes, my husband and I have two boys," she says. "They are twelve and ten years old. My firstborn, Joshua, tells me he wants to become an engineer. I show him my stethoscope and ask, 'Don't you want to become a doctor?' but he laughs and tells me, 'No, mom, I don't want to be a doctor.' I'm not sure if he will change his mind in the future, but between his father and me, we do have medicine in the family."

She cracks a broad smile. Then she hesitates, as if considering how to continue.

"I'd also like to tell you about my second-born, Caleb. He is ten years old now, but I gave birth to him prematurely, at only twenty-seven weeks. In Tanzania, this is really extreme. We say that a child can only survive after twenty-eight weeks. He was born when I was an intern at Mount Meru Hospital. I don't know if his premature birth happened because of all the stress, but that's what happened." Dr. Laizer's voice gets quieter as she remembers. "He was so small. He was like nine hundred grams [two pounds]. He stayed in the neonatal ICU at ALMC for almost three months. He survived, but with disabilities. He smiles. He laughs. He cries. He understands when we talk to him. But he cannot walk or talk himself. We're doing a lot of physiotherapy for him, and it's really helping. Of course, we want the best for him."

I contemplate this information for a moment, respecting the magnitude of what Dr. Laizer has shared with me, before I ask with some timidity, "Have your experiences as Caleb's mom influenced you as a doctor?"

Without pausing, she says, "Yes, absolutely. My stay in the neonatal ICU as a mother led me to specialize in pediatrics. As a doctor, I understand it when moms ask me to help their babies, especially in the neonatal ICU. In fact, I wish I could continue my studies to become a neonatologist."

"This is remarkable," I tell her. "*You* are remarkable." I am in awe of this woman. "Is there anything else you want to share with me?"

Dr. Laizer thinks for a moment before she tells me, "I want girls who grew up like I did to know that anything is possible. My mother passed away when I was only two years old. My father had five wives, and I was taken care of by a stepmother who had her own children to support. I had to do all the chores in the family. If we needed water or firewood, I was sent to collect it. If cooking or cleaning needed to be done, I was asked to do it. So, I was kind of mistreated. My life growing up was not easy, but look at my life now. If this is possible for

> *"I want girls who grew up like I did to know that anything is possible. . . . My life growing up was not easy, but look at my life now. If this is possible for me, it's possible for anyone. Study hard. Pass the exams. Anything is possible for Maasai girls when they are given opportunities."*
>
> —THERESIA MEPUKORI LAIZER

me, it's possible for anyone. Study hard. Pass the exams. Anything is possible for Maasai girls when they are given opportunities."

After I thank Dr. Laizer for her time and her candor, she walks us back toward the hospital's entrance. Along the way, we pass a young Maasai mother with a baby on her back, and I wonder to myself if she might be on her way to see Dr. Laizer later today. Only a few years ago, it wouldn't have been possible for a Maasai mama to talk with another Maasai mama who is also a pediatrician about her child's health.

Dr. Laizer is right. A new generation of Maasai children will grow up in her care, and she will show them that anything is possible.

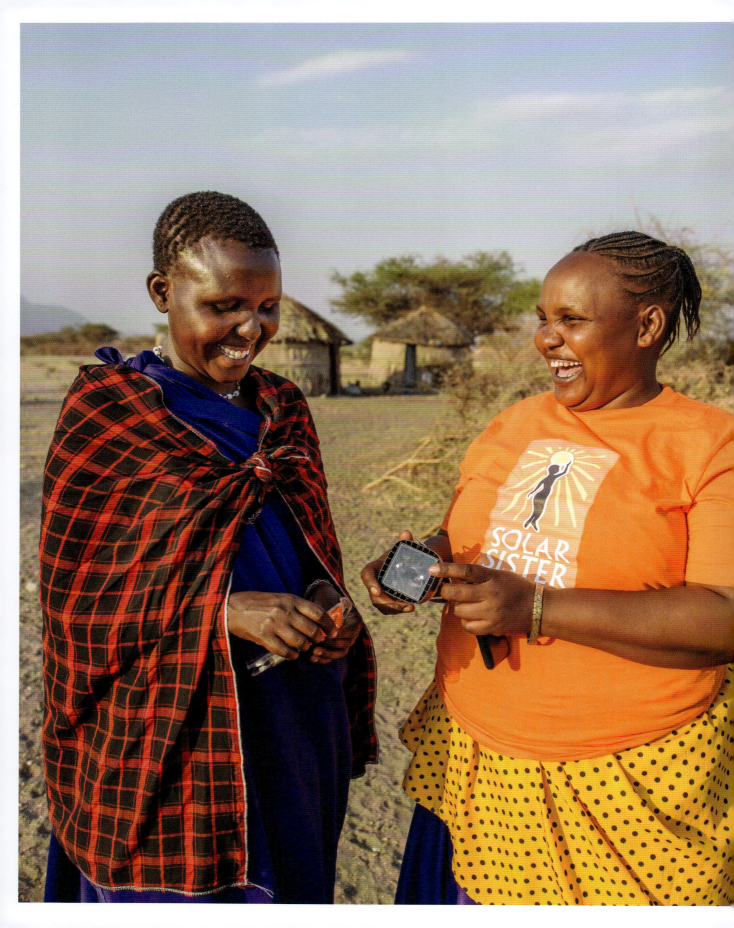

◆ NONPROFITS ◆

AGNESS JOSEPH POROKWA, 2004 GRADUATE, A-LEVEL

A Brighter World Led by Women

On a sunny Sunday afternoon, it's relatively quiet in Arusha's leafy Njiro neighborhood—a place where fancy supermarkets, salons, restaurants, and hotels cater to wealthy locals and expatriates alike. Located just southeast of downtown, Njiro has long been a regional center for Tanzania's nonprofit sector, which remains robust in the Arusha Region. Conservation, community development, and social service organizations provide critical services to people in need and advocate for the region's significant natural resources, which include not just the famous Serengeti National Park but also more than twenty other national parks and conservation areas that encompass nearly one-third of the country's land mass. Arusha's Njiro neighborhood serves as a springboard for much of this activity.

As we drive through the neighborhood, imposing gates guard sprawling bungalows and modern offices. Small local initiatives exist side by side with international heavy hitters, such as World Vision and the African Wildlife Foundation. Somewhere between these extremes is a modest-sized nonprofit called Solar Sister.

With a regional office in Njiro, Solar Sister works to fight energy poverty in Tanzania and other sub-Saharan African countries by promoting solar energy in places where people live off the power grid and are reliant on firewood and kerosene for cooking, light, and warmth—places where many Maasai people live. As the organization's name suggests, Solar Sister reaches these remote places in Maasailand and elsewhere by creating sisterhoods of local women who sell solar energy to their neighbors, creating a two-for-one impact by providing economic opportunities for women and bringing clean energy to places where people live in deep poverty and lack access to the power grid.

Solar Sister's two-story office building is located just a block off Njiro's main

thoroughfare in a quiet corner of the neighborhood. As if harkening to its very mission, the organization's office building is painted a bright sunshine color. It's surrounded by lush green trees and plants. Though largely vacant on a Sunday afternoon, the office has a vibrant, welcoming feel, as does the woman who walks up to greet us as we pull into the building's small, gravel parking lot.

MGLSS graduate Agness Joseph Porokwa is Solar Sister's program manager in Tanzania, and she's been expecting us. Dressed in a leopard-print top and black slacks, Agness's hair is cut into a short bob, her fingernails are immaculately manicured, and she wears a flattering, deep purple shade of lipstick. While her appearance projects modern professionalism, Agness's demeanor is friendly and soft-spoken, her smile warm and kind. As we stand in the parking lot, she introduces herself to the interview team and shakes each of our hands before leading us upstairs to Solar Sister's office.

While the videographer sets up his equipment, I take in Agness's place of work—a large, open room with desks and chairs scattered about to create a common workspace. Boxes of solar panels and lanterns are stacked around the perimeter of the room, and promotional materials adorn the walls. I can tell this is a functional, busy place that houses several employees; I suspect they spend as much time here as they do out in the field, well outside the comforts of Arusha's Njiro neighborhood.

Solar Sister's success is evident in the vibrant images that lend the room intimacy and purpose. Many women featured in the photos wear orange Solar Sister T-shirts. Some stand with their arms slung over each other's shoulders, big smiles on their faces. Others hold solar lanterns, visibly delighted to demonstrate their use. One image I linger on features two girls who I imagine are sisters. Though the background is dark, they are studying by the light of a solar lantern.

A poster behind the desk where Agness has taken a seat depicts the United Nations' seventeen Sustainable Development Goals. Even though I do not yet fully understand the work that Agness and Solar Sister are doing in Tanzania, it's clear that they're working toward several of these lofty international goals, including "affordable and clean energy," "gender equality," and "no poverty."

Agness watches me closely as I study the images around the room. She's eager to share about her work, and even before we begin the recorded interview, she starts telling me about the various people and groups pictured around the office.

"We recruit, train, and support women to be the suppliers of clean energy in their communities," she says as she points to a picture of five women gathered in a happy-looking group. "These are participants in one of our training seminars."

I ask her to tell me more about the women in the photograph. She looks at the image as she speaks, and I can tell by the soft expression on her face that she knows these women and their stories personally. "Imagine you are one of these women who wakes up and goes to bed without

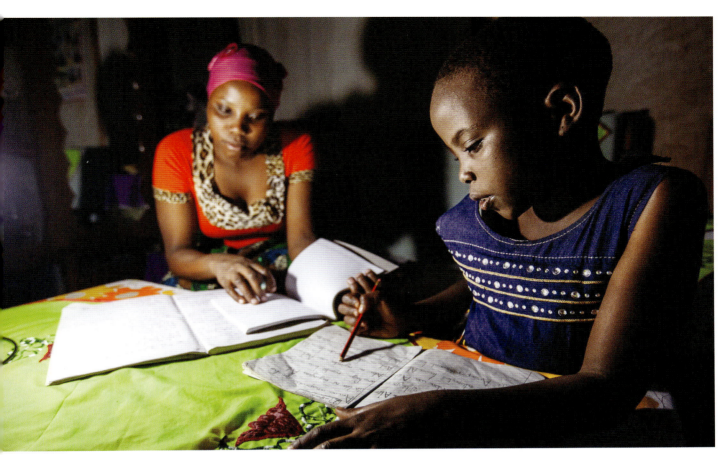
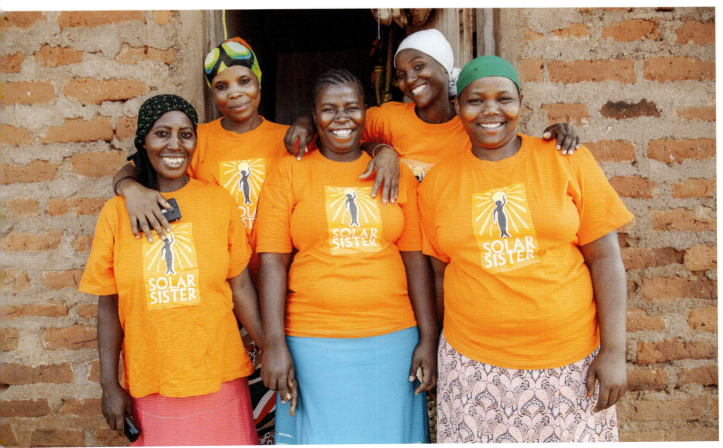

reliable power. To make dinner, you must start early, because it takes time to collect wood to make a fire. Your eyes sting and your lungs hurt from the woodsmoke every day. You wash dishes in the dark by the light of a kerosene lamp. The burden of energy poverty falls on these women"—she points at the image again—"but at Solar Sister, we are changing this."

A wide smile extends across Agness's face and her eyes light up. With this brief introduction to her work, she's hooked me. I want to know more about how Solar Sister is changing the equation for the women whose images surround us. We're ready for the interview at just the right moment, and as the camera starts to roll, I prompt her, "Tell me about your work at Solar Sister."

Her eyes still alight, Agness begins: "I work as a country program manager at Solar Sister Tanzania. We are working across the country with women to eradicate poverty through the clean energy industry. How do we do this? We have employees in every district. We call them business development associates. Their job is to recruit, train, and support women. The women we recruit live in places without electricity. Only 63 percent of Tanzania is covered by electricity, so there are many places that are totally untouched. They have no government services or hospitals or electricity. We go there. We spend time with women, and we teach them the benefits of solar energy." She picks up an orange lantern with a solar panel on top. "For example, this small solar lantern costs 12,000 shillings [about $4.60]. If a woman buys this lantern, she can save on the cost of kerosene every day and use that money for something else. She will bring cleaner air into the house. She can extend the hours for her children to study. She can have extra hours to do her work."

Agness points to another image on the wall, this one showcasing five women, each of them holding a different part of a solar system. One has a small solar panel; two hold LED lamps; another has a battery; the last holds a cluster of charging cables. "For a woman who can buy a phone-charging product like this one," Agness says, pointing to the woman holding the cables, "she can make money by charging the phones in her community. She can charge ten phones each day for 200 to 500 shillings each, and that's a little bit of income [about $2 per day]. In the village, that's actually not a small amount of money. It can buy something else to support the family."

I quickly grasp the ways in which a single solar lantern or a small solar system can improve life for a woman who lives without electricity. I want to know more about how Solar Sister is creating networks of women entrepreneurs who are more broadly promoting clean energy in Tanzania, so I ask Agness to tell me more about that aspect of the organization's work.

"Solar Sister does not manufacture solar products," she explains. "We buy from suppliers that provide a two-year warranty, so we make sure our solar products are reliable. We buy the products and then sell them at a reduced price to women who are interested in starting clean energy businesses. Our prices ensure

that entrepreneurs will make 18 to 20 percent on each product they sell. These women are already embedded in remote communities or places where people can't afford to connect to the power grid, so they are perfect ambassadors for clean energy. These women are trying to create a change. They are improving life for other women and families."

She shows me a black bag with a Solar Sister logo on the front. She pulls out promotional brochures, a receipt book, and a cash bag. "Our entrepreneurs get all the tools they need to start a small business. They are trained in a sisterhood group of five to ten women. They go through twelve modules that are designed to help them grow a business while also building their confidence. Every month has its own specific topic. So, the women benefit personally from using solar power, and then, by creating a small business, they benefit even more. Beyond this, they gain courage and confidence. We build leaders in the community. They inspire each other. We see the difference. We see how women are transforming from one stage to another."

When she pauses to catch her breath, I find myself so inspired by her work that I can't help but interject, "Agness, you must be so proud of your work. It's clear you are changing lives."

She smiles bashfully and looks away, but her enthusiasm has already said it all. She obviously finds her work rewarding and is delighted to share Solar Sister's innovative model—one that brings electricity to women but also gives them newfound skills and confidence. I know that Solar Sister serves a population of women

"Our vision is to see a brighter world led by women. That's what we really want to see. It doesn't matter how long it takes, but that's the vision."

—AGNESS JOSEPH POROKWA

who have had few opportunities for growth and success; I suspect the sisterhood model provides a source of encouragement even beyond what I can imagine, and I can't help but reflect on the sisterhoods that have uplifted me over the years. "There isn't much a group of women can't do when they put their heads together," I say to Agness, and we both smile because we know it's true.

Agness places her hands on the desk in front of her. "Our vision is to see a brighter world led by women," she says with passion. "That's what we really want to see. It doesn't matter how long it takes, but that's the vision. That's what we want to see." She nods and smiles, letting a little silence surround that statement.

As a segue into talking about her life before Solar Sister, I ask Agness if her upbringing prepared her for this work.

"The village where I grew up is called Emboreet," she tells me. "It is in the Simanjiro District of the Manyara Region, and many people there struggle with poverty, so of course I understand the challenges many women face personally. When I was a young girl, I really wanted to go to school, but it was difficult to get money to pay for it. My mom and dad believed in education and wanted me to be educated, but

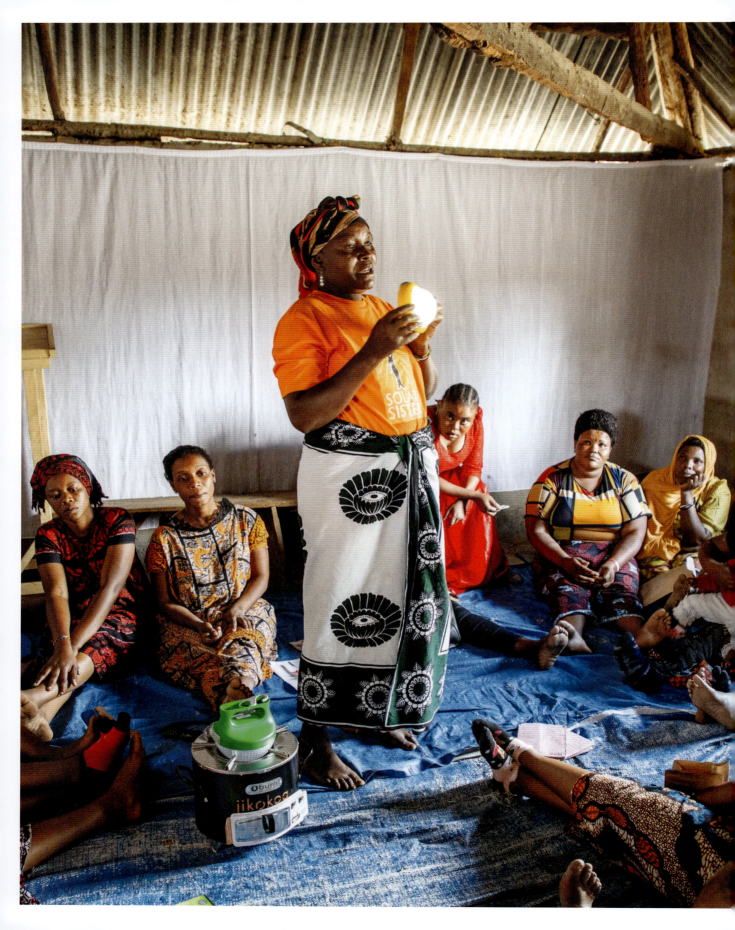

the challenge was income. We had no money. We had no cows. We had no support. When I graduated from primary school, I was asking, 'What's next?' Fortunately, I was selected for a scholarship at the MGLSS. I was among the lucky ones who got the chance to pursue an education and gain other skills. Who would have thought I would go to college and study community and gender development? Among the Maasai, not many girls get the opportunity to go to school, so you can spot them."

While it is difficult to gather accurate demographic data about the Maasai, most estimates suggest that fewer than 50 percent of Maasai girls enroll in primary school, and only 10 percent of girls make it to secondary school. Most Maasai girls are circumcised between the ages of eleven to thirteen, and soon afterward they are married to a man of their father's choosing in exchange for cattle and cash. Even with all the progress the MGLSS has made in educating Maasai girls, I know Agness is right—it is still difficult for the vast majority of Maasai girls to attain an education.

"Those few girls, they really need to go back to the community and contribute in a positive way," Agness says. "This is what I'm doing through Solar Sister."

Like most graduates of the MGLSS, Agness feels her education requires more of her—that with her good fortune has come a responsibility to give back to her community so that more Maasai girls can have the opportunity she had.

"In my home district—Simanjiro District— we gave seven midwives big solar lanterns," she says. "This is an example of women helping more women. The midwives can help women who are delivering at night. The impact is exponential. In 2020, a donor gave one hospital in every district a solar system. That had a big impact. I can't do what the MGLSS is doing, but I can at least do something for the community, even if I'm touching only one person's life. At least I'm helping. That is my dream for my two children, too, that they grow up willing to change somebody's life. That is what I pray for them."

As we close the interview, I tell Agness how inspired I am by her work. She and Solar Sister are changing people's lives across Tanzania—2.3 million of them, in fact, which is the number of people Solar Sister has reached since its work began in 2013. Together, Agness and a sisterhood of women are lighting the way, literally transforming poverty into power.

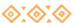

NONPROFITS 99

SELINA NGURUMWA, 2006 GRADUATE, A-LEVEL

Pioneering Solutions for Women and Girls

Though we are in Selina Ngurumwa's comfortable, one-room office in Arusha, fresh air and sunlight streaming in through an open window, it's not difficult to imagine a more challenging time and place in Selina's life. As she transports me back in time to her childhood, I picture her twenty-five years ago as a tall, thin child. In my mind's eye, she is dressed in an unadorned version of what she wears today—traditional red-checkered mashuka and Maasai beadwork. As the eldest of seven children, I imagine her surrounded by younger siblings in a traditional Maasai boma. I can picture her hardworking mother cooking over an open fire, crouched over a pot, woodsmoke drifting in the air around her.

I've asked Selina to tell me about her childhood, and she has started by telling me about her mother.

"My mom was a very courageous woman with a beautiful heart," she says. "She had seven children, and she wanted them all to be educated. When I got the chance to go to school at the MGLSS, my lovely mom went through a lot of violence. It is really because of her that I am who I am today. Otherwise, I would not have had the chance to go to school."

Though she has a warm, friendly presence and a ready smile, around Selina's eyes I can see the telltale signs of grief, as if she is holding back emotions that are too difficult to share. Nonetheless, she forges on.

"When I was very young, my father received a dowry for me. Once I completed primary school, he believed it was time for me to get married, but my mother disagreed. I was her firstborn, and she wanted me to go to school. She went to the head teacher at my primary school and shared my situation with him. She knew I was in danger of being married off. The head teacher talked to a local pastor, and that pastor came with the police to my boma. Even at that time, marriage was not legal before the age of fifteen. The pastor took me to the

MGLSS, where I would be safe and could continue my education." Selina sighs deeply and wrings her hands. "So, I was rescued from an early, forced marriage, but that situation caused a big problem for my mom. She saved me, but my father beat her until she was forced to leave home. For a time, she lived with her parents again. She had no other options. We both suffered a lot during this time. Later, a few Maasai elders worked to reconcile my parents, according to our culture and traditions, but I'm sorry to tell you that my lovely mom passed away three years ago."

From the expression on Selina's face and the deep gulp she takes after she tells me this, I know she misses her mother profoundly.

"Unfortunately," she says, "this situation is still going on within the Maasai community. We operate in a system where men dominate everything. If a woman faces violence at home, she must endure it. She cannot speak out. She cannot own property. She has no way to support herself. And many young girls are still being forced into marriages. These are the reasons I started Pioneer for Women and Youth Transformation (PIWOYOT). We are a nonprofit that supports women and girls that are going through situations like the ones my mother and I went through."

I ask Selina to tell me more about PIWOYOT, an organization she founded with four other Maasai women in 2018 after she completed a master's degree in community economic development.

"My dream when I completed my education was to give back to my community," she

> *"My dream when I completed my education was to give back to my community. Through PIWOYOT, I am supporting women, widows, marginalized girls, and the community in general."*
>
> —SELINA NGURUMWA

says. "Through PIWOYOT, I am supporting women, widows, marginalized girls, and the community in general. The organization is working in three core areas: livelihood, education, and health. We currently work in Sepeko, Lepurko, and Engutoto—three villages in the Monduli District where many Maasai people face hardship because they have few opportunities."

Selina's traditional Maasai beadwork hangs loosely around her neck and makes a light tinkling sound as she leans forward, eager to tell me more about the programs. There is an intensity about her now—a singular focus.

"In the livelihood area, PIWOYOT focuses on women's economic empowerment. We started a microcredit program, which we call a village community bank (VICOBA). We've mobilized women to form savings groups. We train them on financial literacy and teach them entrepreneurial skills. Later, we support them with seed capital to start small businesses. For example, some of them grow vegetables they can sell. In the prolonged drought, we've supported some women with simple drip irrigation systems. Once those businesses are earning money, the women can save it within

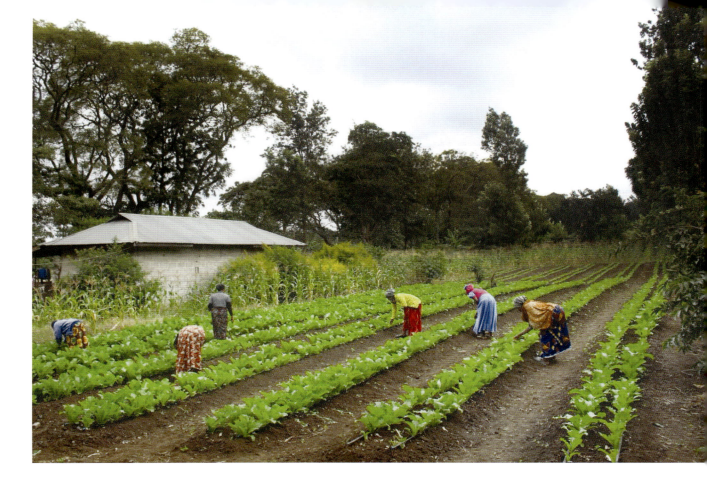

their VICOBA groups and lend it to one another. This gives women some economic independence. It allows them to support their families, to send their children to school, and to buy simple things like pencils, exercise books, and school uniforms."

I imagine how life would have been different for Selina's mother had she had access to some measure of financial independence—something that's so far out of reach for too many women worldwide. But Selina is changing that for the next generation of Maasai women, and she isn't stopping there.

Remembering that VICOBA is only one pillar in PIWOYOT's programs, I prompt her, "Tell me about your nonprofit's work in the areas of education and health."

"Through our focus on education, PIWOYOT has created health clubs in schools," she explains. "We educate girls about issues that can affect their health with a particular focus on menstrual health. In the Maasai community, parents don't talk with girls about menstruation, so you find that girls won't attend school during their menstrual periods. They don't have any help when it comes to managing this, so PIWOYOT supports them by providing reusable sanitary pads. We also talk with them about the effects of early, forced marriages. We tell them to be confident to say no. We teach them songs and dances with messages they can share with the community during parent day or at the local market as a way of changing attitudes.

Women and girls need knowledge about their reproductive health and the importance of prenatal care. Mortality cases among moms and babies are still too common in the Maasai community, so we offer these health education programs too."

Selina remains radiant, upbeat, and unassuming as she talks about her work. One might expect her to carry some hint of resentment, but to her, it seems, this work is less a fight and more an offering of hope.

"PIWOYOT also has a scholarship fund that supports girls who are going through situations like the one I went through at home," she says with evident pride. "This year we supported five girls who came from two primary schools where PIWOYOT has health clubs. The teachers reached out to PIWOYOT, asking for help. The girls were selected to join secondary schools in Monduli, but their parents were financially unable or unwilling to support them. Our scholarships enabled them to join secondary school. This was my dream, really—to give girls an opportunity like the one I got at the MGLSS."

I'm curious how Selina's family sees her now given the challenges her mother faced when Selina went to school. "I know your mother is no longer living, but how does the rest of your family feel about you now that you are an educated Maasai woman?" I ask.

"Before I went to the MGLSS, my family felt that education was nothing," she says soberly. "It just encouraged girls to lose their way and leave the community. They wanted me to fail and said, 'She won't even finish Form Four.' I prayed to God to help me because I knew He had a purpose for me. Once I finished my education and got a job, I started supporting my younger siblings so they could go to school. There are six of them. We now have two with university degrees, two with diplomas [like a community college degree in the United States], and another one who is still in secondary school. He is studying physics, chemistry, and biology because he wants to be a doctor. I sometimes support my siblings' children too, even though I have four children of my own—one girl and three boys. I want them to be able to fulfill their goals. I have shown my family that women can support their families, and now they see education is important."

I press Selina a little further because I am curious about her dad, given the difficult relationship her mother had with him. "Did your dad ever decide to support your education?"

She looks off into the distance before simply saying, "My father never supported my education." She hesitates, as if deciding how to continue, then says in a low voice, "Once I finished my university degree and got a job, the elders brought my father and me together. It was difficult, but he finally blessed me. From that time, we became friends until his death. I do thank God for the life of both of my parents. May their souls rest in peace."

Selina's calm expression and soft smile tell me she has made her peace with this too. In fact, I suspect she claims this history as a strength rather than a weakness.

As we close the interview, I think about the name this trailblazing young woman chose for her nonprofit organization, and what it means to be a pioneer. Pioneers overcome obstacles and see potential where others see uncertainty or even danger. They are innovators who advance new ideas and push boundaries. They are rare, and they often change the course of history.

The Maasai leaders who established the MGLSS thirty years ago were pioneers in their time, advancing the idea that educating Maasai girls would radically improve life for all Maasai people. Today, I see the seeds of that effort at work in Selina—a pioneer who survived her own challenges to blaze a trail for other Maasai women and girls.

JOYCE MICHAEL SYOKINO, 2002 GRADUATE, A-LEVEL

An Advocate for Her People

When I search through my memories of teaching at the MGLSS, I see myself at the front of a Form Four classroom. I'm twenty-five years old, and the room is filled with more than forty young Maasai women who aren't that much younger than me. Sitting behind their desks, they strike me as a reserved, quiet group. Some assess me with friendly curiosity. A few seem tired or bored. Those in the front row wear eager expressions; one or two at the back look confused. Though they've been studying English for nearly four years, my American accent is still difficult for them to understand, and I must remember to speak slowly.

I try not to show it, but I am overwhelmed. I know my students' lives, first as Maasai girls, now as young Maasai women, have been radically different from my upbringing, and I fear my teaching methods may be too foreign or that my tenure as a young English teacher fresh out of university is too short. Mostly, I feel out of my depth—but nevertheless, I tell myself to roll up my sleeves and do my best.

In the middle of this group sits Joyce Michael, who offers me an encouraging grin as if she senses my insecurity in this group so different from me. She's a thoughtful young woman who always seems to be paying attention. When I ask a question, she politely raises her hand and then stands to answer, as is customary in Tanzanian classrooms. She is smart and always responds correctly. Though Joyce wears a school uniform like all her classmates, her appearance always seems tidier than most. Her serious demeanor belies a smile that can light up the room, and her laugh, though rare, is contagious. For all these reasons, her classmates view Joyce as a leader.

This is how I remember Joyce, so when she walks into the lobby of the hotel where I am staying in Arusha, I recognize her immediately. It seems as if she hasn't aged at all. As in the past, she remains formal and

restrained, yet friendly, and so is her greeting today. Her warm smile brightens her face as she shakes my hand.

After our brief greeting, we find a peaceful spot in the hotel's garden for the interview. Today Joyce wears smart khaki slacks, a white blouse, a fuzzy pink scarf, and pearl earrings. Her hair is clipped short, much like it was when I knew her as a student, and her appearance remains just as buttoned up as I remember.

When our videographer is ready, I start by asking Joyce to tell me about her childhood.

She tilts her head and smiles as she reflects on her past. "I grew up in Engarenaibor, in the Longido District, near the Tanzanian border with Kenya. Just like others in my culture, I was raised in a boma with a big family. I didn't grow up in one house with just my parents like many people who live in town. It was a village. We were so many children in one boma. We were one family, but this included many uncles and aunties."

"Did you face any challenges as a child?" I ask.

She responds simply and directly. "At the time I didn't think of my life as challenging, because I was growing up in my culture, the way my family raised me. I didn't encounter challenges that were different from other children in my village."

She shrugs, which conveys to me that her only value judgment about her childhood is that it was beautifully and perfectly Maasai, so I move on by asking, "Can you tell me how you came to the MGLSS?"

"My dad was a counselor [a local leader], so he had a role to play in ensuring the children in his division had an opportunity for education. Therefore, when I passed my class seven exams, my dad found a place for me at Moringe Sokoine Secondary School in Monduli. I went there for two or three months before he told me he'd found a spot for me at the MGLSS. At that time, the school was just being built, so that's how I was in the first class at the MGLSS."

"It sounds like your dad understood the importance of education at a time when many Maasai parents did not," I observe. "Why do you think this was?"

Joyce considers my question before responding, "He had a diploma from Mweka College, which is also known as the College of African Wildlife Management, so he was educated himself. Still, he was a Maasai man who didn't see the importance of selling his cows to support his children's education, but he was a local leader and this was his responsibility, so I was lucky to get the chance to go to school."

I ask Joyce to tell me more about her time at the MGLSS.

"It was a new experience for me, coming all the way from a remote Maasai village to the MGLSS," she says. "That was my first time living with Maasai girls from many other villages. It was also my first time to meet . . . we call them wazungu (white people)." She laughs. "I couldn't understand anything about them. I was like, 'Oh, what are they saying?'" she declares with an incredulous expression. "I remember my

first English words were 'yes' and 'no.' So it was really a different experience from my life back in my village. I appreciated the opportunity I had at the MGLSS. I don't take my experiences there for granted. I benefited quite a lot."

"Did you continue your education after the MGLSS?" I ask.

"I did," she says with a nod. "I attended Tumaini University in Iringa, where I completed a law degree in 2006. When I finished law school, I found a job in Dar es Salaam working as a legal officer, but I kept looking for a job closer to home because I was very far away. When I saw a job posting at Longido Community Development Organization (LCDO), I applied for the job, and I got it. They immediately started me as a program officer, then later they upgraded me to a project manager. I'm working with my people, exactly with people from my home village and other villages in the Longido District. So, I'm absolutely serving my people."

Joyce looks happy and proud to be doing this work, so I inquire further about what her job entails.

"LCDO is a local NGO that works with Maasai people in all the villages in the Longido District," she explains. "I work as a manager, but I also work on legal issues. We don't need to employ an outside lawyer because if we have legal issues, I can advise on these issues and make things happen. We have different projects. One is a livestock business. We look for good livestock markets because, as you know, the Maasai raise cattle and goats. LCDO helps the commercial leaders of different groups to look for the best livestock markets, especially across the border in Kenya. We live very close to the border, and we let groups know where there is demand."

I can see how useful it would be for Maasai people to have an organization working across borders to facilitate these exchanges.

"We also work on water projects," she continues. "Access to water can be challenging for many Maasai villages in this region, so LCDO works to rehabilitate or construct water sources. It is important that we work with the communities we serve to propose solutions that reflect their needs, so we collaborate with stakeholders and individuals. Some of these stakeholders and collaborators are graduates of the MGLSS. We worked with Martha Ntoipo, who was in my class, as our field officer. We also worked with Community Research and Development Services, where Lilian Joseph is the executive director. She was also in my class. Happy Sande is the finance manager for Sauti Moja, and LCDO also collaborates with them. The MGLSS has

"The MGLSS has many, many graduates in the Longido District. For sure, we are impacting this area a lot. . . . We often see each other at public forums. We tell stories about going to the MGLSS. That school has really benefited our community a lot."

—JOYCE MICHAEL SYOKINO

many, many graduates in the Longido District. For sure, we are impacting this area a lot. We have teachers. We have nurses. We have lawyers. We have doctors. We often see each other at public forums. We tell stories about going to the MGLSS. That school has really benefited our community a lot."

I tell Joyce it's no surprise to me that she is a leader among other leaders from the MGLSS. She smiles shyly and acknowledges my compliment.

"I appreciate the education that I and the rest of the girls received at the MGLSS," she says. "Their work is really good, and it's not taken for granted. It's recognized by us."

I want to know more about her family, so this is where I direct her next.

"I have been married for sixteen years," she shares. "My husband is also a lawyer. We met at college. He works in the legal department at the Prime Minister's office. We have five children. I pray they are going to be good women and men with opportunities to do what they really wish to do, just like their mom." She offers up a broad smile.

After the interview, I walk with Joyce to her vehicle. As I watch her drive away, I reflect on all the ways she is just as I remember. Even as a student at the MGLSS, she seemed older than her years, but now her age matches her mature disposition. She has grown into a seasoned leader, a mother, a lawyer, and an advocate for her people.

Much later, when I am back home in the United States, I go looking for a photograph that I suspect must be in a box somewhere

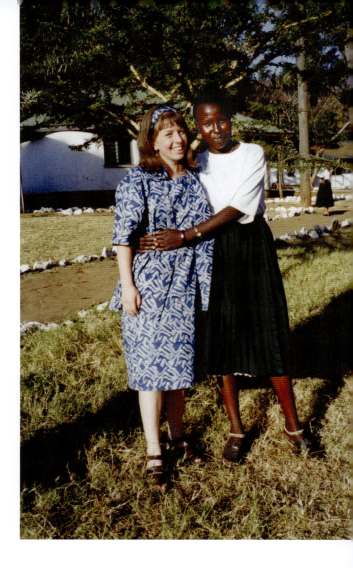

in my basement. When I find what I'm looking for, I smile. There is Joyce on the day of her Form Four graduation—the very first graduation at the MGLSS. She hugs me from the side, the distinction between teacher and student disappearing. Here we are, just two young women encouraging each other. Right before the photograph was taken, she had literally lifted me off my feet in an uncharacteristic show of emotion. Hope floated in the air that day, the future stretching out before Joyce and her fellow graduates in ways it hadn't before for most Maasai women.

None of us could have predicted what life would bring, but for Joyce it has brought rich opportunities to remain rooted in the community where she grew up, working to promote the most traditional of Maasai livelihoods—one that revolves around livestock and the mutual need of Maasai people and their cattle and goats for reliable sources of water. No doubt Joyce's work cannot be easy during these challenging and changing times for the Maasai people, but she is the right woman for the job—a leader deeply committed to preserving her culture into the future.

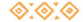

ZAWADI JOSEPH, 2004 GRADUATE, A-LEVEL

Protecting the Rights of Miners and Mining Communities

I remember the first small-scale mining operation I saw in Tanzania and the way it made me feel, for human suffering can seldom be witnessed without leaving a lasting impression.

In 1999, I was traveling from Dar es Salaam to Morogoro in central Tanzania. From the roadway, I observed an open rock quarry cut into the side of a limestone plateau. On an unstable hillside, two young men wielded pickaxes lobbing off large chunks of rock. Nearby, several women squatted with hammers in their hands, manually breaking the rock into smaller pieces. Once broken up, the cobble was collected by the women in large buckets they couriered over dirt paths to aggregate piles at the base of the quarry. From these piles, two men with shovels loaded a truck that I assumed was transporting the rock to a nearby market or construction site. None of the workers wore hard hats, work gloves, or safety glasses. A chalky, white powder covered everyone's skin and clothing. The men appeared exceptionally thin, yet surprisingly strong. Several of the women wore only flip-flops on their feet.

I recall watching this backbreaking, dangerous work with a mixture of horror and sadness, followed by respect. I understood these workers were doing what they must to feed themselves and their families, yet I also assumed they earned very low wages and worked without benefits or breaks in obviously hazardous conditions. The picture of those workers and the injustice of their situation left a searing memory I haven't forgotten to this day.

So, it isn't surprising this memory comes to mind as I sit down with Zawadi Joseph in her office at the headquarters of HakiMadini, a nonprofit organization located in Arusha that advocates for the rights of mine laborers, as well as the rights of communities affected by mining activities. Zawadi serves as the executive director of HakiMadini, a role I suspect requires collaboration with a broad cross-section of stakeholders in government, industry, and

communities across Tanzania. Today, she wears a brown-and-white patterned dress and a black overcoat. I imagine her warm smile, soft-spoken nature, and approachable demeanor serve her well as she works across what must be diverse and often divergent interests.

Once the camera starts to roll, I thank Zawadi for her time and ask her to tell me about her work at HakiMadini.

"I have been working for almost thirteen years at HakiMadini," she tells me. "For the first nine years, I worked as a program officer, and then I was promoted to executive director in 2020. HakiMadini works for the rights of artisanal and small-scale miners who are not recognized by our government and for the rights of marginalized communities that have been adversely affected by big multinational mining companies who have invested in Tanzania's mining sector."

"Could you explain what you mean by artisanal and small-scale miners?" I ask.

Zawadi nods. "Artisanal and small-scale mining, or ASM for short, tends to be carried out by people who have little training in mining and no access to formal credit, like commercial bank loans. ASM is often practiced illegally in poor, rural areas on small mineral deposits. It's labor-intensive, because miners have no resources to purchase machines that could make the work easier, and it is often characterized by low standards of health and safety. It can also impact the environment. Artisanal miners engage in mining to earn a minimal wage, while industrial mining, which is much more organized and regulated, is driven by large-scale profits. Still, ASM has the potential to increase people's livelihoods. In Tanzania, ASM has always run parallel to large-scale mining operations. Mining in Tanzania is a major and rapidly growing part of the economy. About one million people are involved in ASM across the country, compared to only fifteen thousand who are employed by large-scale mining companies."

"How is HakiMadini improving conditions for these workers?" I ask.

Zawadi smiles as she considers my question. "Artisanal and small-scale miners have always faced challenges, including limited access to mining land; few options for loans and financing; long delays to register mining licenses; inadequate education to improve mining techniques, safety, and care for the environment; and poor access to markets for selling their products. But for people with few other options, ASM provides some income with the potential for big payouts for high-quality gemstones and gold. HakiMadini collaborates with the government and other stakeholders to empower people to employ better mining techniques; to help them access reliable, fair markets; and to educate them about regulations and programs that protect the environment and people's health and safety. HakiMadini advances these goals through policy reform, development projects, research, and education. This involves directly engaging government agencies, policymakers, unions and mining associations, financial institutions, local and international nonprofits, and small-scale mining communities to advocate for a safer

and more productive ASM sector. Side by side with this effort, we do advocacy and legal work for communities that are impacted by mining so that they know their rights."

"Can you give me an example of this work?" I ask as I consider the complexity of Zawadi's occupation, which clearly involves many different levels of engagement with local to federal governments who develop and enforce mining policies and regulations, with local people who need help understanding their obligations and rights, with miners who need to know how to operate sustainably and safely, and with a range of stakeholders who have investments in what must be a lucrative sector for those that strike gold, so to speak.

"I have been working with communities in the Manyoni District, where land has been grabbed by Shanta Gold Mine without the consent or fair compensation of local people," she says, eyes flashing. "As an organization, we helped the affected communities understand their rights and empowered them to speak out. After our engagement there, the communities were compensated for the loss of their land to mining activity. As an organization, HakiMadini also advocates for women's land rights in mining areas and their engagement in mining. We want to make sure women have opportunities for leadership in the extractive sector, even though it remains a male-dominated field. For example, about 30 percent of artisanal mining for colored gemstones like tanzanite is done by women, but they often see few of the profits because they don't have leadership in the mines."

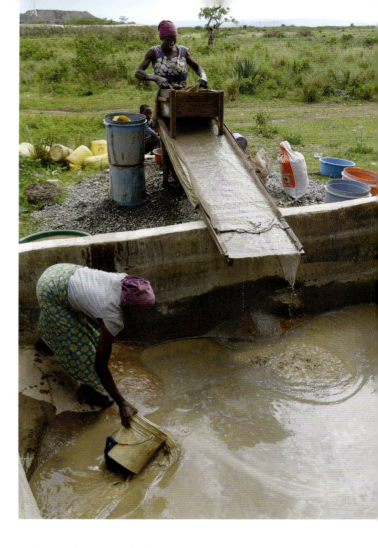

Though Zawadi's demeanor remains friendly, I can see a steeliness in her as she speaks about the specifics of working with people whose rights are threatened simply because they may not have the knowledge nor the resources to represent themselves well.

"You mentioned tanzanite, which I know is found in northern Tanzania," I say. "Can you tell me what other resources artisanal and small-scale miners are mining?"

"We work in eleven regions in Tanzania where there are mining activities, and our focus is on gold (pictured above) and gemstones, such as tanzanite," she explains. "However,

NONPROFITS 115

Tanzania has many types of gemstones beyond tanzanite. We also mine diamonds, rubies, garnets, emeralds, and sapphires. Though we don't deal with it as much, there is also mining for building materials, such as stone aggregates and sand; energy minerals, such as coal and uranium; and metals, such as iron, silver, copper, platinum, nickel, and tin."

"You know a lot about mining," I observe. "How did you become interested in this?"

Zawadi laughs lightly. "To be frank, I was not even aware of the mining industry before I joined HakiMadini. In 2007, I completed a bachelor's degree in law at Tumaini University in Iringa. After that, I volunteered at the Legal and Human Rights Centre in Arusha for several months. The executive director there took my CV and told me he would connect me with anyone who might be looking to employ a lawyer. I had to wait some time at home until I received a call from the Legal and Human Rights Centre asking me if I was still looking for a job. In short, I joined HakiMadini through the recommendation of the Legal and Human Rights Centre. Initially, I was doing a lot of legal empowerment and advocacy work for artisanal miners and the communities around mining, so that was my introduction."

"Your work is very unique and interesting," I say. "I've never met anyone who works in mining, and I've always wondered about that sector in Tanzania. I'm curious if there is mining where you grew up?"

"I grew up in Karatu, near Ngorongoro, and yes, gold extraction is happening in the Endabash Ward in Karatu." She nods.

"HakiMadini did one project on empowering women there."

"Can you tell me a little more about your upbringing and how you ended up at the MGLSS?" I ask, wanting to know more about how she got here.

Like so many of the women I've interviewed, Zawadi pauses for a moment to consider her response. I can imagine it's easier for the women I've interviewed to discuss their professional achievements than it is for them to reveal their personal histories and the challenges they've faced in the past. Nevertheless, they've openly and willingly shared, and Zawadi is no different.

"I come from the Barabaig tribe," she begins. "The Barabaig migrate with their livestock like the Maasai. They are nomadic in that they follow a grazing rotation around the Hanang Plains and beyond. Nowadays they live by hunting, farming, and animal husbandry. Like the Maassai, the Barabaig are polygamous, and marriages are arranged by parents after agreeing on a bride price. Boys and girls must undergo the terrible rite of initiation into adult life, which involves genital mutilation, practiced on girls and boys. The Barabaig have a clear distinction of tasks between men and women. Women take care of homes, food, and children. So, this is how I grew up. My parents did not recognize the importance of education, so after I completed primary school, they thought I would get married instead of continuing to secondary school. When I got the chance to go to the MGLSS, I can say that chance totally changed

my life. Without the MGLSS, I wouldn't be here today. I would probably be a mother with ten kids and looking so old already from struggling with a poor life."

From Zawadi's expression, I can tell it isn't difficult for her to imagine a different path for her life, one she knows would have resulted in hardship and suffering. "So how did you end up at the MGLSS?" I prompt again.

"My pastor linked me with other students from Mang'ola in the Karatu District who were attending the MGLSS," she explains. "He talked to my parents and advised them about the importance of going to school. I remember my mom was a little bit afraid, but because it was our pastor, she and my father did not oppose him and trusted him. I have four siblings and none of them had the chance to go to secondary school, so I was very fortunate."

"Do you have children of your own?" I ask.

"Yes, I have one boy and one girl. They are both in school, because I want them to have the tools to support themselves and others too." She shares this last bit of information with clear pride.

With this, the formal portion of the interview ends, and Zawadi escorts the interview team outside into the bright afternoon sun. Before we depart, she takes my hand and thanks me for my interest in her work.

"I want people to know graduates of the MGLSS like me are working for the community," she tells me. "I feel I must return something to the community where I came

> "I feel I must return something to the community where I came from and other communities beyond where I came from, too. Because I was supported by people who didn't know me, so too I must support others, even those I don't know."
>
> —ZAWADI JOSEPH

from and other communities beyond where I came from, too. Because I was supported by people who didn't know me, so too I must support others, even those I don't know. That's what I'm doing here at HakiMadini."

I smile and congratulate her on her valuable and necessary work on behalf of people in need.

As we pull away from HakiMadini, I reflect on the miners I saw near Morogoro so many years earlier. In the late 1990s, HakiMadini started as a reaction to the human rights abuses that were occurring in mining communities at that time. I'm moved to know that other people saw what I saw and sought to protect vulnerable people and communities and to advocate for a more equitable distribution of Tanzania's abundant natural resources. Today, Zawadi, whose name translates into English as "gift," is paying it forward, using her education and her skills to advocate for the rights of artisanal and small-scale miners and mining communities. And that is indeed a gift.

PAULINA MESARIEKI, 2005 GRADUATE, A-LEVEL

Mentoring the Next Generation

In a quiet residential neighborhood on the west side of Arusha, the interview team pulls up to an imposing metal gate—the only apparent opening in an eight-foot-tall security fence that surrounds a property several acres in size. As we idle outside the gate, it opens only a crack. A commanding Maasai morani exits and swiftly strides toward our vehicle.

Clad in traditional red-checkered mashuka, the Maasai man looks to be in his late thirties and stands at least six feet tall. His muscle-bound arms and serious assessment of our vehicle leave the impression that he has both the wherewithal and the inclination to deny most people access through this gate, which he is clearly guarding.

We have arrived at the Emusoi Centre, a place that provides safety and support to vulnerable young women who come from pastoralist and hunter-gatherer communities, such as the Maasai, Barabaig, Datoga, Hadzabe, Taturu, and Ndorobo. These cultures all face rapidly changing social and environmental conditions and regional development policies that threaten their nomadic and indigenous ways of life. The Emusoi Centre's primary aim is to help young women from these communities. They do this by offering them access to education, which directly supports them to better cope with the changes their families and cultures face while also empowering them to escape the conditions of deep poverty most of them have endured from birth—conditions like not having enough to eat, or wondering where they might next find water, or watching a sibling die of malaria, diarrhea, or pneumonia, all leading causes of childhood death in these communities.

While the Emusoi Centre is not a school, it does offer tutoring, mentoring, scholarships, housing, and other support services that prepare young women who come from remote places to enter Tanzania's multicultural education system, whether that

means secondary schools, vocational training programs, certificate courses, or universities. Many of the young women at the Emusoi Centre have experienced gender-based violence, which explains the tight security we've encountered at the front gate. Creating a safe and supportive environment is critical to the Emusoi Centre's mission.

Our driver, Festo, tells the Maasai guard that we have a meeting with Paulina Mesarieki, a staff member at the Emusoi Centre. At this news the guard's expression softens slightly, but he still tells us to wait while he confirms our appointment. We watch as he turns on his heels and reenters the property.

After a few minutes, the gate swings wide open, and we are granted access.

Behind the gate, a lush and beautiful landscape extends before us. A canopy of mature trees, small shrubs, flowering plants, and neatly clipped lawns surrounds a scattering of buildings, the largest of which resides near the gate. Crops are growing in an expansive garden toward the back of the property. Everything looks well cared for, healthy, and verdant.

Paulina stands just inside the gate and waves at us as the Maasai guard directs us to a parking space nearby. She is wearing a vibrant floral dress and a red jacket and looks just the way I remember her, albeit a few years older. I've known Paulina since her days as a serious, determined student at the MGLSS. Over the years we've kept in touch, and this is the second time I've visited her at the Emusoi Centre. I've followed her work here with interest, eager to know more about the ways she's supporting young women from backgrounds similar to her own. I am delighted to see her again.

When I climb out of the vehicle, Paulina gives me a hug. We hold hands and smile at one another for a few moments, checking in with each other; she seems as happy to see me as I am to be in her presence again.

"How are you?" I ask, emphasizing every word with an intensity that I hope lets her know that I want to know anything she has to tell me.

"Everything is perfect," she replies, tilting her head slightly in an almost bashful expression.

I hug her again. "I am so glad to see you."

After I introduce her to the interview team, we all walk toward the Emusoi Centre's main building—a sprawling structure that contains classrooms, offices, and dormitories but still manages to look like a welcoming bungalow-style home rather than an institutional structure. Neatly manicured shrubs line a walkway that leads to an inviting front porch and the building's main entrance. Behind the roof line, Mount Meru rises skyward under a brilliant mid-morning sun. Nearby, two teenage girls sit together on the grass. One is braiding the other's hair into tight cornrows. They shyly greet us as we walk by.

When we enter the building, we see a dozen young women quietly reading or studying together in classrooms on either side of the front door. Paulina points out different features of the building, including a kitchen and a library, and stops to introduce us to a few staff members as we walk toward her office near

the back of the building. Once there, we are greeted by Sister Mary Vertucci, the Catholic nun who founded the Emusoi Centre in 1999 and continues to lead it today. Though Sister Mary is an American, she has spent most of her adult life in Tanzania, having first arrived in the country as a teacher in 1971. She is pleased to learn about our book project and tells us Paulina is an integral part of the center's staff.

"Paulina knows the challenges the young women at our center face because she has lived through those challenges herself," Sister Mary tells us while looking with pride at Paulina. "She is a wonderful mentor and role model."

I thank Sister Mary for allowing us to visit the center and then guide Paulina and the interview team back outside, where we set up our equipment in the natural light. Once Paulina has shooed away a few chattering young women who would rather observe our goings-on than study, I begin the interview with an open-ended question: "Can you tell me where you grew up and what life was like for you as a child?"

> *"I grew up in a very challenging environment. It was extremely remote, and there were many wild animals. I had to walk fourteen kilometers per day to get to the nearest primary school. We had to walk in groups because we often met wild animals . . ."*
>
> —PAULINA MESARIEKI

Paulina sits still for a moment, collecting her thoughts, before she responds.

"I come from the Simanjiro District in the Manyara Region. My village is Loiborsoit, which is south of Arusha about ninety kilometers. I grew up in a very challenging environment. It was extremely remote, and there were many wild animals. I had to walk fourteen kilometers per day to get to the nearest primary school. We had to walk in groups because we often met wild animals on our way to school, but I still managed to complete primary school. After that, my father didn't want me to continue my education because there was a man who had already paid a dowry for me, but I was fortunate because my mother really struggled to support me. She wanted me to go to school."

When Paulina pauses, I imagine what it might have been like for her to meet an elephant, a Cape buffalo, or even a lion as a small child walking on foot across Tanzania's vast plains.

"Meeting wild animals on the way to school sounds dangerous." This is stating the obvious, but I can't help myself—what she is describing is so far from my American context of walking to school.

Paulina shrugs. "Well, it was part of my life, and it still is for many kids who are growing up like I did."

"I guess that is why the Maasai are so brave," I say, acknowledging a legendary Maasai trait, and then return to the story at hand: "Tell me how you were able to attend the MGLSS if your father had already arranged a marriage for you."

"When I was in Standard Seven," Paulina says, "a group of teachers from the MGLSS visited my primary school. They interviewed me and the other girls in my class. We also took an exam, but I was the only girl who was selected to join the MGLSS. When I told my mother about this, she was the first one to push for me to attend. 'Please keep going in school,' she told me. I think she didn't want me to face the same challenges that she faced in her life. Maasai women struggle to feed and clothe their children. The mothers are the ones who do everything for their kids. Mothers even build the houses. My older sister qualified to go to secondary school, but she was married off instead. My mother didn't want that to happen to me too. I remember a time when my dad refused to give me bus fare to return to the MGLSS after a holiday, so my mom went to her friend and borrowed some money. Though my mother didn't go to school and didn't know how to read or write, she made it possible for me to attend school."

Even though I know she must feel grateful for her mother's love and support, Paulina holds her emotions in check—a point of pride among many Maasai women.

"My mother had seven children: five girls and two boys," she continues. "My two older sisters didn't attend secondary school. I was the first girl in my family to have that chance. When I was finishing my university degree, my mother passed away, so I helped my two younger sisters and my little brother attend school. One sister is a teacher and the other is finishing her degree to become a medical doctor. I think my mom would be so proud of us."

Only here do I witness a slight crack in her tightly guarded emotional façade.

"You should feel proud, too," I say with sincerity. "What did you do after you finished secondary school?"

"Following A-Level at the MGLSS, I went to Tumaini University in Iringa for my degree in business administration, which I completed in 2008. From 2012 to 2014, while I was working here at the Emusoi Centre, I completed a MBA at Eastern and Southern African Management Institute in Arusha."

"And you've been working at the Emusoi Centre for many years," I observe. "Tell me what you do here."

Paulina looks toward the building where she works as she says, "I've been an accountant here at the Emusoi Centre for fourteen years, but I'm also a career advisor for students as they finish secondary school. I sit with them and discuss what they want to study in the future. For example, I might advise a student who wants to become a nurse which subjects she must pass on her national exams if she wants to go to college. I might also discuss which colleges she could attend and advise her on how to complete her college applications. And I'm also doing monitoring and evaluation for the Emusoi Centre. It's part of my job to document our work, especially for funders."

"Can you tell me more about what the Emusoi Centre does?" I ask.

"We help not only Maasai girls but also girls from other pastoralist and hunter-gatherer

communities to access secondary and post-secondary education. The word emusoi means 'awareness' or 'discovery' in the Maasai language, so we are fostering that discovery. After primary school, girls who are not yet ready for secondary school come here. Most of them haven't passed their Standard Seven national exams. We teach them here in a one-year program so that they are prepared to join secondary schools. We have teachers and social workers. We teach them lessons from Standard Six and Standard Seven to help them catch up. Most of them come from very poor environments, and they cannot read or write. We also teach them life skills. We talk to them about the challenges they face at home. We teach them how to study and prepare them for life at a boarding school. For those that can pass our program, we find them positions at private and government [public] secondary schools. Many of them face early, forced marriages at home, so once they begin secondary school, they still stay at the center during school breaks. For those that are unable to pass our program, we find them positions at vocational schools, so they at least get some skills."

"Beyond early, forced marriages, what other challenges do these young women face at home?" I ask.

Paulina sighs deeply and gestures toward a few girls who have just stepped outside the Emusoi Centre's main building. "These girls face many, many challenges," she says. "Quite a few of them are orphans. Nobody is taking care of them. They have nowhere to go. Others are sick. We have several girls with tuberculosis.

We enroll them here and then we take them to the hospital. They get treatment and can proceed with school. We also have girls with physical disabilities. We have one girl studying at Ngorongoro Girls Secondary School. Her leg was injured when she was a little girl, and she couldn't walk well. We brought her to the Emusoi Centre and took her to the clinic. Now she is about to complete Form Four. So, we also concentrate on health here at the Emusoi Centre. Girls can't learn if they don't feel well, or if they are insecure at home."

I nod, encouraging her to continue.

> *"We have many girls who still don't have access to education. We are advocating for girls' education because we know that when you educate one girl, you educate an entire community."*
>
> —**PAULINA MESARIEKI**

"The need is still very big for what we do and for what the MGLSS is doing, too," she says. "We have many girls who still don't have access to education. We are advocating for girls' education because we know that when you educate one girl, you educate an entire community. Like in my family—I'm now helping them a lot. My father didn't want me to go to school so many years ago, but today he calls me all the time. He tells me his plans, and then he asks me, 'What do you think about this? What is your advice?' He knows I went to school

and I have a good job now. I can help him. I also have a daughter who is in Standard Four. She is very clever. She tells me she wants to be a doctor, or an accountant like me. I'm her role model, but I'm hoping she will achieve even more than me."

I smile, inspired by her story. Like Paulina, I know the need to help young women in Tanzania remains great—the work is far from done. Paulina, though, is living evidence of the progress that's been made in the right direction.

"I'm grateful there are places like the Emusoi Centre that fill the gap between primary school and secondary school for girls who need extra help to succeed," I tell her.

With that, we close the formal portion of the interview. However, before we depart, Paulina wants the interview team to meet some of the young women she's told us about. When we eagerly agree, she brings a group of nearly twenty young women outside to where we've been sitting.

As the young women introduce themselves, I'm struck by how much they remind me of Paulina and her classmates twenty-five years ago. Many are shy. Some are outgoing. A few appear very serious. Several smile. Most stick close together and whisper to one another just beyond my range of hearing. In the middle of them all shines Paulina—a mentor, a mama, and a role model who stands as proof that anything is possible for young women with big hopes and dreams, if they only receive a little encouragement and help along the way.

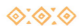

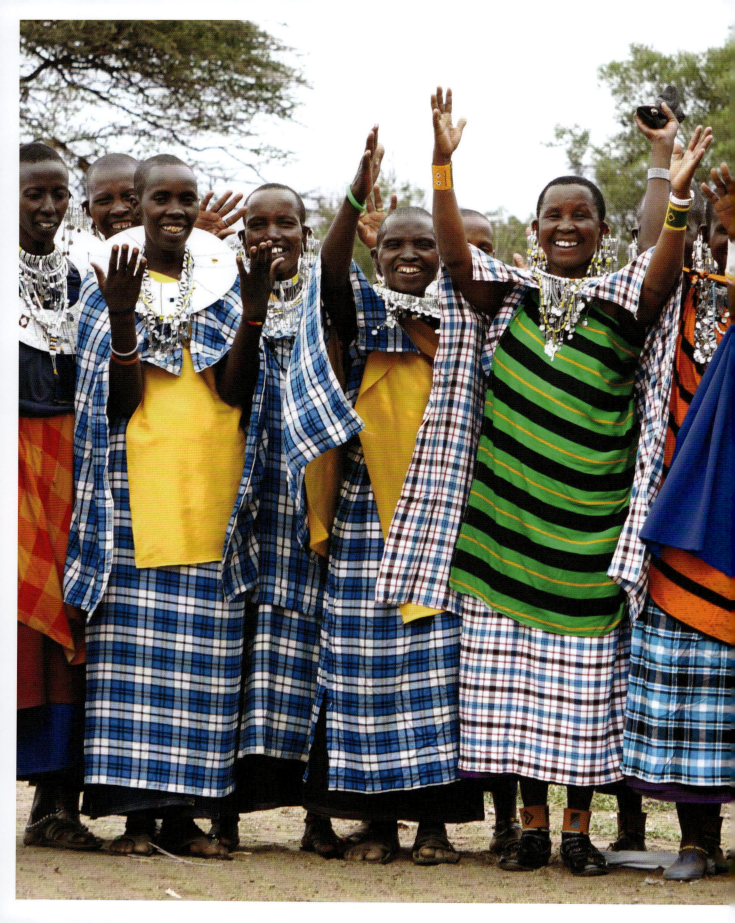

GOVERNMENT

UPENDO KATITO MALULU NDOROS, 1999 GRADUATE, O-LEVEL

Leading Change from Within

Under a bright midmorning sun, Upendo Katito Malulu Ndoros and I sit on traditional, hand-carved wooden stools that stand just one foot off the ground. We've gathered at her family's boma near the town of Longido, which is located about twenty-five miles from Tanzania's northern border with Kenya. Though Mount Longido, with its rainforest microclimate, stands just north of our location, what dominates the landscape here in the surrounding, rolling plains is mostly scrubby acacia trees and dust.

Though our austere, low seats might seem inconsequential and a little uncomfortable to an outside observer, they are, in fact, an essential furnishing at most Maasai homes. Each stool has three legs that splay outward under a shallow, bowl-like seat that appears polished smooth and shiny from regular use. Often made from a single piece of wood, these stools require time and skill to hand-carve. They also reflect the Maasai people's deep and enduring connection to their pastoral way of life by offering a handy place to sit while milking cows, cooking over an open fire, or meeting with family, friends, and even former teachers like me.

In 1999, I taught English to Upendo as she completed her final year of O-Level at the MGLSS. In my memory, she stands out as one of the students who came from a staunchly Maasai background, and visiting her today confirms that recollection. From the hand-carved wooden stools on which we sit to the dozens of traditional mud-walled, grass-roofed structures that surround us to the many people I see in customary Maasai attire, this is a place that holds fast to tradition.

From outward appearances, Upendo seems to fit right in, albeit with a few contemporary twists. Though she wears traditional Maasai mashuka and beadwork, she also wears gold hoops in her ears, a gold wristwatch, a Western-style cardigan, and shoulder-length

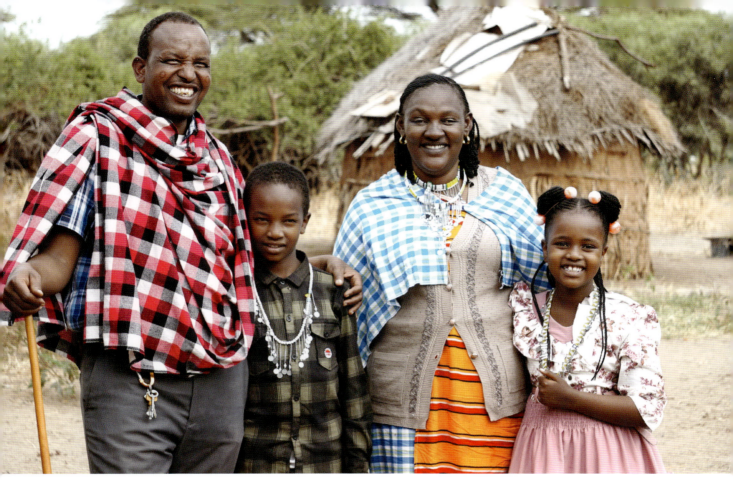

braids rather than the customary close clip of the other Maasai women gathered here today.

In addition to her husband (pictured above), one of her brothers, two of her six children (also pictured above), and several other family members, Upendo has invited about twenty Maasai women who are part of a beading group to her family's boma today (pictured on page 130). These women work together to craft traditional Maasai jewelry, which they market to their community as well as to tourists. Today, they are wearing their handicrafts—beautiful ilturesh, necklaces, bracelets, anklets, and earrings.

When the interview team first arrived, the women sang and danced to welcome us—a special honor reserved for guests. Ranging in age from teenager to elder, they formed a semi-circle in front of us as they raised their voices in the ebb and flow of a Maasai song, bobbing, swaying, and eventually jumping in the customary way of Maasai people—springing higher and higher vertically as they held their bodies stick, straight. Afterward, they formed a single-file line to shake our hands and greet us one by one before gathering nearby to sit on their own small stools or on the ground to observe the interview from a distance.

Their easy presence with one another and their friendly camaraderie demonstrate their tight connections. They do more than simply craft jewelry together. This is a

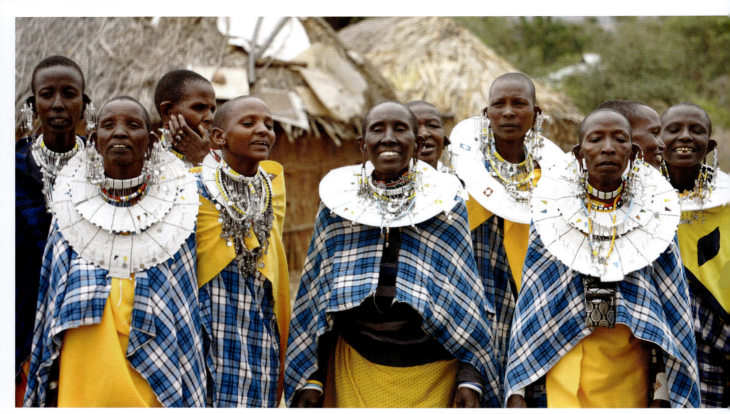
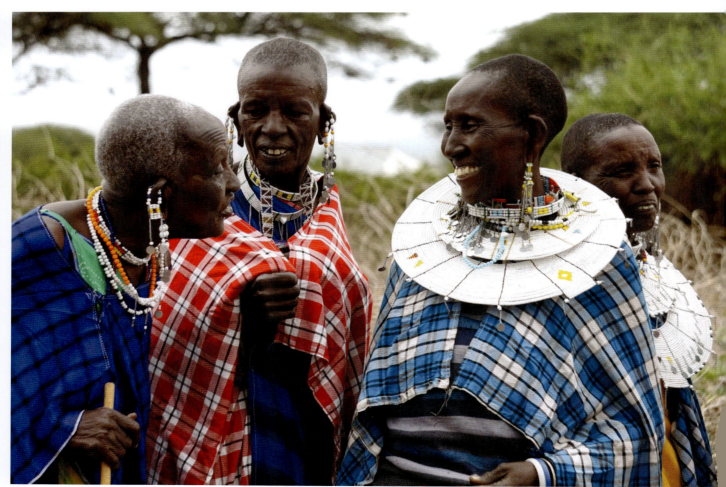

community whose members provide support to one another in the raising of children, in the collecting of water and firewood, in the cooking of food, and in the maintenance and construction of their bomas. In the Maasai culture, women are responsible for all these things and so much more, but they rarely carry the load alone. Women, like those gathered here today, help each other.

Though our interview is taking place on the edge of the boma, away from the gathering of women and the rest of Upendo's family—except for her husband and two of her children, who remain standing just behind me and out of camera range—I know many people are hovering on the periphery, eager to catch a glimpse of Upendo being interviewed on camera. In this festive atmosphere, Upendo seems like a celebrity, and in a matter of speaking, she is. She serves on the Longido District Council, a body of twenty-four elected officials that governs a roughly 3,000-square-mile area of northern Tanzania that is dominated by the Maasai. There's no doubt that a number of people beyond those gathered here today know Upendo, and I suspect this isn't her first on-camera interview.

Given her important position in the region, I kick off the interview with this prompt: "Tell me about your role as an elected official."

Upendo smiles and looks off toward the gathering of people nearby before she begins.

"I'm a district councilor here in Longido. I hold a special seat on the council as a representative for women. In addition, my fellow councilors have nominated me as

> *"I'm a district councilor here in Longido. I hold a special seat on the council as a representative for women. In addition, my fellow councilors have nominated me as the chairperson of the Education, Health, and Water Committee, which does a lot of important work in the district."*
>
> —UPENDO KATITO MALULU NDOROS

the chairperson of the Education, Health, and Water Committee, which does a lot of important work in the district. I've spent most of my life in this district, so I understand the challenges my community faces, and I especially understand those that women face. I've been given a broad scope to address these challenges. I work with other councilors to discuss the district's budget and prioritize what the community needs the most. We also work within the community to advise people and to listen to their concerns and ideas. We know the issues here better than anyone else could, so even the national government takes advice from us. It is our responsibility as leaders to speak up. As a result, our communities are now being supported by the government with many programs."

Like most politicians around the world, I note, Upendo is polished, likeable, and well-spoken.

"Could you tell me about some of these programs?" I ask.

"We've accomplished so much!" she exclaims. "As you know, access to water is a huge issue in northern Tanzania, especially during droughts, so we are working with village water committees to drill wells, and we are providing water tanks and teaching people to harvest water into these tanks. In the education area, we are working with the government to address infrastructure shortages. For example, at Kiserian Primary School teachers were sleeping in classrooms, so we built housing for them. We can't retain teachers in remote areas if there is no housing. We are mobilizing communities to contribute food to schools, so children have something to eat while at school. And we are working to keep kids in school. In the area of public health, we are encouraging women to give birth in clinics and hospitals and providing funding for those who can't afford this. We're also promoting medication that treats trachoma."

This highly contagious eye disease can lead to blindness if left untreated. In the early 2000s, the disease affected more than half of Longido's population. Today, antibiotics and public health campaigns have reduced that number to less than 10 percent. Still, outbreaks are a concern.

Upendo pauses here, so I prompt her to tell me more. "You hold a special role on the council as a representative of women. Can you tell me more about your work in this area?"

"As the district's representative for women, I have started adult literacy classes for women. We are teaching them to read and write so that they can support their kids at home. It's a problem if children don't have anyone at home who can assist them in their learning. If these women have a basic education, they can teach their daughters and sons to read and write. These skills are very, very important to women for many reasons. Even during the election, if women don't know how to read a ballot, it is difficult for them to vote. They tell an election official that they want to vote for President Samia [the first woman president of Tanzania], but maybe the ballot is marked for Tundu Lissu [the opposition leader]. If they can't read, these women never know the difference."

Without stopping, Upendo continues, clearly eager to tell me more about her work with women. She speaks not only with words but also with her body—leaning forward, making direct eye contact, and using hand gestures to emphasize what she is saying. There is an intensity about her that illustrates her passion about these issues. She speaks not of abstract problems or hypothetical solutions but of her lived experience as a leader addressing an array of challenges that confront her daily.

"We have women's groups that help each other build houses. When someone needs her boma repaired or built, we go together to collect the materials we need, such as grass, branches, and twigs. We fix wooden poles into the ground and interlace them with smaller branches. We mud the house. We put the grass roof on. That brings us together as a community. These are the places our families sleep, cook, eat, and socialize. Sometimes we build the thorn fence that surrounds all the houses that make up a

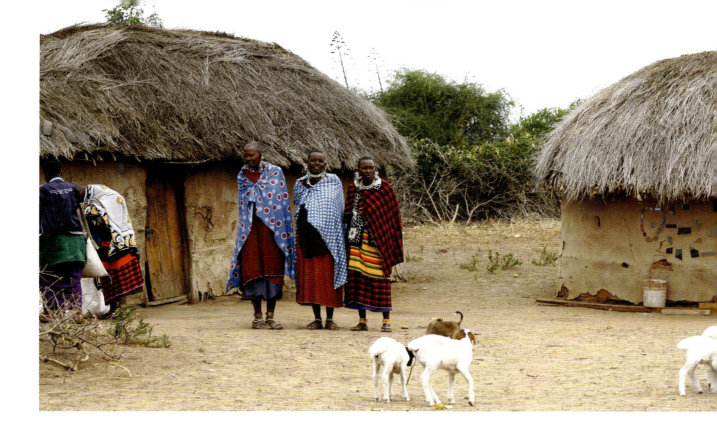

boma. In the middle of the boma, we can build a smaller thorn enclosure where the livestock can safely rest at night. A group of us can build all this in a few days."

As she explains this, Upendo points to these features within the boma where we are seated, which contains more than a dozen small homes scattered across at least an acre, if not two, of bare land.

"Sometimes I choose ladies from the women's groups who are very bright and see the importance of education. We go to schools and talk to the students. Many of our kids are leaving school to be watchmen or housekeepers, so we are teaching them that they can do more if they stay in school. For example, I'm a role model now. Because I went to school, I have a good life. I can provide for my family. I don't have to beg anyone to help me."

Upendo points to a modern concrete-block structure with a metal roof just beyond the boma where we sit. "That's the home my husband and I built for our family. As a child, I never dreamed I would become a district councilor, or that I would be able to build a good house like that one, or that I would be able to help my family and send all my kids to school. I have six children—four beautiful daughters and two sons. My dreams for them

> *"As a child, I never dreamed I would become a district councilor, or that I would be able to build a good house like that one, or that I would be able to help my family and send all my kids to school."*
>
> —**UPENDO KATITO MALULU NDOROS**

GOVERNMENT 133

are very big. My first daughter, Paulina, is a doctor. My second daughter, Hannah, is studying to become an electrical engineer. My third daughter, Nengai, is in secondary school. I want them to be strong ladies in the community . . . to help this family of ours, to help this community of ours. That is possible now for Maasai people. It's so good."

She smiles warmly and points to the two children who are hovering behind me, watching their mother's interview. "That is Alanana. He is in primary school, and he would like to be a pilot. We are praying that he can achieve his dreams. And my daughter Nosim, she wants to be a lawyer."

I suspect Nosim, who looks to be around eight or nine years old, has silently expressed her dissent behind me, because Upendo pauses and chuckles softly.

"Well, maybe she has changed her mind, but she told me she wanted to be a lawyer at a very young age," she clarifies with an amused look. "My youngest son is only two and a half months old. His name is Osotua. I don't know what he is thinking just yet"—she laughs—"but he can choose any profession he likes. So that's my family—plus my husband, Michael. He works for the church here in Longido. We first met in primary school, and we've been married since 2000. We are dreaming very big things for our children, and we thank God that they are reaching their goals."

"You obviously value education for your children," I observe. "Can you tell me how your parents felt about your education?"

"It's funny to think about the past sometimes, but it's good to remember," Upendo says with a nostalgic look. "When I was very small, I was milking goats one day. It wasn't at this boma, which belongs to one of my relatives, but rather at my parents' boma in Kitumbeine, where I grew up. The social welfare office was using the police to find girls who weren't in school and enroll them. So, the police came to my boma looking for me. My brother told me, 'Hide yourself with the goats.' So I crouched down among the goats, but the police found me anyway," she says with a chuckle. "They pulled me out by the clothing on my back and they said, 'Why are you hiding? You must go to school.' My family did not want me to go to school, but I was enrolled in primary school anyway. I'm not even sure how old I was, because I don't have a record of when I was born. At the end of primary school, I interviewed for a scholarship at the MGLSS, and I was the only girl chosen from Kitumbeine that year. When my mom found out, she was very unhappy. She told everyone I was pregnant so I would be disqualified, but I was never pregnant."

Upendo says this last part with an incredulous laugh though I know her story is not an uncommon one. Some Maasai families use real or imagined pregnancies to keep girls out of school. In my own culture and in many parts of Tanzania, premature pregnancies can bring shame to girls and their families, but among some Maasai families a pregnancy can be weaponized as a means to an end—the end of an education.

After a moment, Upendo carries on with her story. "My mom and a local teacher took me to the MGLSS anyway. When we reached the school, I told my mom, 'Mama, I'm sorry, but I have to go to school.' She cried, but she went back to the village without me. During school holidays, the teachers asked me if I wanted to go home, but I told them I wanted to stay at school for my safety. I knew if I went home, I would be forced into marriage and never return. So that's how I came to be at the MGLSS and thank God for that. The teachers loved us like their daughters. They took care of us. After attending the MGLSS, I went to Mount Meru University in Arusha to get a diploma in education because I really wanted to teach so that there could be many more Upendos, and Neemas, and Esuvats in all parts of Tanzania."

Upendo projects pride as she tells me this. It's clear she understands what she's had to overcome to achieve all this.

"After college, I taught for eight years," she continues, "and then I worked for several years as an education and gender officer. I worked in schools talking with children about their struggles. They could report problems to me, and I would help them. I also taught teachers techniques to help their students. We raised funds to build classrooms and toilets and to buy school materials for kids in need. We also helped girls who were pregnant to go back to school after giving birth. Part of this work was doing family mediation to encourage parents to let these girls go back to school. I was already advising the government at this time to change the rule that did not allow girls to go back to school after their pregnancies. I thank God that the government changed the rule because it was very unfair. Many times, girls are forced to get married. They are unwilling and then they are punished for their pregnancies. They don't know where to run, but now the government has changed the rule so these girls can go back to school."

Though Upendo doesn't say it directly, I know that many Maasai women use the words "forced to get married" as a euphemism for rape. Starting in 2002, the Tanzanian government mandated the expulsion of pregnant girls and young mothers from school. Thus, Maasai girls who had endured rape and become pregnant as a result of it were punished for what was deemed their own transgression by government and school officials. Fortunately, due to the work of women like Upendo, this policy was reversed in 2021, and young mothers can now return to school once they give birth.

Recognizing how much Upendo has achieved, I ask, "Is your family proud of you now?"

"My father is no longer living, but today my mother has a house with a metal roof," she says. "We used to cover our houses with grass, but now I have built her a good house with two rooms. She sees the benefit of education now. My mom and the rest of my family thought I would never come back once I went to school. They thought I would live in town and forget my Maasai ways. They didn't want to lose me, but now they have learned that even though I went to school, I came back to them. I am

better equipped to serve my community, and they have seen the benefit of sending a girl to school. My brother is here today to talk to you about this too." She makes a motion at her son, who runs off to collect his uncle.

Though I have visited many Maasai bomas, I'm still never quite sure what to expect at each one, and today has been no different. When we arrived today, we knew we would be interviewing Upendo, but we didn't know that we would have the opportunity to meet the women's beading group, or so many members of Upendo's family. She has prepared all this to honor our presence at her family's home, and I am humbled by these gestures. I now realize she has also asked her older brother to do an interview with us.

"Don't worry," she tells me. "I will translate. He only speaks Maa, but he will offer an interesting perspective on education."

While we are waiting, Upendo and I both stand to stretch our legs. I give her a hug, tell her how impressed I am by her work, and thank her for all she has shared.

We are still standing when her brother walks up, looking every bit the traditional Maasai morani I would expect—erect posture, straight-faced, fimbo (thin wooden stick) in his hand, olalem (a machete) on his hip, and traditional Maasai clothing and beadwork on his body.

After I greet Yakobo Ndoros and thank him for agreeing to the interview, Upendo gives him the stool she sat upon during our interview. I retake my seat as she stands next to me and translates my questions and his responses.

"Can you tell me how you felt about Upendo's education before she went to the MGLSS?" I ask.

In Maa, Yakobo tells me, "Before, we did not want girls to go to school because we thought they would be lost. Upendo is the last born in our family, but the first to go to school. When she reached Standard Seven she passed her exams, and this made us angry. We started to look for ways to keep her from going to secondary school. We went to the witch doctor, and he instructed us how to use witchcraft to stop her from going to school. We tried this many times, but we got tired of it because there was no change. Even the witch doctor got tired of us. There were three of us—my mother, my brother, and me, because we were the only sons. We looked for other ways to stop Upendo from going to school, but nothing worked. Finally, we calmed down and allowed her to go to school."

Yakobo remains somber and authoritative as he speaks. Though I know very little about Maasai witchcraft, I'm aware that it has long been part of traditional Maasai beliefs. This isn't the first time I've heard of a family using witchcraft to persuade a daughter or a sister to quit school. Yet again, I'm reminded of the numerous challenges girls and women are up against when it comes to the pursuit of education and changing cultural norms.

Upendo reveals little as she translates her brother's response, leaving me to wonder how she feels about her family's efforts to keep her out of school. Given the way she values education now, I expect this is a difficult

history to hear, and I wonder how much she and her brother have or have not discussed this in the past. Part of me wonders if, knowing she has achieved so much despite these challenges, Upendo feels triumphant about the history Yakobo has just shared, but her face remains unreadable—a classic, stoic response common among Maasai people in response to difficulty.

"How do you feel about education now?" I ask Yakobo.

"After Upendo went to school, we saw that she was very knowledgeable, more so than other girls. We started to respect her. We saw her as a mature and educated person. Now we are benefiting from her education. She is taking my children to school. I have four girls and two boys. She is the one who supports them. She built a house for our mother. She also started to help the whole family. My prayer is God keeps helping her to bring more opportunities to our society."

In the face of such a sober, traditional Maasai man, I'm a little unnerved and uncertain of what to ask next. The cultural gulf between Yakobo and me seems even wider than that between my female interviewees and me. Though he would never display insecurity of any kind, I suspect he too is a little uncomfortable. So, though I have asked only a few questions, we both sense the interview has ended.

He nods slightly to Upendo and stands, as do I.

"Ashe naleng'," I say in Maa, surprising both Upendo and Yakobo. Despite his tough Maasai exterior, my words of thanks in the Maa language provoke a smile from Upendo's brother.

That afternoon, as the interview team heads back to Arusha, I reflect on the last time I saw Upendo twenty-five years ago. She had just finished O-Level and was struggling with what to do next. I sat with her on the front steps of one of the classrooms at the MGLSS as she told me she wasn't sure if she would be able to continue her education. She came from a very traditional Maasai background, and she was lucky to have graduated from O-Level. Her future was uncertain.

When Upendo left campus, I wept. I wondered what would happen to her—how she would navigate life at home and if she would be able to continue her education. Mostly, I wondered if she would find happiness.

As with many of my former students, I lost track of Upendo after her graduation and never knew what became of her, until today. It was only by chance that another graduate put me in touch with her as a potential interviewee for this project.

I am filled with joy to have met Upendo again and to know that her life is full and rich—that she is happy. She has succeeded on her own terms and is leading on those terms too. Her Maasai heritage clearly remains central to her identity, yet she knows when to embrace change that will make life better for the people she serves in Longido. I'd say her future is no longer uncertain. In fact, the future of many people in Longido is no longer uncertain because of Upendo Katito Malulu Ndoros.

UPENDO BARNABA LETAWO, 2002 GRADUATE, A-LEVEL

Improving Public Health in Africa

I'm waiting for Upendo Barnaba Letawo in a quiet, outdoor garden at a hotel in Arusha when I see her pull into the hotel's parking lot in a Land Rover. She's dressed in a black turtleneck and matching slacks with a long, lime-green sweater over the top. She looks as if she's just come from the office, and in this hotel setting, she also looks like an international jetsetter. I'll soon learn she's just that.

After we greet one another, Upendo tells me that I've just caught her between travels. Tomorrow, she will fly from Kilimanjaro International Airport in Tanzania to Durban, South Africa, with four colleagues to present a paper on "cross-border surveillance of tuberculosis." Already, I'm curious. Upendo is a smart woman on the move.

"Tell me more about your work," I say as the camera begins to roll, though I already know that Upendo works at the East, Central, and Southern Africa Health Community, an inter-governmental organization that promotes cooperation and builds public health capacity among nine member countries and eighteen non-member countries that together span half the continent of Africa. To say Upendo has a big job would be an understatement. Her work covers some 3,000 miles, from Sudan to South Africa, and impacts a population of about half a billion people.

"Let me give you an example of cross-border surveillance," she says as she dives into the details of her work. "The border between Tanzania and Kenya is quite porous. Migratory people such as the Maasai can easily cross that border, and they may seek healthcare in both countries. If we don't have a system to track people with chronic infectious diseases such as tuberculosis, then there may not be any continuity in their healthcare. Drug-resistant tuberculosis is a problem in Africa, so if there isn't any follow-up with people who start treatment, then we risk creating worse forms of the disease. We are working on a web-based

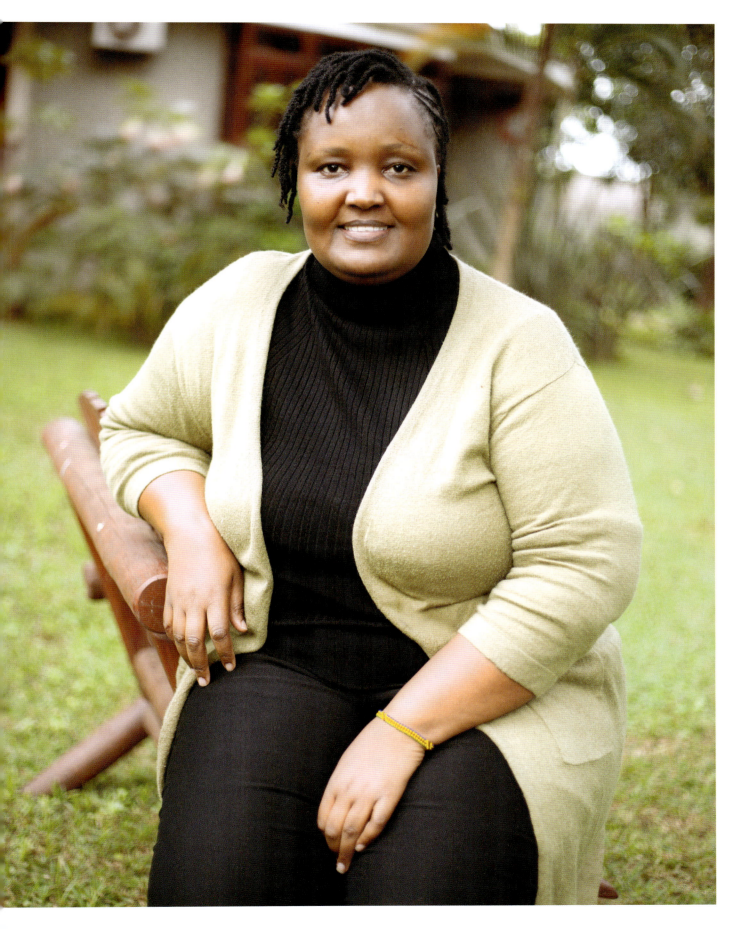

system to track tuberculosis patients and health indicators across borders. This is what my team will present in Durban."

"What is your background?" I ask. "Are you a doctor?"

She laughs. "No, people often think I'm a doctor, but my background is in communications. But of course, yes, I've had to learn a lot of things about medicine and health reporting, which is quite specialized. In 2005, I completed a bachelor's degree in journalism at Tumaini University in Iringa. I worked for a while with the United Nations Development Programme in Arusha on a cross-border biodiversity project before I joined the East, Central, and Southern Africa Health Community. We call it ECSA for short. I've worked in a variety of roles at ECSA over the last eighteen years. I started in communications, then after a while I became a monitoring and evaluation officer. Right now, I work as a knowledge management, monitoring, and evaluation officer."

Before I have a chance to ask her what the job entails, she's already on top of it, saying, "So, let me explain what that is, because people are always confused by these terms."

As Upendo speaks, I'm struck by her gentle demeanor. Though she undoubtedly holds an important role in shaping public health policy in Africa, she remains soft-spoken and patient, ever ready to explain the technical ins and outs of her work to a layperson like me.

"The monitoring and evaluation part of my job is about defining what we plan to do during a project's initiation and then making sure that we achieve those plans. This has been around for a long time. Knowledge management is a new term, but it's something that has also been done for a long time. ECSA conducts research and develops policies, processes, and standards based on this research. We want to preserve that knowledge and make sure that it is available for use. It's a problem if the research is there, but nobody knows about it. My job is to package it in a way that it's user-friendly to our member states but also to other countries and the international community."

"How does this information get used?" I ask.

"Let me go back and explain more about where I work," she says.

I can tell Upendo is good at her job because she anticipates the information I need to know even before I ask about it.

"ECSA is owned by nine member countries in Africa," she says, "but we also have projects that are funded by not only our member states but also by USAID, the Global Fund, and the

"We act as advisors to African governments, specifically their ministries of health, to build capacity and help them address the specific health-related challenges found in their countries. We guide policy development and disseminate guidelines and standards based on our research."

—UPENDO BARNABA LETAWO

World Bank at different times. These projects reach additional African countries beyond just our members. We want to monitor and evaluate our work and share it broadly. We act as advisors to African governments, specifically their ministries of health, to build capacity and help them address the specific health-related challenges found in their countries. We guide policy development and disseminate guidelines and standards based on our research. Part of ECSA's purpose is also to share member countries' progress toward the United Nations' Sustainable Development Goals, one of which addresses improving global health outcomes."

"Tell me about the specific projects ECSA is working on," I say.

"We focus on food security and nutrition. Malnutrition rates in most ECSA member states are high and disproportionately affect women and children. We are working to change this by strengthening each country's capacity to monitor the quality and safety of nutritious foods. Infectious diseases are a big focus too. Of course, there are many different projects under infectious diseases. Tuberculosis is one of our big focuses, as is HIV/AIDS prevention and care. We also have projects focused on family and reproductive health, noncommunicable diseases, and health systems and capacity strengthening."

"Given the scope of ECSA's work, you must employ many people," I assume out loud.

"Our team is only about forty people," she says, shaking her head, "including support staff, though we also work with a lot of consultants. For the tuberculosis cross-border surveillance electronic system, we are working with the University of Dar es Salaam."

Switching gears, I ask, "Can you tell me where you grew up? I'm also curious how you think your upbringing and your education have influenced your life and your work today."

"I grew up here in Arusha, in a place called Ilboru," she tells me. "I would say I had a normal life as a Maasai child. I was raised by my grandparents because my mom had me when she was still in secondary school."

In Tanzania, it is not uncommon for grandmothers or aunts to raise their grandchildren or nieces and nephews if a parent has fallen on hard times, or, as in Upendo's case, if a young woman gets pregnant and would otherwise be unable to continue her education.

"She went back to school and became a teacher, but I stayed with my grandparents until I joined the MGLSS," Upendo continues. "I benefited both professionally and socially from my time there. Professionally, my education has enabled me to be who I am today. Socially, I'm part of a sisterhood through the girls' school. This is something very special." She nods and smiles. "Oh, yes—we are family."

I can guess from her expression that these connections are as important to her today as they were when she attended the MGLSS, maybe even more so now. I don't even have to ask her to share more about these long-time friends; she just dives right in.

"I hear a lot of stories from my friends about the work they are doing in different Maasai communities," she says with energy. "We are

> *"In the past, the Maasai community had to rely on people from the outside who would come in and work in our communities. Now, we have our own people, and their understanding of cultural context has changed a lot of things."*
>
> —UPENDO BARNABA LETAWO

activists, teachers, nurses . . . we are changing history. In the past, the Maasai community had to rely on people from the outside who would come in and work in our communities. Now, we have our own people, and their understanding of cultural context has changed a lot of things. The MGLSS graduates are a big part of this." Her eyes shine as she continues, "At ECSA, I'm not working directly with the Maasai, but I'm supporting my community in other ways. I'm a member of the board of directors for several organizations in Arusha. One of them is a nonprofit called Wine to Water. They make water filters and distribute them in Maasai communities, so people have clean, safe water. I'm also helping members of my family to go to school. I paid for my younger sister's education from secondary school through college. I'm supporting my cousin's daughter, too, who just received very good national exam results. She will continue to A-Level. I'm super proud of her. This makes me so happy."

"Do you have any children of your own?" I ask.

"I have no children," she says rather matter-of-factly. "I'm not married."

In Maasai culture, it's unusual for women to be without children. I suspect this and Upendo's professional success means she may not always be viewed favorably in what remains a largely patriarchal society in Maasailand and in Tanzania in general. Though the question is a little uncomfortable, I take a risk and ask, "In your culture, this is something quite rare. Can you say more about this?"

To my relief, Upendo doesn't hesitate to tell me more. In fact, she seems eager to elaborate.

"Growing up, I only heard girls aspiring to be wives and mothers because marriage and motherhood are considered important milestones in the life of a Maasai woman. Therefore, it's not easy for my people to comprehend an educated woman with a job who is not married and does not have children. Personally, it doesn't affect me. I'm happy. I've met a few men, but not the right one yet. Maybe I'm too choosy, or maybe I scare them off."

This is not the first time I've heard this from a strong, successful woman. I'm glad Upendo has found contentment in her life just as it is.

As we close the interview, I ask Upendo if she has a next step in mind for her career. She gets a far-off look in her eyes as she says, "I feel like I'm ready for a change. I don't know what the future holds, but I'm thinking about that."

"Whatever you choose, no doubt, you will succeed," I say with full sincerity.

After she bids me farewell with a wave and climbs into her Land Rover, I reflect on this woman who is forging her own way. I'm not sure she realizes how impressive she is—a Maasai women who is working on a diverse,

global stage to help define public health policies that impact vast swaths of the African continent. I think about how some of us are meant to work close to the ground—at the roots, where we were planted and raised—while others are meant to fly free like seeds cast into the wind, growing in a world that needs the gifts we bring. And the world needs what Upendo brings: a deep understanding of the African context and a passion to improve lives not only where she was planted but also in the places where she now flies free.

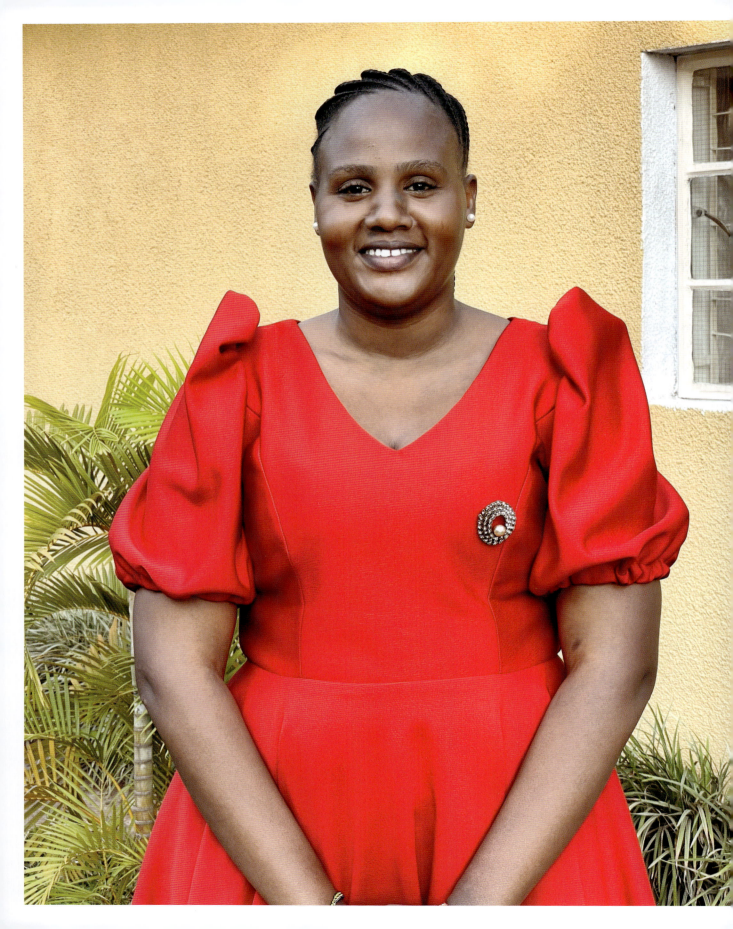

SANGAI MAMBAI LENGARUS, 2012 GRADUATE, A-LEVEL

A Real-life Superhero

In American culture, our superheroes are typically all-powerful. They ride fast motorcycles, drive expensive cars, and have special powers that help them vanquish evil and overcome injustice. Think about Wonder Woman, for example, or the women warriors of Wakanda.

Though the women of Wakanda have African roots, my image of an African superhero is more akin to Alexander McCall Smith's Precious Ramotswe. Though a fictional character in Smith's book series, *No. 1 Ladies' Detective Agency*, Ramotswe strikes me as an authentic citizen of Botswana, where the series is set, and a real-life superhero. She is a "traditionally built," savvy woman who sees things as they are, wears sensible shoes, and speaks honestly about the challenges people in her country face. In addition, she holds the distinction of being the first female private investigator in Botswana. Though Ramotswe holds traditional cultural beliefs, she also recognizes some of the inherent problems with her culture, such as the discrimination and violence that many women and children face—through her experiences with an abusive ex-husband, she conveys her firsthand knowledge of these challenges. She is a generous and kind woman whose aim in life is to be of assistance to those in need. Because she has a wide circle of friends, she is often able to solve problems she otherwise might not. As in much of Africa, in Ramotswe's world, community and family are central.

After spending a sunny afternoon with Sangai Mambai Lengarus, I suspect she is a superhero too.

When we meet, Sangai is wearing a brilliant, eye-catching red dress. She has just come from a presidential event in downtown Arusha, though she is quick to tell me she only saw President Hassan from a distance. She laughs as she says this, implying she doesn't think she is important enough to get close to the president—at least, not yet.

As Sangai tells me about her work, it's clear she's proud of her position as a division officer for the Arumeru District, which surrounds Arusha like a horseshoe to the north, east, and west. Yet she is also grounded in the gravity of the problems she is working to address. Most of the time, her job isn't the glad-handing of politics but rather the tough work of listening to people's problems and working to solve them.

Sangai tells me her days typically start early. As the sun rises, she climbs aboard the back of a motorcycle, riding sidesaddle behind a driver, as many Tanzanian women do. Some days she takes off for the forested foothills between Mount Kilimanjaro and Mount Meru. Other days she traverses the rolling plains north of Mount Meru—a place where giraffes and elephants still roam among Maasai bomas.

Sangai lives in a densely populated place—a town east of Arusha called Maji ya Chai—but she can most often be found heading into the remotest places on the roughest roads in the Arumeru District, always on the back of a motorcycle. Most of the communities she visits represent the Maasai or Meru cultural groups. Nearly everyone in the district farms or raises livestock—and yet even with so much food production, one in three people Sangai meets are hungry. Even more live without access to clean water. Malaria, typhoid, tuberculosis, diarrhea, and malnutrition are common, and access to medicine and medical services can be uncertain. This is the context of Sangai's work.

"Sometimes I meet with community members at their homes, but most often under the shade of trees," she tells me. "My job is to listen to them and to find solutions to the challenges they face. In the Arumeru District, we have six divisions, so I am one of six division officers. I am responsible for the King'ori Division, which has ten wards, ninety villages, and one hundred and forty subvillages."

Hearing this, it seems to me that Sangai should look exhausted, but instead she looks determined, even radiant. Her warm, ready smile projects joy. She clearly loves her work, and I can see why people trust her.

"Right now, we are working on eliminating marijuana [which is illegal in Tanzania] in our district," she goes on. "We are building classrooms and hospitals and working to improve conditions for young entrepreneurs. We are undertaking so many activities that concern the community in general, such as improving access to water and electricity."

Beyond the larger societal problems that are within Sangai's purview, she also addresses the everyday problems of individual citizens. Frequently, she resolves land conflicts between neighbors and works with women and girls who are experiencing gender-based discrimination or violence.

"In the Arumeru District and elsewhere in Tanzania, the Maasai are experiencing tremendous change, and this is resulting in conflict," she says pensively. "As land and

GOVERNMENT 147

> *"In the Arumeru District and elsewhere in Tanzania, the Maasai are experiencing tremendous change, and this is resulting in conflict."*
>
> —SANGAI MAMBAI LENGARUS

water become privately owned, national parks and conservation areas expand, and climate change brings unpredictable weather, many Maasai are forced to forego their pastoral lives. Instead of herding cattle and goats in a seasonal pattern that follows the long and short rains, many Maasai are becoming more settled, diversifying their livelihoods into crop production and business. These shifts in land use have increased conflicts as the Maasai who are still migratory illegally herd their livestock onto private land, and those who seek to grow agricultural crops need land to do so. I work with land officers, police, and social workers to solve these conflicts."

As a Maasai, Sangai clearly understands the stresses associated with the loss of traditional ways of life, and she can talk to people from that perspective. As a Maasai woman, she also knows the difficulties women and girls face from personal experience.

"Maasai girls face so many challenges as they grow up," she tells me. "The first is early, forced marriage. I faced this challenge, and thanks to my aunt I was able to overcome it, but not every girl has a supportive family member."

Sangai grew up in a traditional Maasai home in a remote village in the Longido District. Though her brother wanted to arrange a marriage for her when she finished primary school, her aunt had other ideas about Sangai's future. She understood that education would give Sangai opportunities many Maasai women lack, so she encouraged her niece to attend the MGLSS.

"Access to education is another challenge for girls," Sangai says. "Primary schools have been built throughout the Arumeru District, but teachers, books, and other resources are in short supply."

While attendance rates at primary schools are high in the Arumeru District today, less than half of its adults have completed primary school. Across Tanzania, secondary school attendance remains below 40 percent. For Maasai girls, the number is much lower.

"I benefited a lot from my time at the MGLSS," Sangai recalls. "Not every girl has that chance. At the MGLSS, I learned to be a leader, and today I am still a leader. The school prepared me well to help my people. I graduated from the MGLSS in 2012 and went on to complete a bachelor of education and a master of education, policy planning, and administration at Tumaini University in Iringa." She continues, "Graduates of the MGLSS have

> *"I benefited a lot from my time at the MGLSS. Not every girl has that chance. At the MGLSS, I learned to be a leader, and today I am still a leader. The school prepared me well to help my people."*
>
> —SANGAI MAMBAI LENGARUS

removed the misconception that a girl has to be married when she reaches a certain age, or that she can't go to school because she doesn't have a voice in the community. I work with Maasai people, and they see I have a voice and I have influence. I have removed the misconception that girls can't lead."

When she's not out changing the world, Sangai looks forward to spending time with her husband and her two children—a boy and a girl. She gets a wistful look on her face as she says, "I have big dreams for my children. I want them to go even further than me without the challenges I faced. I want them to get a quality education that prepares them to help the community."

Though balancing her role as a mother and a community leader must be difficult at times, Sangai seems unburdened, as if she has the world by the tail. She is, without question, an extraordinary woman. Unlike fictional superheroes, she lives in the real world, and the problems she faces are not trivial—and yet she leads with hope. There is no discouragement or defeat in any part of her. She closes our time together with a Tanzanian proverb with Biblical roots: "The hand that gives is more blessed than the hand that receives. I want to be the hand that gives."

In the Arumeru District, I suspect people know Sangai as the one who always gives a hand.

In March 2024, after this interview took place, Sangai was promoted to district administrative secretary in the Busega District in the Simiyu Region near Mwanza. She works on similar issues in this district and serves as an advisor to the district commission.

UPENDO LEBENE LUKUMAY, 2005 GRADUATE, A-LEVEL

Enhancing the Welfare of Women through Social Work

Upendo Lebene Lukumay asked us to meet her at her office, a government building on the outskirts of Arusha, for our interview today. It's a simple, one-story, concrete-block structure that's painted a sunny pastel hue. A Tanzanian flag flies out front.

As we pull into the small parking area behind the building, Upendo comes around the corner with a friendly smile on her face. She wears a tangerine-colored dress and has her hair neatly slicked back into a claw-style clip. She sports black-and-white Nike sneakers on her feet—a punchy addition that makes her appear young and hip despite the fact that she is in her early forties.

Mostly, she looks happy.

When I walk up to meet her, Upendo exclaims, "Ah, mwalimu (teacher), how have you been?" She takes both my hands in hers and holds eye contact as she says this, signaling that her question isn't just a formality.

We've known each other since 1999, when Upendo was a Form One student at the MGLSS and I was her teacher. Over the years we've stayed in touch. She looks much as I remember her as a student, her ready smile and kind-hearted demeanor always on display. Even though our visits have been intermittent over the years, it feels as if no time has passed since we last saw one another—like we are old friends who see each other regularly. Upendo has a knack for making those she knows feel like close friends no matter the depth of the relationship. She's always treated me more like a favored aunt than like a teacher who has come and gone from her life.

After we exchange pleasantries and Upendo meets the interview team, she shows us around her office and introduces us to her coworkers. The building contains one large central meeting room bookended by smaller offices at each end, one of which is Upendo's. She is a social worker in the Oloirien Ward, located on the northwest side of Arusha. Much like a

town hall, her office building is a busy, noisy place where conversations reverberate off the stark concrete walls, so we walk up the road to a modest, local lodge where we find a quiet spot outside to conduct the interview and enjoy a hot cup of tea afterward.

Once we are set up, I ask Upendo to tell me about her work.

"I'm a community development officer in the Oloirien Ward," she launches in. "We have special activities that help the whole community, but my job is mostly focused on counseling women and children. For example, we've created groups of women we support on many issues, including women's and children's rights. We talk about violence prevention, and we support women and children who are experiencing abuse. The groups of women provide support to each other on a range of issues, but they can call me for counseling or to report violence. We can involve the police too when it's necessary."

I'm heartened to know about public programs, like Upendo's, that are addressing gender-based violence in Tanzania. This issue remains prevalent here; in fact, the World Bank estimates about half of women and girls under the age of fifty in Tanzania have experienced physical or sexual violence. This is a difficult statistic to contemplate, and one that I suspect is even higher among Maasai women and girls, some of whom are still subjected to FGM and child marriage even though a new generation of Maasai women like Upendo are spearheading efforts to eliminate these practices.

As I think about Upendo leading groups of women toward a better future, she tells me more about her work.

"Empowering women is about more than just telling them about their rights, so we also provide education and support on financial literacy, loans, small business development, and leadership. If a woman creates a small business plan, we will review it to see if she qualifies for a loan. A small business can change a woman's life. If she has her own income and a way to support herself and her children, she is empowered. I count this as a great success." Upendo leans forward, nodding. "We also encourage women to become involved in positions in the community to influence decision-making even when challenges are there. In this ward, we have many Maasai people, but the community is broader too. We are working with women from many different tribes, because all of them need opportunities to thrive."

> *"A small business can change a woman's life. If she has her own income and a way to support herself and her children, she is empowered. I count this as a great success."*
>
> —**UPENDO LEBENE LUKUMAY**

Upendo shares information that I already know for the sake of the interview—that she's been a social worker for fourteen years, since she completed her undergraduate degree in sociology and anthropology. She also has a

post-graduate degree in social work that she recently completed while working full time. Though she has all the right credentials, I know there are reasons beyond her education that qualify her to do this important work. "I suspect you can personally relate to the challenges women and girls face. Can you tell me about some of the challenges you have faced?"

"Uh-huh." She nods and pauses for a moment, clearly considering her response. "When I was a child, my life was good in many ways because I was born into the Maasai community. We kept cattle and we sang traditional songs together. Everyone knew each other, but in terms of social services, like having access to education, clean water, or good healthcare, those facilities were not there. Even beyond this, I faced my own forms of gender-based violence, like FGM and early forced marriage."

With this revelation, Upendo's voice cracks. She holds her face in her hands for a moment. I sit quietly, waiting for her to take the lead, not wanting to press for information she may not feel comfortable divulging.

After a minute, I simply ask, "Do you want to share more about that?"

Upendo gathers herself and continues, even though tears have begun to run down her face. "I remember the day they took me for FGM. They didn't tell me anything about what was happening. My sister-in-law came to find me while I was taking care of the cattle. I was eight years old. When I arrived home, I found an old woman holding a razor. My sisters held me tight and removed my clothes. The old woman cut me."

Upendo openly weeps now, unable to say more, so I quietly thank her for sharing her experience as we both struggle to regain our composure.

When she's ready, she tells me, "As you know, Maasai customs and traditions require circumcision for boys and girls. My mother and my sisters, like other women at that time, believed I would be ostracized from my culture without the procedure. Without circumcision, I would be considered a child and unfit for marriage. Unlike today, we weren't educated about the harmful effects of FGM. It's a very cruel act, causing unbearable pain, but if you cry you will be ridiculed, so you must endure it. There are instances where FGM involves a ceremony, and others where it happens unexpectedly, like it did with me. Nowadays, ceremonies are not held openly due to government bans on FGM. Though fewer girls are subjected to the practice now, I would say more than 95 percent of my classmates at the MGLSS had this experience."

Though this does not surprise me because I've heard these statistics before, I sit with this information for a moment. Upendo still lives with the trauma of her experience, and the idea that so many Maasai women live with it too sends a wave of grief through my body. The brutal practice involves entirely or partially removing the external genitalia, without anesthesia, and the health implications can be profound, including chronic infections and pain, scarring, increased risk of HIV and other sexually transmitted diseases, and increased risk of obstetric fistulas and childbirth

complications. Beyond this, the practice often threatens a women's sense of safety and well-being and, as is clearly the case for Upendo, causes long-term trauma.

Unfortunately, circumcision has been a significant part of Maasai culture for generations. Though Upendo's experience was singular and without ceremony, groups of Maasai girls and boys are often circumcised in separate coming of age ceremonies that also involve singing, dancing, and the passing on of stories to the next generation. These groups form age sets that last a lifetime and define the tribe's social structure. Without the ceremony, this central part of Maasai culture is lost. Thus, some Maasai women today are looking for ways to maintain this coming of age tradition without the cutting.

"I feel so much," Upendo says with a hard swallow. "It's difficult to talk about these issues, but I will tell you there's another thing that I struggled through. My dad planned a marriage for me when I was still very young, but my mom helped me."

"How old were you?" I ask.

"I was sixteen years old when I completed primary school, and that was when I was supposed to get married," she answers. "It's actually a very touching story, because if it wasn't for the MGLSS, I would have a much different life now."

"Will you tell me that story?" I prompt.

She nods. "There were some teachers who came from the MGLSS to my primary school. They conducted interviews with all the girls in my class, but unfortunately, one of my teachers chased me away. I don't really know why he did this, but I missed the interview. I explained what happened to my mother, and she was very upset. Early the next morning, she went to my school and talked to that teacher. I don't know what was said, but later she took me to the local pastor, who arranged for an interview at the MGLSS. During those final days of primary school, my dad was also telling me not to perform well on my exams. I wondered why he would give me this advice, so I asked my mom. She then realized his plan and explained to me that my father wanted me to get married so that he could get a lot of cattle. She sent me right away to the MGLSS. That's how my mom helped me escape the forced marriage. She told me to stay at school even up through Form Four, otherwise I would have been married."

"So, it sounds like your mom valued education and she encouraged you a lot," I note.

"Yeah, I was the last born of her ten children and the only one of her kids to go to secondary school. Though my mom didn't have an education herself, she had a big mind. She wanted me to go to school so I could help myself and so I wouldn't face the mistreatment some Maasai women experience. Things like being beaten. She helped me go to school, and several of her grandchildren, too. Though my mom is no longer with us, she was alive when I finished university, and she was so happy. She would be so proud today because I have three kids, and they are all in school."

Upendo wears a distant expression on her face as she shares her mother's influence on her life. It's evident she misses her deeply.

"All these experiences prepared me professionally," she tells me. "I understand the challenges women and girls face because I have also faced some of those challenges."

"Did you marry the Maasai man your father chose for you?" I ask.

She chuckles. "No, not at all, but my dad is happy anyway. I send him money and I take him food. I built him a house. So I think he sees that educating me was even better than finding me a husband."

Like many of the women I've interviewed, Upendo has remained loyal to her father despite the challenges of their relationship—challenges born of a widening gap between Maasai traditions that harm women and a generation of women working to change those practices.

"This will make you laugh," she tells me. "I met my husband by email."

I smile and joke, "So you have an e-husband?"

Upendo tosses her head back and laughs. "First of all, I want to tell you about my first boyfriend. He was a Maasai guy. He was tall and handsome. I loved him so much, but I soon learned that I had to leave him because he was very harsh and abusive. I was heartbroken." She holds her hand over her heart.

This is not the funny story I had imagined when Upendo began it. *Why*, I silently wonder, *couldn't she have found an encouraging, gentle man*? And yet I recognize these are not valued characteristics among most men who proudly wear the badge of Maasai warrior.

"While I was in college in Nairobi," she continues, "I got an email from this guy who said he got my email address through a classmate. He invited me for a date. I told him I wasn't ready to be in a relationship, but he was persistent. He convinced me." Upendo giggles at what is obviously a fond memory. "After that, I finished college and we got married. He is an accountant, and he is also Maasai."

I'm delighted to see her smiling and to know that she found a suitable Maasai man after all. I also reflect on how difficult it is to speak openly about abuse and violence, and I'm grateful to her for sharing her story.

Over the years, I might have guessed at Upendo's experiences simply because she is a Maasai woman, but now, looking at her, I'm filled with wonder at how she has remained so open, trusting, and happy despite all that she has endured. Even more, she's now actively working to give other women space to share their stories and the tools they need to break the cycles of poverty and violence. I can't imagine a better woman for the job—and I tell her so as we enjoy a hot cup of tea and reminisce about our days at the MGLSS.

◆ **OTHER FIELDS** ◆

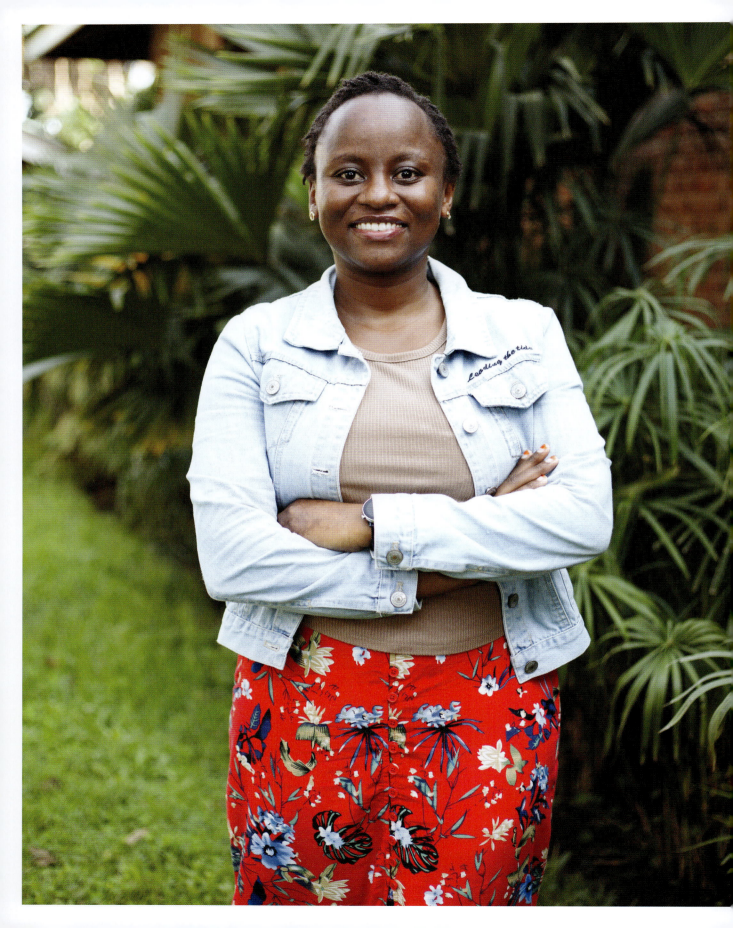

NASHIVA ALBERT MEGIROO, 2010 GRADUATE, O-LEVEL

Architectural Design by and for Women

We meet Nashiva Albert Megiroo in downtown Arusha's business district, where she has opened her own architectural practice. In this part of town, government offices, banks, safari companies, and classy coffee shops and restaurants line streets bustling with professionals in suits and dresses and tourists in khakis and wide-brimmed hats. Nearby the Ngorongoro Tourism Centre, a mirrored, eighteen-story skyscraper dominates the horizon. The building stands at least a dozen stories taller than any surrounding buildings and serves as a bold statement on Tanzania's wildlife-filled national parks and the tourism shillings they attract. Just blocks beyond this, the United Nations' International Criminal Tribunal and the Arusha International Conference Center attract a global audience. In other words, this is a happening part of town.

Nashiva meets the interview team on the street and greets us with a wave and a friendly smile. She is wearing a navy-blue blouse with jeans and ballet flats. A delicate gold chain hangs around her neck, and a gold bracelet encircles her wrist. Her long hair is neatly gathered at the nape of her neck in a series of elegant, twisted dreadlocks. With an office in this part of town and her chic look, Nashiva fits the part of a hip, young design professional.

After brief introductions on the street, Nashiva guides us up two flights of stairs to a modest, one-room office. Inside, there are two desks and several chairs for visitors and clients. The desk nearest to the door is topped with a large monitor and computer. An adjacent shelf contains sketchbooks, colored pens and markers, and other drafting tools one might expect to see in an architect's office.

"This is Anna," Nashiva says, gesturing to a young woman who is sitting behind one of the desks. "She is working with me as an intern."

Anna stands and shakes our hands but remains quiet, seemingly shy and unsure

of what to say. She looks to be in her early twenties, still a timid young professional.

Our purpose today is twofold: We have come not only to interview Nashiva but also to see the architectural designs she is working on for Esuvat, who is with me today and who has been instrumental in organizing the interviews for this book. When Esuvat isn't organizing interviews in her fleeting spare time, she serves as the executive director of Eripoto for Girls and Women, a nonprofit organization she founded in 2022 to provide lifesaving interventions for Maasai women and girls who have suffered violence at home. The organization operates a safe house in Arusha that provides room and board, counseling, vocational training, and other support services, including scholarships, to young women—some still girls—who have endured rape, beatings, forced marriages, and other forms of gender-based violence.

As a survivor herself, Esuvat knows firsthand the challenges these young women face—as does Nashiva, who as a Maasai women is uniquely qualified to consult on developing a new campus for Eripoto. The circle of professional Maasai women in Tanzania is small, tight, and well connected, so it's no surprise that Esuvat and Nashiva have found each other and are working together on this project. The idea that Eripoto—a safe place for Maasai girls—is growing through the knowledge, experience, and wisdom of these two Maasai women is deeply moving to me, and I'm gratified to be here seeing firsthand the impact they are making on women's lives.

As if on cue, Nashiva leans toward us, raises her eyebrows, and asks almost conspiratorially, "Do you want to see the designs?"

Esuvat and I nod enthusiastically, and before we know it the site plan unfolds before us on Nashiva's desk.

"Ladies, these are the plans for Eripoto for Girls and Women!" Nashiva says with a flourish. Her excitement is contagious. As she points to the designs, she tells us, "This began as a straightforward effort to review Eripoto's plans for their existing safe house site, but it quickly became clear that they didn't have enough space for their planned growth. I suggested they search for a larger location that could support their long-term vision, and I'm delighted they found a piece of land large enough to accommodate their project's space requirements."

"The safe house's current capacity allows us to serve around twenty-five girls," Esuvat chimes in, "though as you know, the need remains far greater. I asked Nashiva to look at our existing site to see how we might expand it, but it quickly became clear that we didn't have enough space. She helped us identify another

piece of land not far from our current site where we can really grow our vision. Fortunately, OBA and other partners helped us acquire this land, and Nashiva is helping us create a site plan."

Nashiva uses a pen to point to various features of her designs, including dormitories, a kitchen and dining hall, a small clinic, classrooms, and offices, as well as agricultural and garden plots.

"The large site allows us to grow some of our own food," Esuvat explains. "This can also be a learning opportunity for our girls."

"And there is a small stream on one side of the property," Nashiva says, referencing the location of the stream, "that ensures Eripoto will have access to water."

Nashiva explains that most of the buildings have been designed with internal courtyards to bring fresh air and light into the buildings. We spend several minutes going over the specifications for various spaces before Nashiva hands the site plan to Esuvat.

"The next step is to develop more detailed drawings of all the buildings," Nashiva says.

I'm warmed by these women's joint effort toward something that will change so many lives.

Now that it's time for the more formal interview to start, Nashiva clears off her desk and sits more upright, preparing herself for my questions.

"How did you decide to become an architect?" I ask.

"I became interested in architecture after secondary school. I always wanted to be a pilot," she says with a far-off expression, "but I didn't get the chance. My second choice was to work in the construction industry. I wasn't interested in engineering, so I decided to study architecture."

"Tell me more about your education," I prompt her.

"When I completed O-Level at the MGLSS in 2010, the school was not offering physics, geography, or mathematics, which I needed to study to become a pilot, so I went to Ifunda Girls' High School in Iringa to study these subjects. After I completed A-Level, there wasn't an opportunity for me to go to pilot training, so I went to Mbeya University of Science and Technology, where I became interested in architecture. After four years of study, I completed a bachelor of technology in architecture in 2017. After graduating, I worked for a small firm in Arusha, but there were no paid positions, so I was just working as a volunteer for two years. Then I decided to start my own practice as a freelancer. I started working at home and then I got this office."

Nashiva beams with pride as she recounts the details of her journey, and I'm impressed by her courage. "What were the challenges you faced striking out on your own as a young woman?" I ask her.

"From the start, I didn't know what the challenges would be, but there have been big challenges for me as a woman. The construction industry is a man's world," she says with a wry chuckle. "You need to be tough in the mind and in the heart." She points to her temple and then to her chest. "Many people believe only men can consult on construction. I get asked, 'Are you a fundi (construction worker)? Can

> *"From the start, I didn't know what the challenges would be, but there have been big challenges for me as a woman. The construction industry is a man's world. You need to be tough in the mind and in the heart."*
>
> —NASHIVA ALBERT MEGIROO

you do this?'" she says, lowering her voice to mimic a man's. She sits up straighter, squaring her shoulders. "I tell them, 'I can do this.' The biggest challenge is lack of trust simply because I'm a woman, but I'm slowly getting there. People are starting to trust my capabilities and the lengths to which I will go to help them with their projects. This year my company will be registered with the government, which means I can now work on public projects. Prior to this, all my projects have been private."

I'm captivated by her drive to transcend boundaries in a society that is still largely dominated by men. "Tell me more about the types of projects you work on."

"I've worked on residential projects, as well as schools, lodges, and one hospital," she explains. "My favorite project to date is a guest lodge I designed for a client. It is now being built. I designed six rooms with an atrium in the middle that provides light and ventilation. I've also designed an additional dormitory at the MGLSS. Although the dormitory is similar to other existing buildings, the project required that I truly understand and respect the school's defining architectural concepts while also creating something new. I'm also working on a new girls' dormitory at Masange Juu Secondary School in Lushoto. Girls who don't live on campus face many difficulties, such as lack of electricity at home. When it's dark, they can't study, and they often have many responsibilities at home that don't leave enough time to study. They must travel great distances to get to school. This project provides girls with a place to stay at school so they can be more successful in their studies. It's currently under construction, and I'm eager to see it finished."

"What was your childhood like?" I ask, quickly pivoting to a topic I want to hear about before the interview ends.

"I come from a rural part of the Arusha Region, from an area formerly known as Arumeru," Nashiva says. "It's a village called Olgilai in the foothills of Mount Meru. As a child, it was difficult to get a good education because we did not have schools around my village, but my parents were very passionate about education. They wanted me to get a good education from an early age."

I'm surprised by this response. I expected Nashiva to tell me that her parents did not want her to go to the school. "Your parents had an uncommon view of education," I say.

"Their supportive attitudes toward education were rooted in their own experiences, especially my mother's. She recognized that education could open doors for me. I first got interested in going to school when I saw my mother helping girls she had rescued from forced marriages. She would find opportunities for them to

study at the MGLSS, or at other schools that could support them. When I finished primary school, my parents weren't working. Though they wanted me to get a good education, it was difficult for them to pay school fees. I got the chance to interview at the MGLSS, and I got a scholarship. The MGLSS was a very good school for me. Having an opportunity to study there was a gift." She laughs lightly. "And because I was there my parents slept well, knowing they didn't have to worry about where they would find school fees."

"Your mother sounds like a remarkable woman," I say. "Tell me more about her efforts to help girls."

"I cannot remember the exact number of girls my mother helped, but I can quickly name more than ten," Nashiva says. "My mom went to primary school, but then her mother wanted her to get married. She resisted, with the help of her brothers. Even her father asked her if she wanted to get married or go to school. When she chose school, he supported her, which was so rare at this time. My grandfather had five wives, and my mother was the only one among his daughters fortunate enough to have that choice. My mom went on to study O-Level but couldn't go further than Form Four. She saw the importance of education for girls, and that inspired her to help others. My mom always wanted the best for her kids, but her hope extended to girls who were suffering at home. She knew education would change things for them. She is still helping girls today." Nashiva tilts her head in thought. "My mom

> *"Through my career, I'm targeting communities that need better housing, schools that need better dormitories for girls, and nonprofits like Eripoto that are helping Maasai girls in need. . . . I want to give back, to bring important services closer to the Maasai community, to help them move out of poverty."*
>
> **—NASHIVA ALBERT MEGIROO**

taught me to give back what I have learned. Through my career, I'm targeting communities that need better housing, schools that need better dormitories for girls, and nonprofits like Eripoto that are helping Maasai girls in need. The MGLSS played a part in this. As a graduate of that school, I want to give back, to bring important services closer to the Maasai community, to help them move out of poverty."

"I'm so grateful for your work," I tell Nashiva as we wrap up our time together.

Even a decade ago, no Maasai women had the training to design homes, lodges, schools, or hospitals, let alone safe houses. Nashiva's firsthand knowledge of her community and her unique perspective as a Maasai woman enable her to design structures others could not. She is a trailblazer in Tanzania, waging an uphill battle in a male-centric field, but she remains undaunted. Her designs—architecture by women and often for women—will help shape a better future for us all.

OTHER FIELDS 163

ELIZABETH LOIRUCK, 2006 GRADUATE, A-LEVEL

Building Agribusiness in Tanzania, Part One

Just around the corner from Elizabeth Loiruck's office in central Arusha, Tanzania's flourishing agricultural sector flaunts its wares in the city's market district (pictured on page 166). Shoppers clog the streets and sidewalks, and higgledy-piggledy produce stands fill storefronts, walkways, and every vacant nook and cranny. Colorful buckets are piled high with avocados, oranges, mangoes, onions, potatoes, and green peppers. Small piles of carrots, okra, and tomatoes, as well as larger piles of papayas and watermelons, are stacked on tarps or in boxes. Bunches of bananas and plantains hang from the rafters. Bulk bags of red beans, maize, and rice tip against each other. Amidst this colorful array, hawkers walk the streets selling roasted peanuts and cashews, and women roast maize for sale hot off the small charcoal grills found on many street corners. This thriving riot of sights, sounds, and smells feeds the city.

After navigating the busy streets around the market district, our interview team arrives at the business headquarters of Tanzania Advanced Agriculture (TAA), where Elizabeth serves as the director. We're here to learn more about her work enabling small-scale farmers to participate in Tanzania's agricultural sector—a pillar of the country's economy that employs roughly 75 percent of its population and represents nearly one-third of its gross domestic product.

Elizabeth's second-floor office is bright and airy, a wall of windows offering a bird's-eye view of the bustling street below. Several desks and a large round table fill an open floorplan.

Elizabeth greets us warmly and welcomes us to her office. She and I have known one another for many years, so we make small talk about her family while Tryphone sets up his recording equipment.

"My three beautiful daughters and my husband are doing very well," Elizabeth tells me with a radiant smile. "We have some small projects as a family, keeping cows and growing

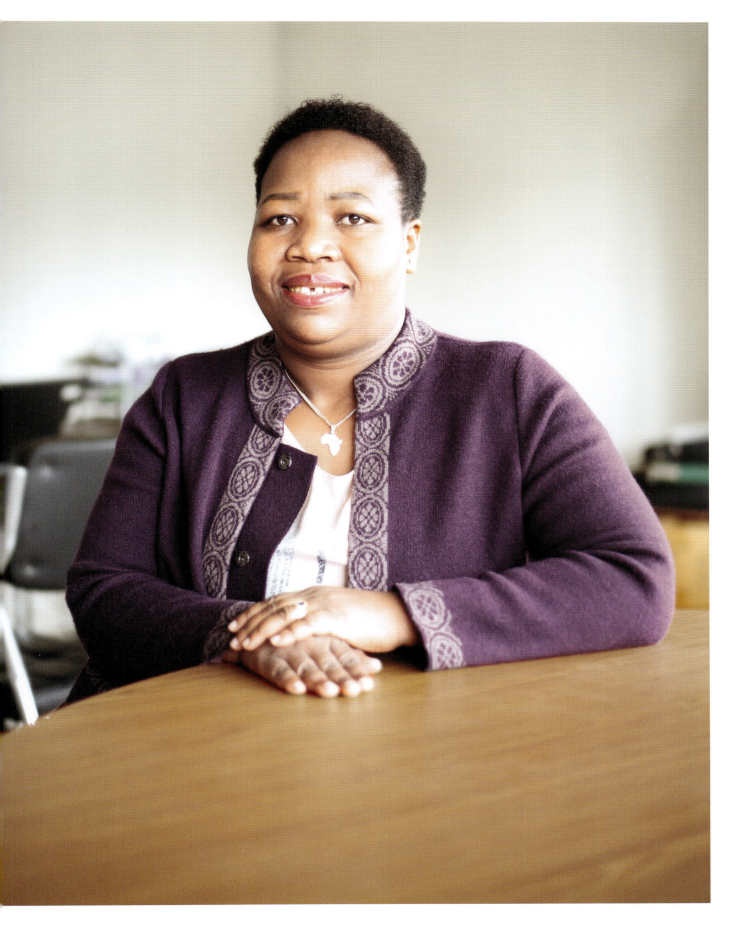

feed for the farm. We are all doing very fine. My life is really a blessing."

This is the Elizabeth I remember: always smiling, always positive, and always looking for the next opportunity. She is an entrepreneur at heart, so that's where I start the interview—by asking her about her most recent venture, TAA, which she started with another graduate of the MGLSS in 2022.

> "We started TAA Limited as a small business that aims to help small-scale farmers and pastoralists, especially women who are organized in cooperative groups."
>
> —ELIZABETH LOIRUCK

"I am one of the founders," she tells me with pride. "We started TAA Limited as a small business that aims to help small-scale farmers and pastoralists, especially women who are organized in cooperative groups. We want to help them gain access to low-cost financing. For example, TAA has expertise in issuing revolving credit funds to people in rural villages that have no access to financial services. Participants can access loans to grow their businesses without going through institutions that require high guarantees. We emphasize the importance of understanding loan terms and conditions before taking out credit. We want to help people without prior experience with loans to get reasonable terms and build a good credit history. If they can get funding for better seeds, or more cows, or equipment that helps with planting, harvesting, or processing, then they can grow their profits. TAA has positioned itself to work inclusively with all actors in the agribusiness value chain, connecting farmers and pastoralists with processing, packaging, storage, transportation, and marketing. Beyond this, we have also established a nonprofit, the TAA Foundation, to give the farmers and pastoralists we work with the knowledge they need to participate in and even develop this value chain themselves. We are now working with about five hundred farmers and pastoralists who are getting skills, training, and credit support so they can increase their economic activity."

"Terms like 'value chain' and 'agribusiness' are new to me," I admit. "Can you give me an example of a project that TAA supports so I better understand your work?"

"Yes," she says with a nod. "TAA is supporting a group of women who are working together to establish a dairy-processing initiative that will allow them to deliver milk products to consumers. This increases their income and expands what they are doing beyond just raising animals that produce milk for their families to raising animals to produce milk they can sell to others. They are trained in proper techniques for milking and handling to maintain high standards of hygiene. This includes using clean equipment, ensuring cows are healthy and udders are clean before milking, and filtering milk to remove impurities immediately

after collection. They are also trained in the importance of refrigeration and alternative methods of preserving dairy products using solar-powered refrigerators. Since most Tanzanians are on Facebook and WhatsApp, we are also training the women on how to use these platforms to market their products. Beyond this, TAA Foundation is training the women in entrepreneurial skills and financial literacy. Training introduces the concept of entrepreneurship as an opportunity to create value, take initiative, and take control of their financial futures. TAA Foundation also teaches basic money management like understanding income versus expenses and setting aside money for savings and emergencies."

I'm learning a lot from this interview and the work Elizabeth is doing, and I'm eager to uncover more. "So, a value chain is a pathway from farm to consumer, correct?"

"You are right," Elizabeth says.

"And TAA helps small-scale farmers and pastoralists by giving them financing and knowledge to improve their products, packaging, labels, storage, transportation, and marketing to consumers," I say, verbally processing what I've just heard. "It seems like you're achieving multiple positive outcomes with a strategy like this. By investing in small-scale farmers and pastoralists, TAA improves their economic outlook, raising them out of poverty. And these farmers feed people who live in areas where access to products like fresh milk and vegetables may be scarce. You give people in rural areas access to these types of healthy foods. Diets improve. Children grow up healthier. Agribusiness brings the promise of a better life for farmers and the communities they serve."

Elizabeth nods enthusiastically. "Yes, yes!" she exclaims. "TAA Foundation is empowering Maasai women and youth through programs on climate-change adaptation, sustainable agriculture, and livestock management so they can make more informed decisions about resource use and conservation. They are trained in contemporary animal husbandry practices and climate-resilient strategies. This involves blending traditional knowledge with modern approaches to sustainably manage livestock. For example, we give them information on how to cross-breed indigenous Maasai cattle with more climate-resilient breeds to enhance productivity and survival rates. They also learn about modern veterinary services, including regular vaccination and disease monitoring to prevent outbreaks and reduce losses. They learn about rotational grazing and controlled herd size to help prevent overgrazing, which depletes the land and makes it less resilient to droughts. And lastly, instead of focusing solely on cattle, they also learn how to raise other livestock, such as goats, sheep, and chickens. These animals often have higher tolerance to drought and heat, providing a buffer against climate shocks."

"It's amazing," I say, shaking my head with appreciation, "that you're helping the Maasai turn their pastoral way of life into an agribusiness that can support them economically while also building on the importance of livestock culturally. Certainly,

milk production is one way, but so is meat production, if they can find a way to balance herd sizes with available land and raise healthier cattle. They no longer have to watch their herds dwindle without access to grass and water. They can have fewer, more productive animals that they sell to different types of markets. How many people does TAA employ to do all this work?"

"Right now, we have five people," she explains. "Three are doing field work, and two are working on fundraising and managing the business operations. This is a small staff for the number of groups we are working with. We have fifty-nine groups in Mbeya and twenty-six groups in Morogoro. Then we have another thirteen groups in the Arusha Region (one group pictured above)."

"How did you get into this type of work?" I ask.

She gazes out the window for a moment before answering. "I suppose my whole life has been a preparation for this work," she says after a beat. "I grew up in a village called Kakoi, near Tarangire National Park. My dad had two wives, and my mom had seven children. The other wife had eleven children, so we were eighteen in our family. The economic situation for my family was difficult, so I understand the challenges for pastoralists. We had few opportunities. The scholarship I got from the MGLSS was really a blessing to me, and that school influenced me in so many ways. Actually, the MGLSS is an agricultural school, so I learned a lot there that informs my work today. We took agriculture subjects from Form One to Form Six, and we helped on the school farm growing coffee, maize, and beans. I discovered while I was at the MGLSS that I really love agricultural work. I wanted to

> "We took agriculture subjects from Form One to Form Six, and we helped on the school farm growing coffee, maize, and beans. I discovered while I was at the MGLSS that I really love agricultural work. I wanted to transfer that knowledge to other farmers and pastoralists."
>
> —ELIZABETH LOIRUCK

transfer that knowledge to other farmers and pastoralists. Many of them lack qualifications to go to the bank to get financial support. They also don't have an opportunity for technical training and education that would help them do agriculture in ways that are economically viable and friendly to the environment. So, TAA is filling this gap by helping small-scale farmers. Because I come from a pastoralist society, I'm trusted. TAA can go there and give people training about different breeds that have higher values compared to the local livestock. Then, on the financial side, I have a bachelor's degree in accounting and finance, and I'm a certified public accountant. This knowledge has helped TAA develop the microfinance and revolving credit fund approach and manage this part of the business."

"I understand you're working with a classmate from the MGLSS on TAA," I say.

"I am working with Faraja Kimetuu Kurubai," Elizabeth confirms. "She and I graduated in the same class, and we have a shared interest in agribusiness. We are the founders of TAA. In Mbeya, where Faraja grew up, we are working with several women's groups to create small agribusinesses."

"I'll also be interviewing Faraja in the weeks to come," I tell her. "So I'm sure I will learn even more about the great work you are doing."

Elizabeth smiles at this. "Karibu, mwalimu. You are warmly welcome."

After we bring the interview to a close and say our goodbyes, the interview team and I drive back through Arusha's market district. Now I see things anew because of our interview with Elizabeth. Through TAA, she is teaching people to participate in local and regional markets like this one. She is financing systems that help struggling farmers and pastoralists in Tanzania to scale up, produce more, and become profitable, not just to feed themselves but to feed their neighbors, too.

I think about the disheartening images I've seen of skeletal Maasai cattle starving during Tanzania's increasingly frequent droughts, and then I picture groups of women working together to raise healthy cows as part of milk cooperatives. Elizabeth's mission is agriculture as hope—a viable path forward for Maasai people who are eager to find sustainable ways to maintain their pastoral lives in a new era.

FARAJA KIMETUU KURUBAI, 2006 GRADUATE, A-LEVEL

Building Agribusiness in Tanzania, Part Two

Faraja Kimetuu Kurubai and I first connected at Concordia College, located in Moorhead, Minnesota, on a brisk weekend in December 2009. We'd both attended the school's commencement ceremony, which was followed by an after-party hosted by the college's president. From 2002 to 2016, Concordia College provided eleven scholarships to support top graduates of the MGLSS, one of which was awarded to Faraja. On that weekend in December, one of Faraja's peers from the MGLSS graduated—a student I remembered well and one I was proud to see complete college. At the after-party, I mingled with alumni of the MGLSS, as well as a small but powerful group of faculty members who were enthusiastic supporters of the tight-knit group of Maasai women attending college in a place very far from home.

At the time, I was working on my first book, *Among the Maasai*, and I asked Faraja and a few other Maasai women attending Concordia College to talk with me about their experiences over the course of that weekend. My conversation with Faraja was far-reaching, spanning everything from her personal history to her insightful reflections about her culture and the challenges it faced. She struck me as a forthright, confident, and very smart young woman during our first conversation.

I archived an audio recording of our interview from 2009, and I listened to it again the day before my second interview with Faraja. With fifteen years separating our two conversations, I'm interested to hear how the ideas and plans she shared with me during our first conversation have evolved, and how experience and time have shaped her views today.

During the first interview, I asked Faraja about her home village, her family, and her life growing up, and we talked extensively about the problems the Maasai people faced at that time. She started by telling me that she grew up in a village called Matebete in the Mbeya

Region of southern Tanzania. Like many Maasai girls, she was raised in a traditional Maasai boma and struggled to find her way to secondary school. She recognized that the MGLSS offered her an incredible opportunity for an education that could have easily passed her by. Though her mother never received a formal education, she learned to read and write at church and was instrumental in encouraging Faraja to attend the MGLSS.

Once there, Faraja excelled. She sang in the choir, participated in student leadership positions, and performed exceptionally well academically—so well that she became part of the elite group of students selected for scholarships at Concordia College, which she attended beginning in 2006 (pictured above).

I expressed interest in what this cross-cultural experience had been like for her.

Earnestly, she told me, "When I arrived here, I was determined to do my best, but I think the difference in cultures challenged me. For the first two years, I built a shell to protect myself. I feared losing my Maasai values, and Tanzanian values in general. Being homesick and not really knowing who to talk to, this made for two years of hardship. Since that time, I've continued to explore what correlates with my values and what I would like to do. Now I've coped in a way that I haven't thrown away my traditions, but I can still fit in this life. I've found people who have been very helpful and supportive. We must intermingle and work together within a broad community that includes the Maasai, surrounded by other friends."

Faraja talked more about her Maasai values, saying, "I still have my old values. In Maasai culture, we value most respect, humility, and kindness. We value the relationships between people." She spoke of how this contrasted with American individualism and culture. At the time, I deeply connected with these ideas, having experienced generosity and the rich fullness of community life in Tanzania in a way I often found lacking in my own country.

Faraja went on to tell me about a microfinance project she had already established in her village. This was still a relatively new concept in Tanzania then, but Faraja was clearly a woman ahead of her time.

"Muhammad Yunus, who won the Nobel Peace Prize in 2006, came to Concordia College and spoke about how to eradicate

poverty in developing countries," she told me. "He founded a community bank in Bangladesh that gives microloans to women. He was very inspiring to me. In Maasai society, women do not have property ownership rights. So, I wondered, how can I set this up there? How can I help women sustain themselves, to have some finances outside their husbands? I did an internship at Uchumi Bank in Tanzania and learned how microlending practices were being done in Tanzania. I wrote a proposal to create a microeconomic development project in my village. Luckily, my proposal was selected. I recruited low-income women in my village who were willing to work together as part of a savings and credit cooperative. Initially, we formulated a group of ten women with the goal of reaching more women later. We gave the first group small loans. The women circulated this money in their small businesses. After a short time, they returned the loans, and then another group of women got help. My intention is to be able to provide microloans, financial education, intermediary services, and business consulting services."

Through my recent interview with Elizabeth Loiruck, I learned that Faraja went on to do just that. In 2022, she and Elizabeth established TAA to assist farmers and pastoralists with financing, skills, and knowledge that equips them to participate in Tanzania's agribusiness sector. I also learned that TAA has a special focus on empowering Maasai women through its services and programs, and this tracks with Faraja's early vision.

Fifteen years ago, Faraja expressed a clear-eyed view of the seemingly insurmountable challenges facing the Maasai people—as well as her deep-seated desire to help. In a steady, serious voice, she told me, "Maasai life is at stake. For years we've had hundreds, even thousands, of cows, but now we watch them die. Some people don't have even a single cow. Poverty is rushing into the Maasai community, and how are we going to handle that? The land is decreasing for pastoralists. The Maasai economy is failing. The cows are dying. The drought. The disease. The government. Everything is kind of breaking right now. The only way we can secure Maasai life is if children go to school and fight against the injustice that is going on in Maasailand. What I pray for those that still have their cows is that they can adapt a new way of keeping their livestock. That means keeping some cows, but also investing in other activities. Perhaps they might crossbreed their animals with other animals that have higher milk-production levels. Maasai cattle don't have high milk production. In trying to create a stable economy for them, what should we do? Maybe have cows that produce a lot of milk. Women would be able to sell their milk and finance their children's education. Some things like that need to change."

She was on a roll, and I didn't have to prompt her to continue.

"Being the first generation to go to school, I now understand all this," she told me. "I want to secure the future for the next generation of my people. I don't want to lose them. I don't want

> *"I want to secure the future for the next generation of my people. I don't want to lose them. I don't want to see them perish just because of economic circumstances or upholding traditions that don't help us any longer."*
>
> —FARAJA KIMETUU KURUBAI

to see them perish just because of economic circumstances or upholding traditions that don't help us any longer. Traditions are important, but we also need to adapt to new ways, preserving some of our traditions and letting some of them go. That one is very difficult. I have the responsibility for myself, for my village, for my community, for the Maasai people. How am I going to start doing that?"

All this is fresh in my mind as I sit down to talk with Faraja again. I'm curious how she feels about these issues today and what choices she's made for her own life since we last spoke. She carried a heavy load back then—what seemed like the entire future of her culture. In the intervening fifteen years, I know things haven't gotten much better for many Maasai people; in fact, the clash between pastoralists, the government, and private interests over land rights has only gotten more intense during that time. The Maasai way of life is still very much under threat.

While all the other interviews for this book were conducted in person in Tanzania, Faraja still lives in the United States, so we meet via a video conference call for our conversation—something that would not have been possible even a few years ago, and something that has made connections with Tanzanians around the world much easier.

Faraja wears her long hair in braids. She's dressed in a red shirt, matching red earrings, and a gray jacket.

"Where are you?" I ask—mostly because she looks cold.

"I haven't moved to a warmer climate yet," she jokes. "I'm not in Minnesota any longer, but I live in Vermont, which is equally cold in the winter."

Faraja tells me that she moved to Vermont for graduate school and completed a program in sustainable development at the International School of Training in 2015. She then took a job with a nonprofit organization that supports needy individuals and families who are seeking access to mental healthcare, transitional housing, employment, and life-skills training. She continues to do this work today.

In her typically candid fashion, she tells me, "I struggled after I finished my graduate degree because I really wanted to go back to Tanzania, but I had to admit that I was torn. I was torn because there are advantages to life in the US. I felt like staying in the US would give me the freedom, time, and space to discover my path, so I've been working for this nonprofit organization. I would say it really has humbled me, and it has shown me life in a different light. In Tanzania, the services are very limited, and issues of mental health are often not addressed. I'm blessed that in a

country like this there are both nonprofit and governmental efforts to support individuals. It is a very meaningful job, but it's difficult work. I'm happy to be giving to the community and the society that I'm living in now."

She tells me that she and her partner, Joe, who is originally from Liberia, have just had a baby boy, their first child. She also updates me on life back home in Tanzania. "I speak to my mom every day," says Faraja. "I'm planted here, but my heart is in Tanzania. It is important for me to stay very connected."

I begin the interview by reading Faraja her comments from fifteen years ago about the challenges of life in Maasailand. My voice cracks with emotion as I read her words aloud. "Can you talk about how you see these issues now?" I ask her.

She sighs deeply before answering. "It's compounding. It's getting worse. Here in the US, we have a group called the Maasai Diaspora Group made up of Maasai people from Tanzania and Kenya. We interface about the issues that confront Maasai people, and we fundraise a lot. For example, in Ngorongoro and Manyara, anytime the government decides to create a national reserve or change land use, it impacts Maasai people. There was a Maasai man in Manyara whose cows were confiscated. It's not clear why, and there is no transparent way of paying fines and getting his livestock back. In Kilimanjaro, they needed to expand the airport, so the Maasai people near the airport are being evicted. If they don't leave, their lives are at stake. It's that way in my home area, too. Ruaha National Park and the Ruaha River go through some communities, and the pastoralists, which are not only Maasai but also the Sukuma and the Barabaig, are not safe. Unless you have your own private land, you are at the mercy of whatever may be handed down. And very few pastoralists have private land."

Faraja shakes her head. "I still strongly believe in what I shared in the past. However, it is no longer education alone that is needed; it's so, so many things. We need educated, well-positioned Maasai people who are willing to speak up. Overall, Tanzanians don't really speak up about injustice. The few people that try, they get silenced. We saw a demonstration in Ngorongoro, though. I think that was big, and that happened because of many factors. A lot of people are doing underground work, and there's still ongoing work paying lawyers. So, there are definitely advantages to educating Maasai children and having well-rounded citizens that can speak for themselves and advocate for their own issues."

When Faraja pauses, I wonder to myself if the founders of the MGLSS, who already understood many of the threats the Maasai people faced in the early 1990s, had any idea what a new century would bring. That the graduates of the MGLSS would be called on not just to feed, clothe, and educate their children but also to guide the Maasai people based on changing values, needs, and priorities in a context where their ancestral lands would be gobbled up and their traditional livelihoods would disappear. Past to present, Faraja has seen the need to empower Maasai people, especially women, with financial resources and

skills that will help them escape poverty, but she also now more clearly expresses the need to protest injustice and advocate for Maasai rights—something she is doing with other Maasai people even from a distance.

"In 2009, you told me about a microfinance project you started in your village," I say. "You had plans to grow that work. Can you tell me how those plans have evolved since that time?"

Faraja quickly jumps in with her response; she seems excited to share more about this work. "Initially, the scope was very limited because I was here, but I was corresponding with my classmate Elizabeth Loiruck in Tanzania, and we had similar interests. We came together to create two organizations with different functions." She repeats some of what Elizabeth shared with me about TAA Limited and its efforts, then adds, "Agriculture remains the backbone of many rural Tanzanian communities. As daughters whose parents practiced farming and pastoralism, we strongly believe one way of giving back is to invest in our people by supporting economic activities they love and know how to do. We want to help small-scale farmers to improve their productivity, to improve their climate resilience, and to make them viable suppliers of quality products that they can sell in the marketplace. TAA Limited is a business venture, but with that we created a nonprofit organization called the TAA Foundation that focuses on education, giving small-scale farmers the knowledge and skills to be successful. We needed to start small, so we are working with our people to support what they already know

> *"Agriculture remains the backbone of many rural Tanzanian communities. As daughters whose parents practiced farming and pastoralism, we strongly believe one way of giving back is to invest in our people by supporting economic activities they love and know how to do."*
>
> —FARAJA KIMETUU KURUBAI

best, like livestock keeping. Women already have indigenous knowledge, so we are seeking to augment their knowledge and give them support. Maybe they can go from having a cow that does not produce much milk to a cow that can produce enough milk to feed the family and have a little bit spare to sell. This is our second year in operation. It's a start at helping people meet their basic needs. As the proverb says, 'Give a woman a fish, and you feed her for a day, but teach a woman to fish, and you feed her for a lifetime.' This is our aim. To teach people to fish."

"And she feeds her family and her whole community and teaches others to do the same," I say with a laugh. "Women are amazing at taking care of each other and working cooperatively, aren't they?"

"Yes," Faraja says. "I have women I can collaborate with, and some I know very well, like my good friend Elizabeth and other folks that are going to join us. That's the power of the alumni of the MGLSS. We support each

other. So, the work is growing, and as it's growing, it's no longer about just my village. We now have an entity, a system, that can reach across not only people in my community but people in nearby towns. It's so fascinating. Our aim was to improve life for small-scale farmers and pastoralists through the prism of our own villages, but I'm here in America, and our office is there in Arusha, and we work in regions from the north to the south of Tanzania. The word continues to spread."

"So, you are volunteering to do this work in Tanzania?" I ask, thinking about her other job helping people here in the United States.

"Yes, I do this work outside my nine-to-five job, and we are not yet paid. I don't know how Elizabeth is managing. She's self-running things. I respect her a lot because she's putting in her skills and time with TAA not being able to pay us right now. We have monthly meetings. I often focus on things that need writing, like preparing a presentation. I also oversee our work in regions outside of Arusha, collaborating closely with staff on the ground. They do a lot of site visits to the farmers. Elizabeth is leading us with government applications. For now, we are happy that we get to see people working and making small strides."

"Is part of your role networking here in the US, looking for capital for the business and grants and donors for the nonprofit?" I ask.

"Yes and no." She laughs. "It has not fully materialized as we would like. Twice OBA has helped us with a grant that we used to lead trainings. That's significant support that gives us legitimacy by showing that we are working with an established organization. They ask us tough questions, and we prepare reports for them. But raising money takes time, so we keep working on that."

As our interview ends, I'm curious about what it is like for Faraja to be so far from her beloved Maasai people and how she continues to bridge the cultural differences between America and Tanzania. It's clear she remains embedded in Maasai culture through her work at TAA and through her involvement with the Maasai Diaspora Group, and she has built a family and a life in the US; still, Vermont is very far from Mbeya.

When I ask her about this, Faraja tells me, "I identify with being a global citizen. Without the gift of education from the MGLSS and Concordia College, I would've lived a very limited lifestyle. Right now, I have autonomy and the ability to make decisions for myself. My experience of the two worlds inspires me to give back to the people that need it most. For me, these are the women who carry heavy burdens in an era when Maasai wealth is vanishing. My passion has always been about mothers. I don't know why, but I guess partly because I saw many moms carrying the burdens of their families. Growing up, I saw not only my mom but also other mothers struggling to feed their children and wanting to educate their children, but without the capacity to do so."

Faraja has never been one to look away from deprivation and pain, whether it's that of Maasai mamas or underprivileged Americans. She sees injustice and names it, then rolls up her sleeves and gets to work wherever she

finds herself. From empowering a group of women in her home village in 2009 to starting a business and a nonprofit that are already serving hundreds of farmers and pastoralists across Tanzania, Faraja's vision keeps growing, but it's always rooted in the same soil. Soil that the Maasai people and their herds have roamed for hundreds of years. Soil that has taught her the Maasai values of respect, humility, kindness, and service to community. And from this soil Faraja is growing new and innovative ways for the Maasai to move into a future where they can remain rooted in the values that define them yet also have the financial resources and skills that empower them to see possibilities, much as Faraja has.

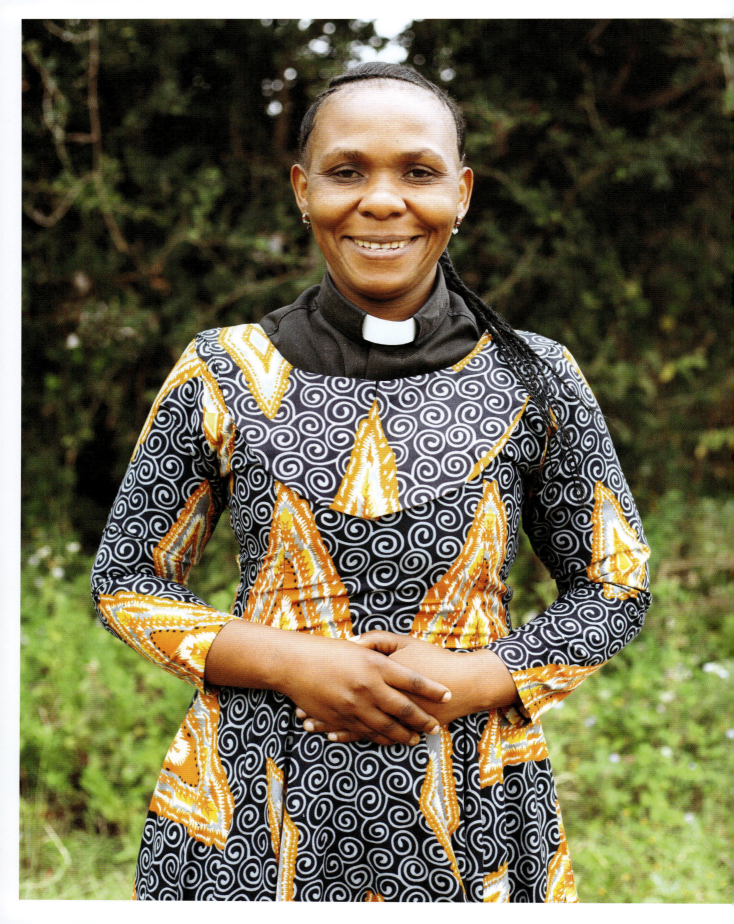

DORCAS WILLIAM PHILIPO, 2006 GRADUATE, O-LEVEL

A Spiritual Counselor for Youth

When I first meet Dorcas William Philipo, it is after dark, and I suspect we both feel as tired as we look. Dorcas wears two different kangas (lightweight patterned fabrics worn by women in Tanzania as wraps or shawls), one around her shoulders and another around her waist. Her casual appearance signals that she has retired for the day. Something I'm ready to do, too.

Though we greet one another warmly, Dorcas and I are both openly weary. I can see dark circles under her eyes and suspect mine must look the same. She just traveled over ten hours by bus from Singida, in central Tanzania, to Arusha so that we could meet. In the last forty-eight hours, I've conducted five interviews and traveled to a remote area outside of Monduli for a photoshoot. Though Dorcas and I are doing our official interview tomorrow, I'm here tonight to thank her for making such a long journey and to do a brief check-in.

"I'm grateful and honored that you have made such an effort to get to Arusha to participate in this project," I tell her.

"This interview is very important to me because I want to thank supporters of the MGLSS and show them that their investment in my education has been worthwhile," she replies softly. "My time at the MGLSS shaped me into the person I am today."

Though I know very little about Dorcas other than her profession, she strikes me as a thoughtful, gentle woman, which undoubtedly serves her well in her role as a school chaplain.

"I'm eager to learn more about you and to hear about your work in Singida, but I think we are both very tired tonight," I tell her before we part ways with smiles and mutual gratitude that we are each heading to bed.

In the morning, following a good night's sleep, Dorcas and I sit down over tea with Esuvat. She is here to help me conduct the

interview in Swahili, which Dorcas has told us she feels more comfortable using.

Today, Dorcas wears a beautifully handcrafted dress made from kitenge (a type of brightly colored, patterned fabric made in East Africa) over a black shirt with a clerical collar, signaling her identity as a pastor. I begin by asking her, with the help of Esuvat's translation, to tell me about her work as a chaplain in Singida.

"Currently I am working as a chaplain at Ihanja Technical Secondary School, which is a boarding school run by the ELCT," she explains. "Both boys and girls attend the school. We serve a needy population, including many orphans. Most of my students face difficult economic conditions and struggle academically. While some students have support from their parents, others require financial aid from the school to meet their daily needs and to cover their school fees. I'm often the first one to counsel students who are struggling. I pray with them and support their spiritual development."

"Can you tell me about your path to this career?" I ask.

"I was born outside the city of Singida in the Mkalama District, in a very rural area," she says. "I'm Hadzabe, not Maasai, though we have similar customs and traditions to the Maasai. I'm the firstborn in my family. My father left us when I was very young, so I was raised by a single mother. She was the only person taking care of me and my two siblings. Even from the time I was a small child, I felt called to serve God, and I made a vow to do that, but I lost my way until recently."

> *"Students at the MGLSS have an opportunity to grow and develop spiritually while they are at school, and this happened for me through morning and evening chapel services, which were so much a part of our daily life there, and through Bible knowledge classes."*
>
> —DORCAS WILLIAM PHILIPO

This piques my curiosity, so I lean in and ask Dorcas to tell me more about how she lost her way and then found it again.

"As you know, students at the MGLSS have an opportunity to grow and develop spiritually while they are at school, and this happened for me through morning and evening chapel services, which were so much a part of our daily life there, and through Bible knowledge classes," she says. "But after I completed Form Four, I did not have support to continue my education even though I was passionate about my faith and had a dream to become a pastor, so I had to go back to my village. I was married in 2010 and had my first child in 2011. My second child was born in 2014. Both are currently attending primary school. After the birth of my second child, my husband went to military training. Since then, he has not returned and we have no communication, so I'm raising my children alone."

Dorcas is somber as she relays this information, and it's hard to wrap my mind around this reality—of a husband and a

father leaving and not returning, of his wife and children not knowing whether he will ever return.

"For over ten years, I had to sell food and do other small jobs to survive and support my children," she continues. "During this time, I also volunteered to teach at a primary school, but I struggled a lot. I sometimes felt lost, as if God might have turned away from me. However, in 2019, the local Lutheran bishop approached me to ask if I wanted to study theology because he had witnessed my faith through many of these challenges, and he knew I had a dream to become a pastor. He arranged for me to attend Mwika Lutheran Bible and Theological College, where I completed a course in pastoral ministry in 2022. After that, I worked as a pastor for one year before I continued my education at Kilimanjaro Christian Medical Centre, where I studied pastoral counseling. After that, I joined Ihanja Technical Secondary School as a chaplain. Through this work, I am fulfilling my call. I am providing spiritual counseling to kids who have few resources in this world."

I breathe in, absorbing all she's told me, and gently shift the conversation to the MGLSS. "It sounds as if you faced similar challenges to some of the students you work with," I say. "Do you think your upbringing and your time at the MGLSS prepared you to work with these kids?"

"Yes, for sure," she responds without hesitation. "My mother did not understand the importance of education and did not want me to go to school. As I told you, my father left us when I was a child. I grew up very poor, like in the wilderness. I would not have even gone to primary school had the government not required it. After I finished primary school, I participated in an interview to attend the MGLSS. The school was taking only girls from the poorest families. That's how I got a chance to go to school. This upbringing is like many of the students I work with today. They come from very poor backgrounds, with parents who may not be supportive of their growth and development, either because they don't have the resources to be supportive or because they don't understand the value of education."

As an aside, she mentions, "My younger sister also went to the MGLSS. She is an engineer today."

I can see in her expression the pride she feels in both their accomplishments, especially in light of how they grew up.

"My sister and I benefited from our education at the MGLSS a great deal," she says with feeling. "In the past, many members of my Hadzabe society didn't prioritize education, but now that they are seeing the impacts of education, they are becoming more supportive. For example, they see how my education has prepared me to guide young people to choose the right path. When parents don't want to send their children to school, I talk to them and give them advice. I tell them that education is very important. Now they are taking their kids to school. If it wasn't for the MGLSS, I wouldn't be a pastor. I would not be able to help children the way I can now. I might have stayed in the wilderness."

I understand that Dorcas means this in more than one way. While she grew up in the literal porini, which translates to "wilderness," she also knows what it means to wander in the wilderness in a spiritual and emotional sense.

As we close the interview, I think about the word porini, and I imagine Dorcas as a child wandering in the vast, arid plains around Singida. I think about what it must have been like for her, and her mother before her, to eke out an existence in this difficult environment, not always knowing how they might feed their children. I can't help but be moved by the deep faith I've observed in Dorcas, who has remained steadfast in her vow to serve God even in the face of many challenges and who today serves as a spiritual guide to young people experiencing their own wilderness times, counseling them and reminding them that they are neither forgotten nor forsaken.

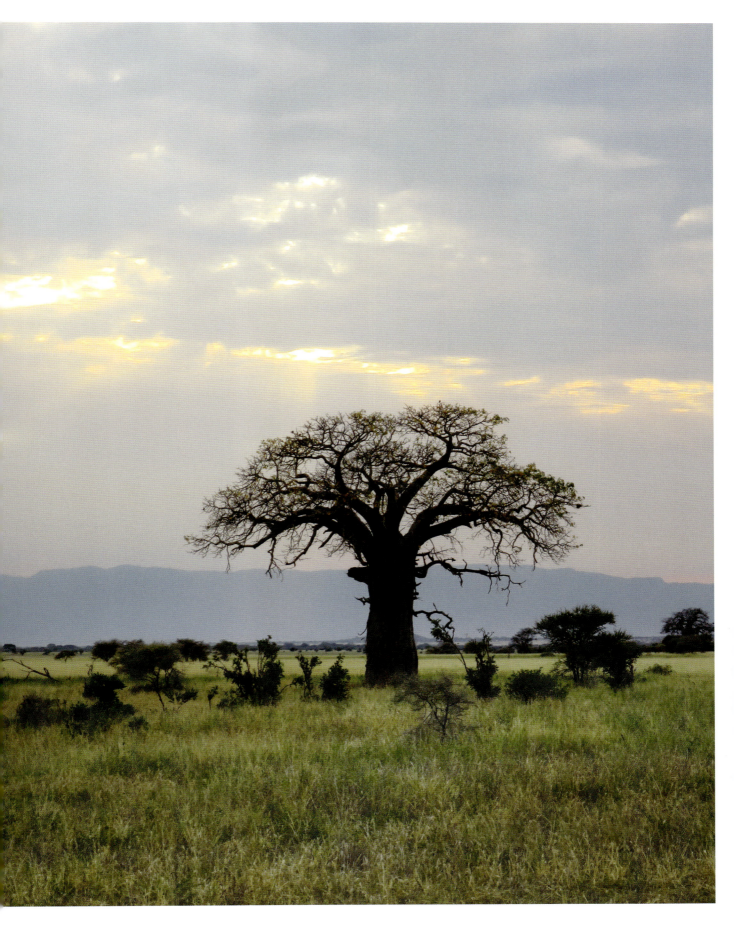

ENDESH LAZARO YAMAT, 2005 GRADUATE, A-LEVEL

An Entrepreneur in Action

Our driver, Festo, pulls up and parks adjacent to a strip mall that houses four small shops in the bustling Mianzini neighborhood on Arusha's north side. A sign advertising Trinity Laundry and Cleaning Services hangs over the entrance to one of the shops near the center of the building. Owned and operated by Endesh Lazaro Yamat, this shop represents one of two locations in Arusha, though I already know from recent communications that Endesh aspires to expand her business to a wider customer base and more locations.

As the interview team gathers our equipment and belongings out of the back of the vehicle, Endesh waits for us at the shop's entrance. She wears a smart dress with a delicate floral pattern. Her hair is gathered into a neat bun at the nape of her neck and gold hoops hang from her ears. While she waits, she scrolls through messages on her phone, giving the impression she is busy—and in fact, she is.

Endesh runs this laundry business alongside working a full-time job as an information technology manager with Tanganyika Farmers Association. She employs a young woman to assist customers when she can't be at the shop herself, but today she's offered to use her lunch hour to show us her shop before hurrying back to the office.

When I approach her, Endesh breaks into a wide smile. "How are you, mwalimu?"

I hug her and tell her I'm doing fine before also inquiring about her well-being.

While we make small talk and she meets the rest of the interview team, I recall Endesh as a Form One student at the MGLSS: a serious young woman with a somewhat bossy streak. I remember she would often seek to bring order to a noisy classroom with a fast, sharp stream of Swahili. Yet she would also playfully ham up an answer to a question or tease one of her friends before tipping her head back and laughing out loud—only to cover her

face in mock embarrassment, as if she wanted to be more subdued but couldn't quite help herself. She looks much the same today as she did then, and I'm happy to see her again after many years.

After greetings have been exchanged, Endesh shows us around the small—roughly fifteen-foot-square—shop. Shelving on the back and left walls contains folded and bagged clothing, blankets, and other fresh laundry. Cleaning supplies such as soap, mops, and buckets are displayed to the right. Earrings and other accessories are for sale at the check-out counter that separates the back one-third of the space from the front. Posters at the entrance and around the room detail the services offered by Trinity Laundry and Cleaning Services.

As we look around the modest space, Endesh explains her work: "When I started this business, I did research into the needs of the community. Currently, people are so busy working that they don't have time to wash their clothes, so I started my laundry business to save people time. Instead of washing their own clothes, my customers bring them to me so they can spend more time doing other things."

> "I started my laundry business to save people time. Instead of washing their own clothes, my customers bring them to me so they can spend more time doing other things."
>
> —ENDESH LAZARO YAMAT

As she talks, I realize this is the first laundry shop I've seen in Tanzania. I know most wealthy Tanzanians typically hire local girls or young women to cook, clean, and wash clothing in their homes. Others who work outside the home but earn only a modest income find relatives or enlist their own children to do these chores. As more people, and women in particular, participate in a wage-earning economy in Tanzania, I can imagine there is more need for services designed to help nine-to-five workers with household tasks they no longer have time to do. I suspect a rapidly growing middle class also has more income to pay for services like this.

"Currently, my clients are individuals or families," Endesh continues. "Soon, I will expand to restaurants and lodges. I'm doing a lot of marketing, so I'm not just depending on the neighborhoods where my two shops are located. The neighborhoods are small, niche markets, but I need a broader customer base. So, I'm using social media to introduce myself and my laundry services. Since professionally I'm in information technology, I understand how to market my business through Instagram, Facebook, and other sites, so that's where I'm getting my customers currently. I started my laundry business with one branch in 2022, but now I have two."

"Tell me about your plans to expand the business," I prompt.

"I would like to have more locations," she says candidly. "It's just a matter of capital. I hope to open one or two new branches in the next year. I'm still exploring the

most marketable locations. Currently, I'm considering how to address some logistical challenges. We use washing machines and dryers that are not located at the shops. The shops are just where customers drop off and pick up their garments. We're doing the washing process far from the shops, and I'm thinking about a way to make this easier, particularly for express customers or those that want to drop off their clothes in the morning and pick them up at night. I need to work out how to do this efficiently. In the future, I see myself running a big company focused on laundry and cleaning services. I would like to expand to offer cleaning and housekeeping services."

Endesh comes across as focused and driven, and I'm impressed by her determination, which aligns with my memories of her as a student. In fact, her go-getter attitude seems like a hallmark of many Maasai women. "I can imagine you are very busy with this business and working full time elsewhere," I say with admiration. "You mentioned you work in information technology. Can you tell me more about that?"

"I'm working as an information technology manager with Tanganyika Farmers Association, or TFA," she says. "The association has more than 4,800 members from the farming community, including small landholders, large commercial farmers, village and government farms, family-owned farms, and farm cooperatives. TFA sells agricultural products, such as seeds, fertilizers, pesticides, and animal feed especially for poultry and pigs, and they also own some rental real estate too. We have seventeen branches across Tanzania, with the head office here in Arusha, which is where I work. As an IT manager, I ensure strong and secure information systems that support TFA's operations across the country."

"This sounds like a big job," I observe. "I understand you were recently invited to talk with current students at the MGLSS about how you're accomplishing all this."

"Yes, I was glad to be invited to encourage the students," she says with a nod. "I told them about a time in my life when I struggled and how I overcame this. When I finished my A-Level studies, my dream was to become a doctor, but unfortunately, my exam results were not good enough. I was so discouraged. I asked myself, 'Okay, so now what? Maybe becoming a doctor isn't God's plan for me.' That's how I encouraged myself. Then I found myself pursuing another field where I've found success. From the outside, a person might look at this and say, 'Oh, she failed.' But it was not a failure. It was resiliency. I found a different path to success. I became a doctor of computers instead of a doctor of people. This made them laugh," Endesh says with a light chuckle. "So, I told them, 'In this life, there are times when you find yourself falling. When that happens, you must pick yourself up and brush off the dust. Don't let failure stop you. Seek other opportunities. Move forward with life.' That was my main message." She gestures animatedly with her hands.

"Given the challenges many young Maasai women face, I imagine this was an important

> *"In this life, there are times when you find yourself falling. When that happens, you must pick yourself up and brush off the dust. Don't let failure stop you. Seek other opportunities. Move forward with life."*
>
> —ENDESH LAZARO YAMAT

message for them to hear," I say. "I know there are still too few Maasai girls who find success the way you have."

Endesh offers me a satisfied smile at this acknowledgment of her achievements.

"Can you tell me about your childhood, your education, and how you ended up as such a successful businesswoman?" I ask, switching topics.

"I was fortunate because my parents encouraged my education," she says, nodding. "Still, I was the only girl from my primary school selected to join the MGLSS. I benefited a lot from my time at the school. I studied hard, but I learned many things outside the classroom, too. For example, we learned to love and care for each other. We all came from different homes, but we had to respect each other. The MGLSS joined us together as a community of students. We also learned to be confident. I gained the confidence to join university and get a degree in computer science. I also did my master's degree in business administration and information technology. Today, I'm not only a businesswoman but also a leader in my community. I've been selected to represent my ward at the district level. We help the community access government programs and ensure the help is going directly to the people. We encourage parents to send their children to school. I also volunteer with an orphanage. There are some very young children there. We provide some supplies to them, and we encourage them that even without a parent, there's always support and help."

Thinking about Endesh's many roles and responsibilities, I wonder if she's a mother too. After all, her laundry business is built on the premise that people are so busy they need more help with household tasks, and I suspect she knows this struggle well. "How do you balance all this?" I ask. "Do you have children at home too?"

"Yes, I have an eleven-year-old son. My parents are playing a very big role in taking care of him. I thank God for them. When I can't do it all, they help me." Her tone conveys just how important they are to her. "I've also hired some employees to help with my laundry business, so I'm not doing it alone. As I told the students at the MGLSS, it's just a matter of moving forward with confidence and asking for help when you need it. The help students receive at the MGLSS remains essential. As graduates, we are successful women who support our communities. You know, there is a saying, 'When you educate a girl, you educate the whole world.' That's true. There are so many examples of Maasai communities where one educated woman is improving life for the

people there. As you know, there are still many Maasai girls that need a helping hand. As graduates, we are helping them, but OBA, sponsors, and partners, we still need you. Your compassion and generosity remain important to so many girls."

As the interview comes to a natural close—the last in a long line of interviews—I'm reminded that none of us picks ourselves up alone. We all need a helping hand to pull our bootstraps up, or to do our laundry, or to find a place at a school for girls. More than three decades ago, the MGLSS began with a mission to give young women like Endesh the opportunity to advance their own lives and communities through education, and the school's graduates have done just that. The results speak for themselves, quite literally—a sisterhood of Maasai women demonstrating the exponential power of compassion and generosity that, once extended, ripples into a future filled with hope.

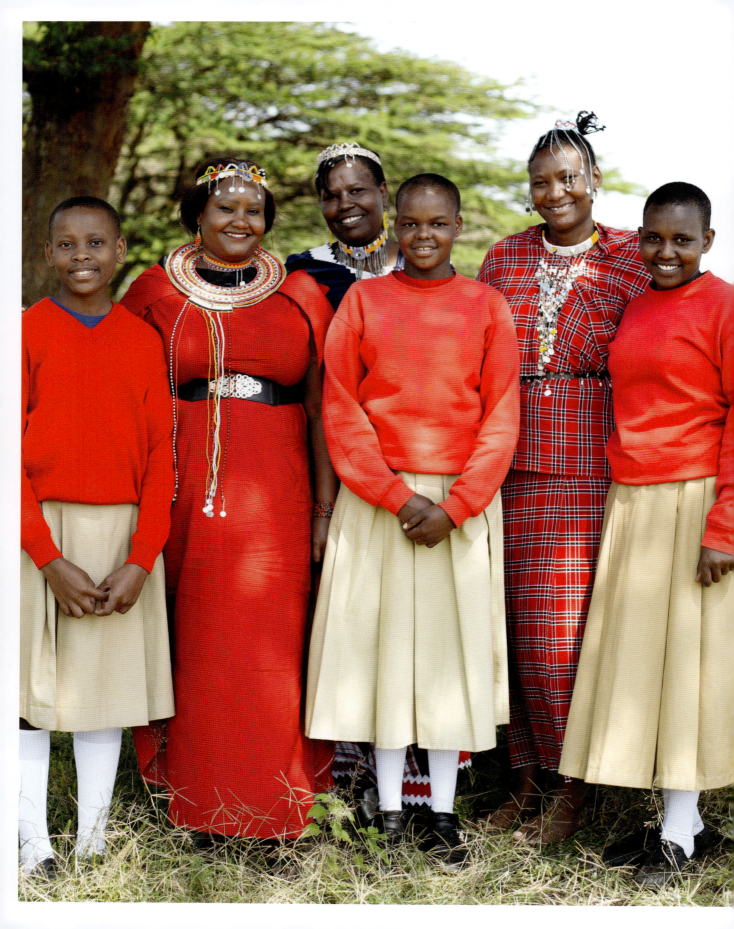

CLOSING

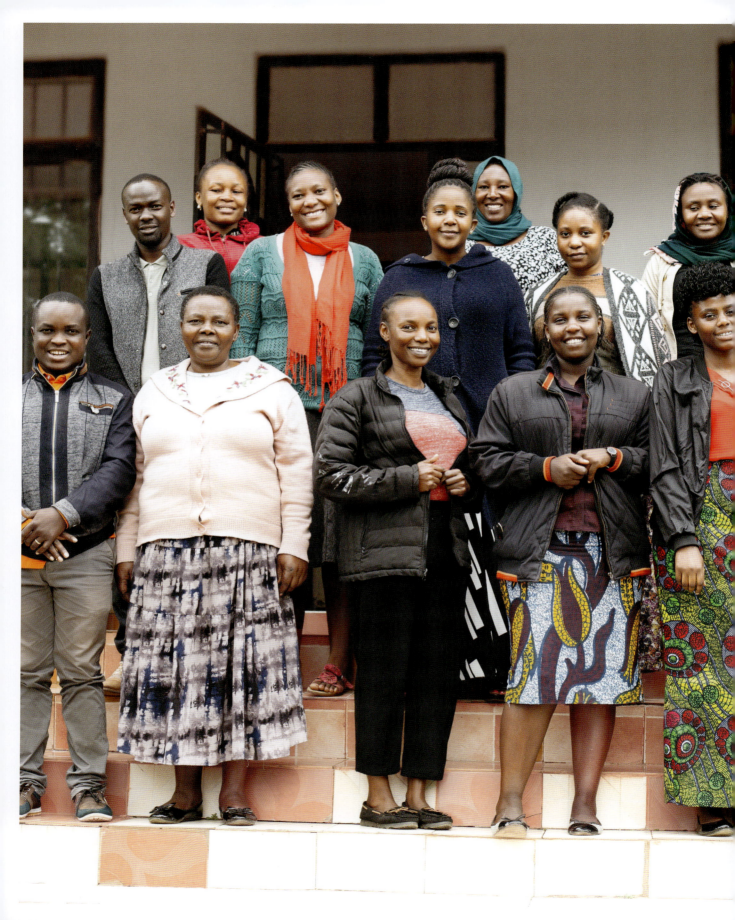

Let's Here It

FROM THE BOARD & STAFF

The MGLSS's teachers, staff, and leaders are at the forefront every day, educating and serving the young Maasai women in their care. They intimately know their needs and are actively working to transform lives. The profiles in this book are a testament to the many ways in which they are succeeding. In a chorus that stretches across Maasailand, we all say, "Asenteni mno tena na tena"—thank you very much, again and again.

PASTOR JOEL NANGOLE MOLLEL
FOUNDING BOARD MEMBER OF THE MGLSS

In the 1990s, Pastor Nangole worked with Maasai leaders and elders to build support for the MGLSS and to find land for its construction. Since that time, he has served on the school's board of directors and provided pastoral care to its students.

"The idea of building a secondary school for Maasai girls came from the late Prime Minister Edward Moringe Sokoine and was carried forward by the late Bishop Thomas Laiser," says Pastor Nangole. "These Maasai leaders wanted to build a school for girls who were being left behind—those who had no opportunities to gain an education. Today, the MGLSS takes girls that no other school wants, and we give them a chance to improve their lives. We are setting an example in this country of how to uplift marginalized people."

> *"We are setting an example in this country of how to uplift marginalized people."*
>
> —PASTOR JOEL NANGOLE MOLLEL

TULIZAELI MBISE
HEADMISTRESS & TEACHER: ENGLISH & AFRICAN LITERATURE

Tuli Mbise has been teaching English and African literature at the MGLSS since 2011. In 2022, she became headmistress of the school. She holds a bachelor's degree in education from Tumaini University Makumira.

"When students arrive here from primary schools," Tuli says, "they feel shy and inferior. Some believe they don't have the skills to succeed, but the teachers are ready to counsel them. We make them feel comfortable. We encourage them to learn. We want them to feel they are loved. By the time they finish their studies, they feel confident and strong. They change from shy, timid girls to women who are very capable. They are ready to face any challenge."

> *"By the time they finish their studies, they feel confident and strong. They change from shy, timid girls to women who are very capable. They are ready to face any challenge."*
>
> —TULIZAELI MBISE

LOISHOOKI MOLLEL
ASSISTANT HEADMASTER & TEACHER: CHEMISTRY & MATHEMATICS

Loishooki Mollel has been teaching chemistry and mathematics at the MGLSS since 2000 and has served as assistant head of school since 2022. Prior to teaching at the MGLSS, he earned a bachelor's degree in science education from the University of Dar es Salaam. "As a Maasai man and a teacher, I have seen what education can do for girls," Mollel says. "While students are here, they become different people. We see a light emerge in them. The girls who have passed through the MGLSS are bringing big impacts to our community. It is important we treat girls as equal to boys, because we all have roles to play in improving our society."

> *"It is important we treat girls as equal to boys, because we all have roles to play in improving our society."*
>
> —LOISHOOKI MOLLEL

DR. SETH MSINJILI
FORMER HEADMASTER & TEACHER: RELIGION

Seth Msinjili has been an educator for over forty years. He served as the headmaster at Moringe Sokoine Secondary School in Monduli from 1998 to 2010, when he became headmaster at the MGLSS. He held that position for twelve years before retiring in 2022.

"The Maasai way of life is changing from what it was in the past, and some are already understanding and accepting these changes," Dr. Msinjili says. "One day, educating Maasai girls will be honored, but it will take time for some Maasai parents to see the value of educating girls. My passion has always been to help the girls understand that they have the right to choose their own paths."

> "My passion has always been to help the girls understand that they have the right to choose their own paths."
>
> —DR. SETH MSINJILI

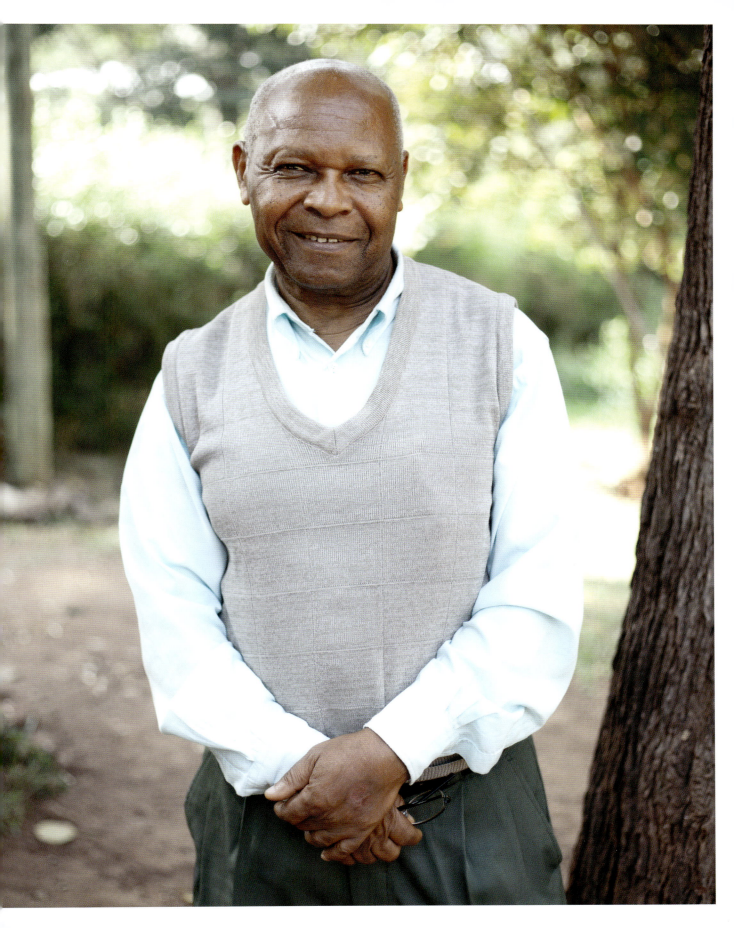

CIWILA SAVEE SHIRMA
TEACHER: HISTORY & CIVICS

Since 2000, Ciwila Savee Shirma has been teaching history and civics at the MLGSS. She received a teaching certificate in 2000 from Marangu Teachers' College and later earned a bachelor's degree in 2011 from the Open University of Tanzania, a degree she completed while also working at the MGLSS.

"We serve girls who come from very poor families with very, very difficult lives," Ciwila says. "They walk long distances—maybe four hours—to get to the nearest primary school. They eat only once a day. They are so tired and hungry that they can't perform well in school. When they come to the MGLSS, they find a different environment. Here, they get breakfast, tea, lunch, and dinner. They live in good dormitories. They have electricity and water. This is a good opportunity for them, and they start to thrive."

> "Here, they get breakfast, tea, lunch, and dinner. They live in good dormitories. They have electricity and water. This is a good opportunity for them, and they start to thrive."
>
> —CIWILA SAVEE SHIRMA

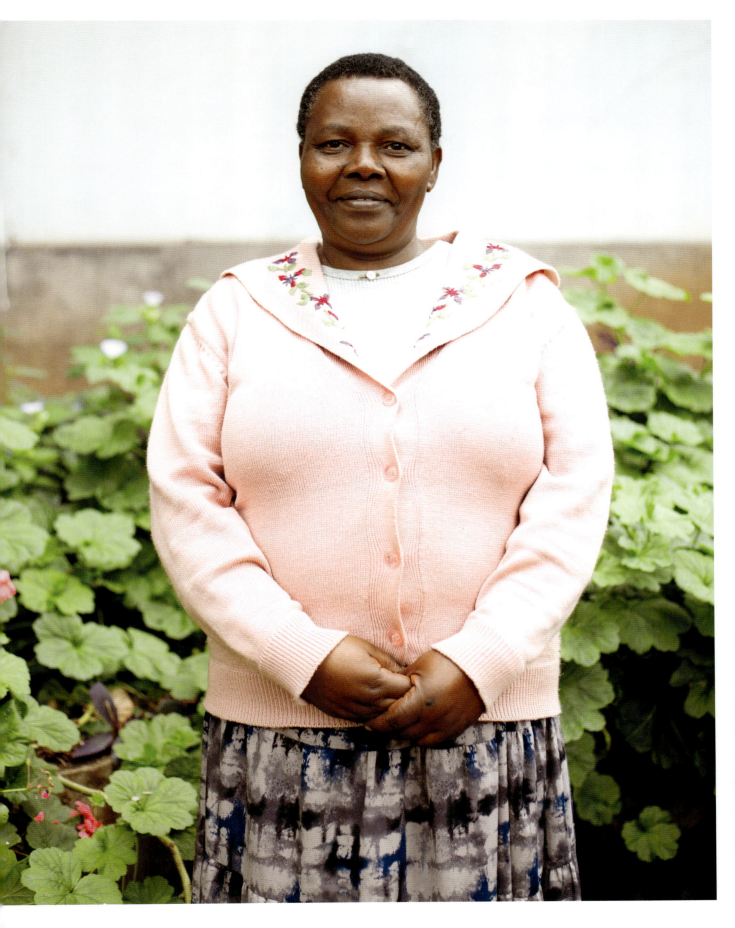

ELISIFA NGUNGAT MOLLEL
MATRON, 2002 GRADUATE, A-LEVEL

Elisifa Ngungat Mollel graduated in the MGLSS's first class, and today she serves as the school's matron ensuring the health, safety, and well-being of students. In 2005, she completed a bachelor's degree in social work at the Catholic University of Eastern Africa in Nairobi.

"I often act as a mother or an auntie to students while they are at the MGLSS. As the matron and a graduate of the MGLSS, I encourage and advise them to work hard and stay focused on their studies," Elisifa says. "Hard work pays off, regardless of your background. If not for the MGLSS, I wouldn't be where I am today, and this is the same for many of the girls here."

> *"Hard work pays off, regardless of your background. If not for the MGLSS, I wouldn't be where I am today, and this is the same for many of the girls here."*
>
> —ELISIFA NGUNGAT MOLLEL

BELINDA MATINDA
TEACHER: HISTORY & CIVICS, 2004 GRADUATE, O-LEVEL

Since 2013, Belinda Matinda has been teaching history and civics at the MGLSS, where she attended O-Level from 2001 until 2004 before completing A-Level at Moringe Sokoine Secondary School and then a bachelor's degree at the Catholic University of Eastern Africa in Nairobi.

"I want to thank OBA and the sponsors of the MGLSS for their time and contributions," Belinda says. "Please don't get tired of helping the girls. Together we have created an important partnership and, through that, an amazing school community."

> *"Please don't get tired of helping the girls. Together we have created an important partnership and, through that, an amazing school community."*
>
> —BELINDA MATINDA

NANYORRI MORRIS
TEACHER: ENGLISH & CIVICS, 2007 GRADUATE, A-LEVEL

As a former graduate of the MGLSS, Nanyorri Morris has been teaching English and civics at the school since 2012. Prior to this, she completed a bachelor's degree in education at Mount Meru University and a master's degree in educational management and leadership at Arusha University.

"When a woman is educated, she becomes empowered to change not only her own life but also the lives of those around her," Nanyorri says. "As educated Maasai women, we are diminishing harmful practices like FGM and early marriages that are still too prevalent in our community. We are supporting our parents and families. We have not forgotten where we come from."

> "As educated Maasai women, we are diminishing harmful practices like FGM and early marriages that are still too prevalent in our community. We are supporting our parents and families. We have not forgotten where we come from."
>
> —NANYORRI MORRIS

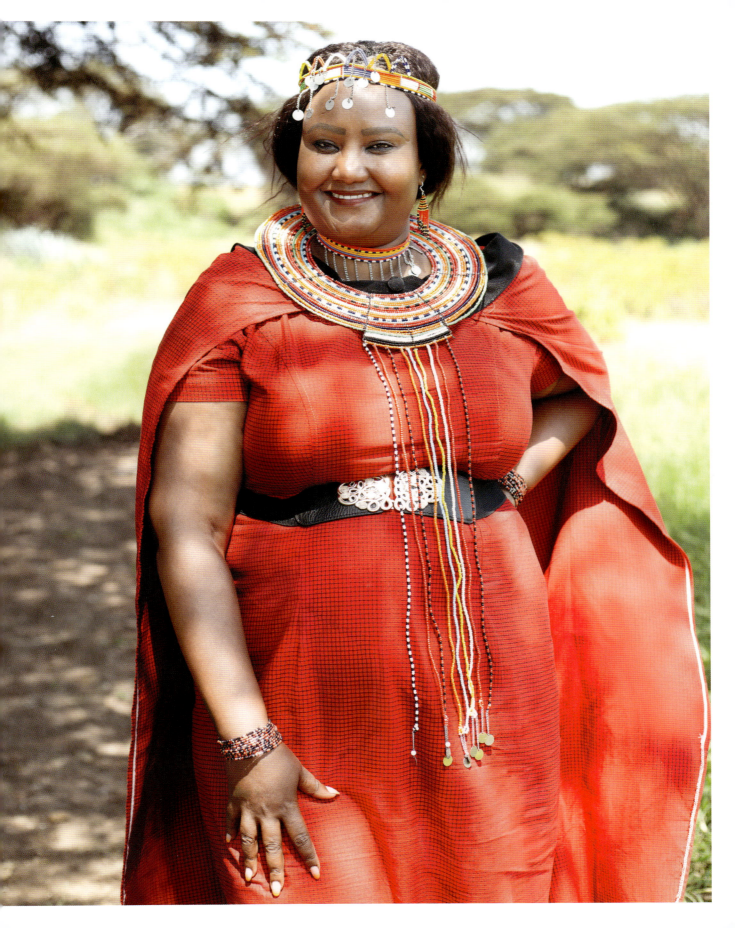

Afterword

Lessons in Hope: A New Era for Maasai Women in Tanzania is more than a beautiful coffee table book—it's a journey. Through words and images, Juliet Cutler and the team of contributors to this book have offered us a profound and respectful exploration of Maasai culture by interweaving stories of resilience, hope, and transformation. In this book, we've met incredible Maasai women who've shared their successes and failures, their joys and challenges. We've heard from them about the ways they are finding their voices, embracing their traditions, and shaping a new future. Their stories celebrate the potential women and girls hold when galvanized by education—the potential to bring the changes they dream of seeing in their lives and their communities.

My own journey in East Africa began in 2000 with my first visit to Tanzania. Since that time, I have studied Maasai culture and observed its evolution. In 2018, I joined OBA as the organization's executive director, a role that has allowed me to witness firsthand the transformative power of education in marginalized communities. I've seen how empowering Africans to create the change they wish to see leads to sustainable, lasting impacts that uplift entire generations.

Like me, Juliet has seen this transformation too, and her obvious passion for empowering girls through education shines through in her writing. She has remained a strong supporter of the MGLSS and OBA through the years, but *Lessons in Hope* isn't her first literary gift to us. Her earlier book, *Among the Maasai*, laid the foundation for her deep connection to the Maasai people and their stories. Over the years, I've come to know and admire Juliet's ability to approach her work with both honesty and respect. She doesn't shy away from addressing aspects of Maasai culture that many Americans might struggle to understand, yet she always does so with a deep appreciation for the dignity and strength of the Maasai people. I believe she has written this book as an invitation to us all, for it is a profound testament to the ways each of us, no matter where we come from or where we grow up, have the power to change lives for the better.

It is my prayer that hearing from the Maasai women featured in this book will inspire you to action. Whether you make a gift to OBA that supports our mission to empower more Africans through education and other development projects, travel on one of our life-changing discovery tours to East Africa, or engage in a community that is important to you, may this book touch your heart, challenge your perspectives, and motivate you to make a difference.

—With excitement and expectation,
JASON BERGMANN, Executive Director
Operation Bootstrap Africa

If *Lessons in Hope* has inspired you, please visit www.bootstrapafrica.org to learn more about how you can support the work featured in this book.

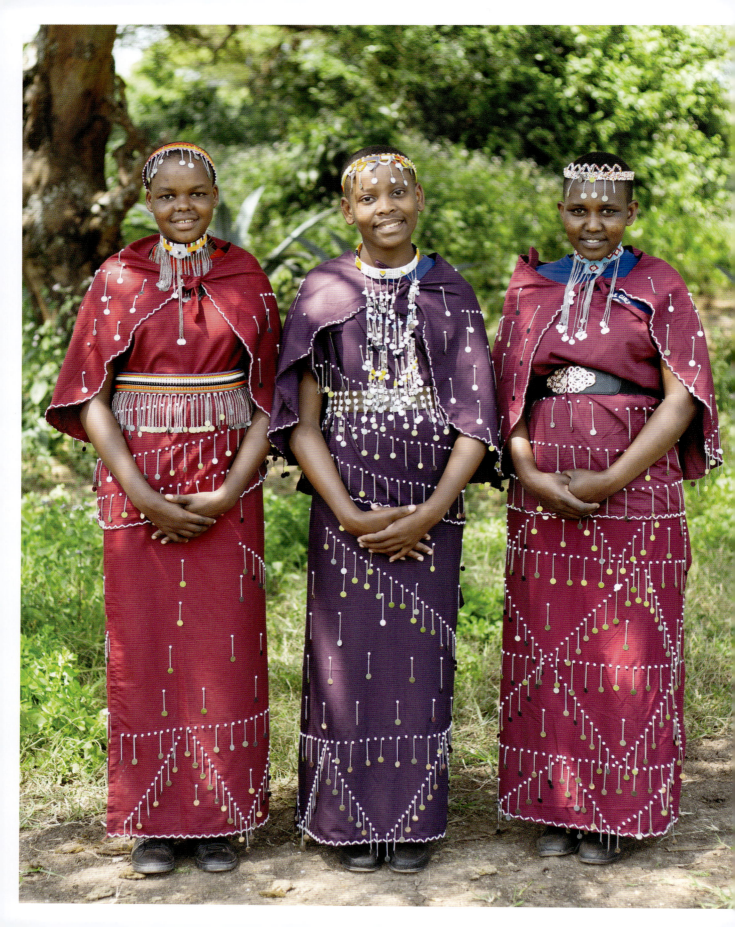

Acknowledgments

To the women featured in this book—thank you for generously and openly sharing your stories and your aspirations for the future. You are bringing hope to so many, including me. Thank you for welcoming the interview team into your homes, places of work, families, and communities. Your insightful reflections made the writing easier, and your feedback was critical to getting each profile right. I'm grateful for your patience and diligence in responding to my inquiries, and for your thorough review of the text. Ashe naleng'.

To the staff at OBA, including Jason Bergmann, Briana Pokorny, Aaron Bartholomew, and Karen Rose—thank you for championing this project. You knew these stories needed to be told, and I'm grateful you entrusted me with this important work, which has been incredibly fulfilling. Your encouragement, guidance, and support were critical. Over and again, the women featured in this book expressed profound gratitude for OBA, the work of its staff, and the support of its donors. I share that sentiment. Without OBA, none of this would be possible.

Though members of the interview team are acknowledged elsewhere in this book, they bear mentioning here again. Esuvat Lucumay's advice as a Maasai woman was essential to this book's success, and her encouragement was vital to me personally. Through our work together, Esuvat and I discovered that we are more than simply friends, we are dada (sisters) called to a common cause: shining light on the tremendous challenges many Maasai girls face and finding ways to empower and support those who have suffered violence. Mungu akubariki—God bless you—Esuvat. Like the women featured in this book, you are changing the world.

Striking photographs fill the pages of this book and bring life and dimension to the women featured herein. These images are predominantly the work of Lameck Tryphone Mutta and Aron Williams, each of whom became my friend as we worked together. Tryphone and Aron, your ability to tell stories through images is helping the world understand what it means to empower women and girls in Tanzania even beyond the pages of this book. I'm so grateful for your important contributions to this project. Asanteni mno—thank you very much.

In addition to the core interview team, this book would not have been possible without the input of Martha Mereso Sengeruan, Neema Melami Laitayock, and Agness Joseph Porokwa, who helped to identify and contact the MGLSS graduates who participated in this project. Upendo Barnaba Letawo reviewed portions of the manuscript, and she and Pastor Joel Nangole Mollel answered many questions about the early years of the MGLSS. Additionally, Festo Mtui and Robert Dausen Swai were instrumental in providing transportation and logistical support during interviews that took place across northern Tanzania. Current and former staff at the MGLSS, including Tulizaeli Mbise,

Loishooki Mollel, Nanyorri Morris, Belinda Matinda, Ciwila Savee Shirima, Elisifa Ngungat Mollel, and Seth Msinjili, also supported the project in countless ways. Asanteni sana marafiki zangu—thank you, my friends.

I'm grateful to Brooke Warner for her unwavering support and editorial expertise. She reviewed the profiles in this book one by one during the two years it took me to conduct the interviews and write the book. Her thoughtful questions and insightful comments shaped the manuscript in ways large and small. When the little devil of self-doubt whispered in my ear, Brooke cheered me on and reminded me of the power of women championing other women. Thank you, Brooke, for championing me, the women featured in this book, and so many women writers.

My friend and confidant Phyllis Bleiweis also served as an unflagging supporter and hawk-eyed editor throughout this project. She and I shared many lunches during which she buoyed my spirits and encouraged me on. Though Phyllis's age (as a mzee, or respected elder) precluded a trip to Tanzania, I know she really wanted to go with me to meet the extraordinary women I interviewed, and in many ways she did. Most days when I was in Tanzania, I got a text message from Phyllis checking in to see how things were going, and she reviewed every profile with interest and care. For all this, Phyllis, I owe you a debt I'm unable to repay. Additionally, I owe thanks to Kristin Bodiford, Noa Hecht, Clare Martorana, Bethany Krepela, Jean Wahlstrom, and Marvin Kananen for their editorial and publicity support. Thank you also to Slade Kemmet for his superb photography, which is featured on the cover and elsewhere in the book.

Brooke Warner, Lauren Wise, Shannon Green, and the team at She Write Press expertly guided me through the ins and outs of publishing. I'm grateful to She Writes Press for their ongoing advocacy for women in publishing and for the community of authors they've created. Thank you especially to Tabitha Lahr and Leah Lococo for their graphic design talent, and Krissa Lagos and Cait Levin for their editorial expertise.

To my family—especially my parents, Ann and Dennis Rehrig, and my sister and brother-in law, Heather and Chad Ashcraft—and to those who've adopted me either through marriage or through friendship: None of us walk through this world alone, and you've been willing to walk through it with me. Thank you for your willingness to join me in learning about Tanzania and the amazing Maasai women and girls who live there. Your support means the world to me—and to them, too.

Finally, thank you to my spouse, Mark Cutler, for accompanying me on this journey. Our time in Tanzania has shaped us in ways we couldn't have foreseen when we were youngsters heading off to volunteer there, but I believe we are stronger, more compassionate humans because of our engagement in the wider world. Thank you for supporting me always, reading early and later drafts, and tolerating me through the ups and downs of writing and publishing not one but two books. Bega kwa bega, you and me, as long as this life will hold us.

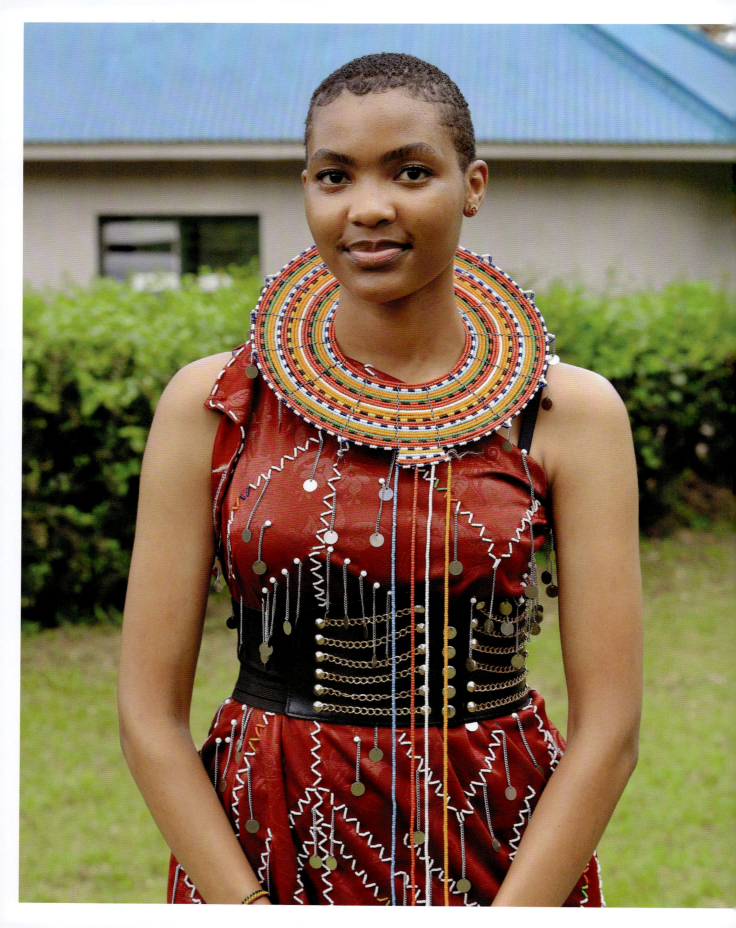

Swahili / Maa to English Glossary

Asanteni mno: thank you very much (Swahili)

Asanteni mno tena na tena: thank you very much again and again (Swahili)

Asanteni sana marafiki zangu: thank you my friends (Swahili)

Ashe naleng': thank you very much (Maa)

Bajaji: three-wheeled motor taxi (Swahili)

Bega kwa bega: shoulder to shoulder (Swahili)

Boma: traditional round Maasai dwellings made of sticks, mud, grass, and cow dung and urine; also used to refer to a group of Maasai dwellings surrounded by a fence of thorn bushes (Swahili)

Dada: sister (Swahili)

Dala dala: minibus (Swahili)

Elongo: shield (Maa)

Emusoi: awareness, discover (Maa)

Engang': a group of Maasai bomas (dwellings) surrounded by a fence of thorn bushes (Maa)

Fimbo: thin wooden stick (Swahili)

Fundi: construction worker, technician (Swahili)

Hapana: no (Swahili)

Ilturesh: rigid, disk-shaped necklace (Maa)

Kafika: arrive (Swahili)

Kanga: lightweight patterned fabrics worn by women as wraps or shawls (Swahili)

Karibu: welcome, as in an invitation (you are welcome to) or a greeting (to be welcomed) (Swahili)

Kitenge: a type of brightly colored, patterned fabric made in East Africa (Swahili)

Koko: grandmother (Maa)

Mashuka: swathes of (often red-checkered) fabric worn by Maasai women and men in a toga or cape-like fashion; informally used as blankets (Swahili)

Mama: mother (Swahili)

Mayieu: no (Maa)

Morani: warriors (Swahili and Maa)

Mungu akubariki: God bless you (Swahili)

Mwalimu: teacher (Swahili)

Mzee: elder, old person (Swahili)

Ol Doinyo Lengai: mountain of God (Maa)

Olalem: machete (Maa)

Pikipiki: motorcycle (Swahili)

Porini: wilderness (Swahili)

Sherehe: celebration (Swahili)

Ugali: a stiff porridge made of ground maize often served with beans, stews, vegetables, or collard greens (Swahili)

Uji: a thin porridge made of ground maize often served for breakfast and to children (Swahili)

Wazungu: white people (Swahili)

Zawadi: gift (Swahili)

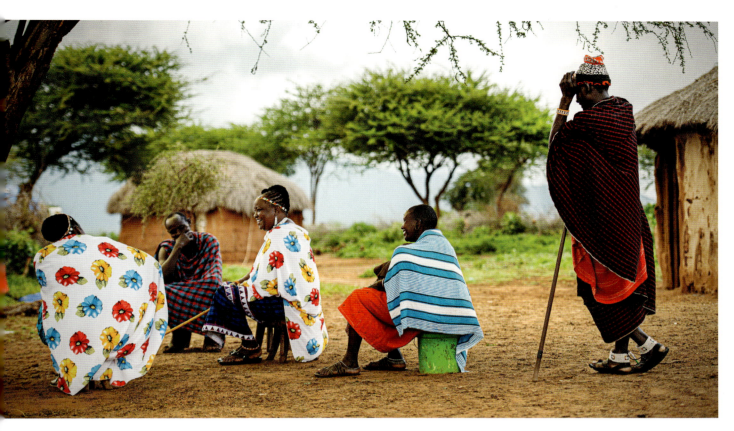
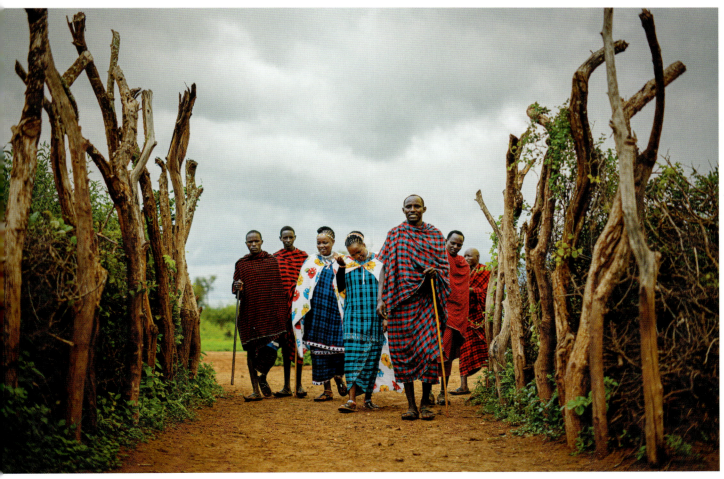

LOCATION OF TANZANIA IN AFRICA

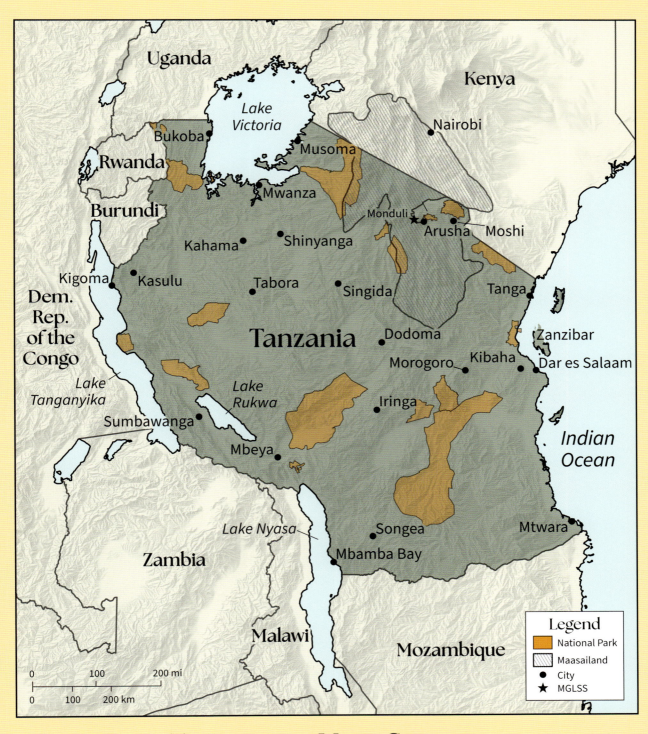

Tanzania with Major Cities and Neighboring Countries

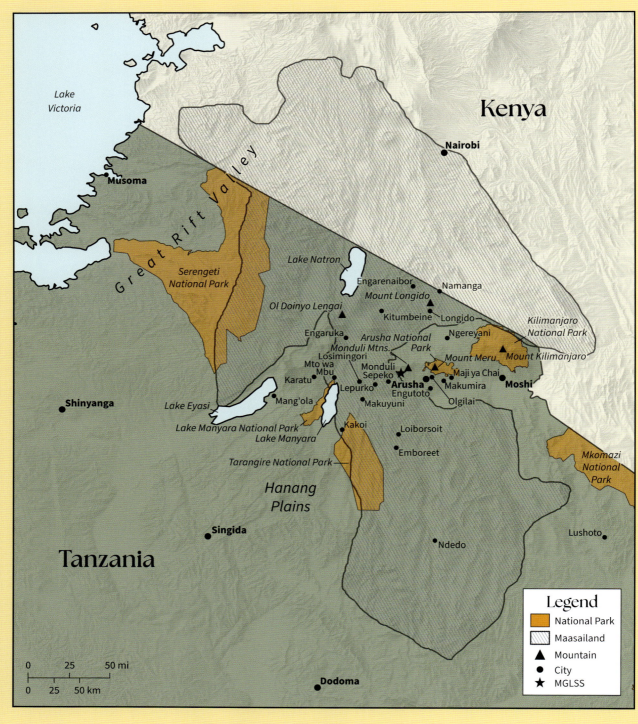

NORTHERN TANZANIA WITH LOCATIONS MENTIONED IN THE BOOK

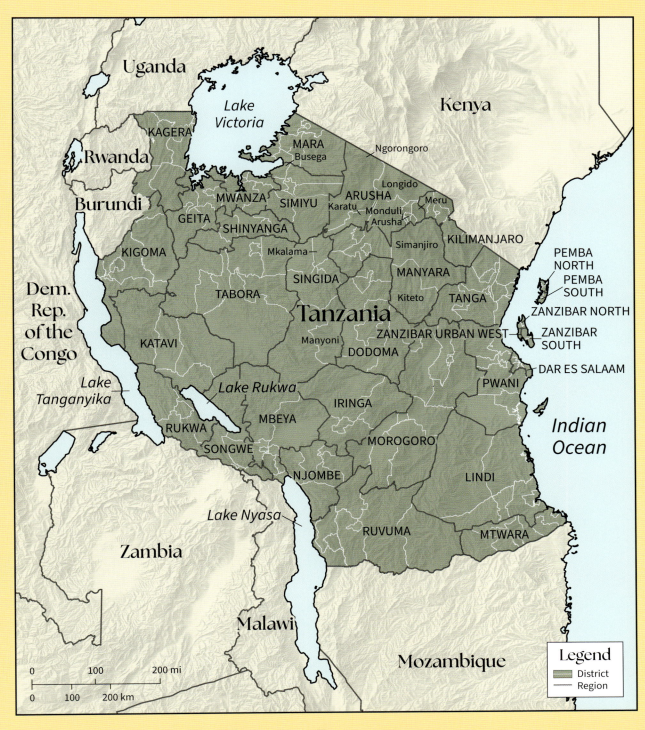

Tanzania Regions and Districts Mentioned in the Book

Photo Credits

On pages with multiple photographs, contributors are lists from top to bottom and left to right.

FRONT MATTER

ii:	Lameck Tryphone Mutta	
x:	Dani Werner and Hussein Hassan Schango	
xi:	Lameck Tryphone Mutta (both)	
xiii:	Lameck Tryphone Mutta, Solar Sister	Joanna Pinneo, and Slade Kemmet
xiv:	Juliet Cutler (top) and Slade Kemmet (both at bottom)	
xvi:	iStock.com	VilliersSteyn

OPENING

3:	Slade Kemmet	
5:	Slade Kemmet (top, middle left, and bottom left), Lameck Tryphone Mutta (middle right), and Alamy	Pajac Slovensky (bottom right)
7:	Gift Heriel Daudi (both)	
8:	Mark Brown and Eripoto for Girls and Women	
11:	Alamy	John Warburton-Lee and Slade Kemmet
12:	Slade Kemmet	
13:	Slade Kemmet	
15:	Eripoto for Girls and Women	
17:	Operation Bootstrap Africa	Jason Bergmann

EDUCATION

18:	Slade Kemmet	
20:	Aron Williams	
25:	Aron Williams	
26:	Lameck Tryphone Mutta (both)	
29:	Mark Brown	
30:	Aron Williams	
32:	Aron Williams	
36:	Aron Williams	
37:	Aron Williams	
39:	Aron Williams	
43:	Aron Williams	
44:	Shutterstock	sabine_lj
45:	Aron Williams (both)	
47:	Engaruka Community Initiative Organization	Olarivan Paul Mollel
49:	Engaruka Community Initiative Organization	Olarivan Paul Mollel
51:	Aron Williams (both)	
54:	Engaruka Community Initiative Organization	Olarivan Paul Mollel
57:	Engaruka Community Initiative Organization	Olarivan Paul Mollel

HEALTHCARE

58:	Kafika House	Minttu Saarni
60:	Aron Williams	
62:	Kafika House	Daniel Samwel
63:	Kafika House	Minttu Saarni
66:	Aron Williams	
68:	Zach Peters	
71:	Alamy	Jake Lyell
73:	Lameck Tryphone Mutta	
76:	Zach Peters	
79:	Aron Williams	
81:	Lameck Tryphone Mutta	

228 LESSONS IN HOPE

83: Lameck Tryphone Mutta
85: Lameck Tryphone Mutta
89: Alamy | PhotoStock-Israel

NONPROFITS
90: Solar Sister | Roshni Lodhia
92: Aron Williams
95: Solar Sister | Joanna Pinneo (both)
98: Solar Sister | Joanna Pinneo
101: Aron Williams
103: Pioneer for Women and Youth Transformation
107: Lameck Tryphone Mutta
110: Mark Cutler
113: Lameck Tryphone Mutta
115: Alamy | Joerg Boethling
118: Lameck Tryphone Mutta
121: Lameck Tryphone Mutta (both)
125: Lameck Tryphone Mutta

GOVERNMENT
126: Aron Williams
129: Aron Williams
130: Aron Williams (both)
133: Aron Williams
139: Lameck Tryphone Mutta
144: Aron Williams
146: Lameck Tryphone Mutta
147: Operation Bootstrap Africa | Jason Bergmann
151: Lameck Tryphone Mutta

OTHER FIELDS
156: Alamy | Mile 91/Ben Langdon
158: Lameck Tryphone Mutta
160: Juliet Cutler
165: Lameck Tryphone Mutta
166: Lameck Tryphone Mutta (all)
169: Tanzania Advanced Agriculture
171: Alamy | Charles O. Cecil
173: Mountain Hearts Photography
174: *The Forum of Fargo-Moorhead* | David Samson
180: Alamy | Findlay
182: Lameck Tryphone Mutta
187: Mark Cutler
189: Lameck Tryphone Mutta

CLOSING
194: Lameck Tryphone Mutta
196: Lameck Tryphone Mutta
198: Lameck Tryphone Mutta
200: Lameck Tryphone Mutta
202: Lameck Tryphone Mutta
205: Lameck Tryphone Mutta
207: Lameck Tryphone Mutta
208: Aron Williams
210: Aron Williams
213: Lameck Tryphone Mutta

BACK MATTER
216: Lameck Tryphone Mutta
219: Robert Lederman
220: Aron Williams
223: Slade Kemmet (both)
224: Mapping Specialists, Ltd.
225: Mapping Specialists, Ltd.
226: Mapping Specialists, Ltd.
227: Mapping Specialists, Ltd.
230: Aron Williams
232: iStock.com | hadynyah

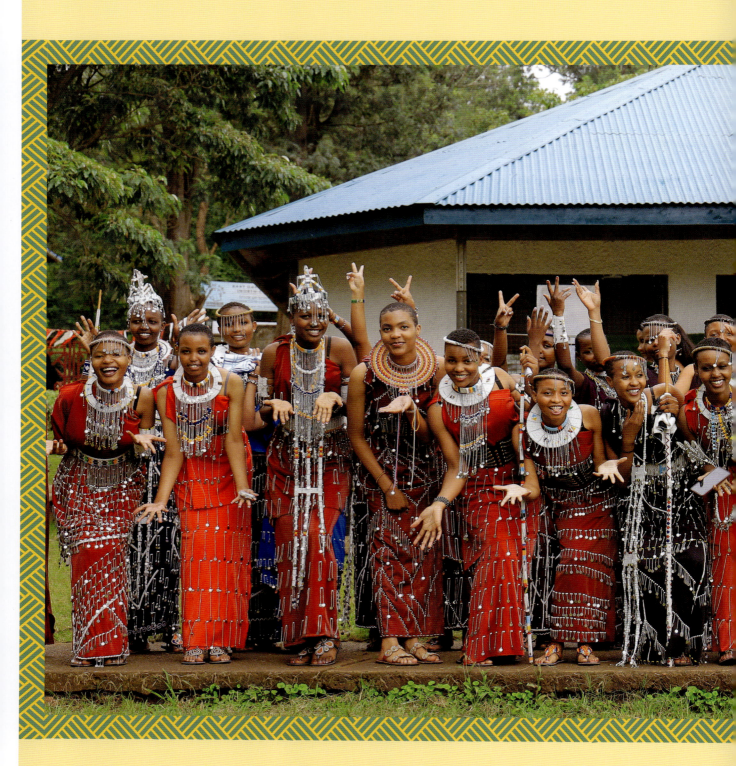

◈ **CLASS OF 2025** ◈